SNAPSHOT CHRONICLES

◇◇◇◇◇

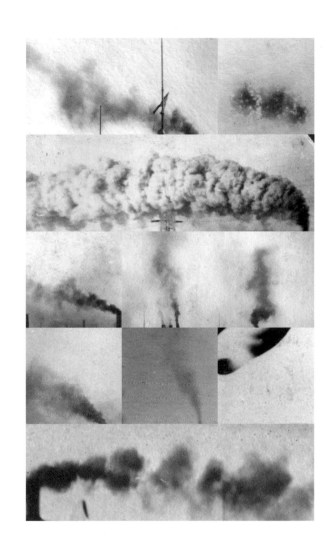

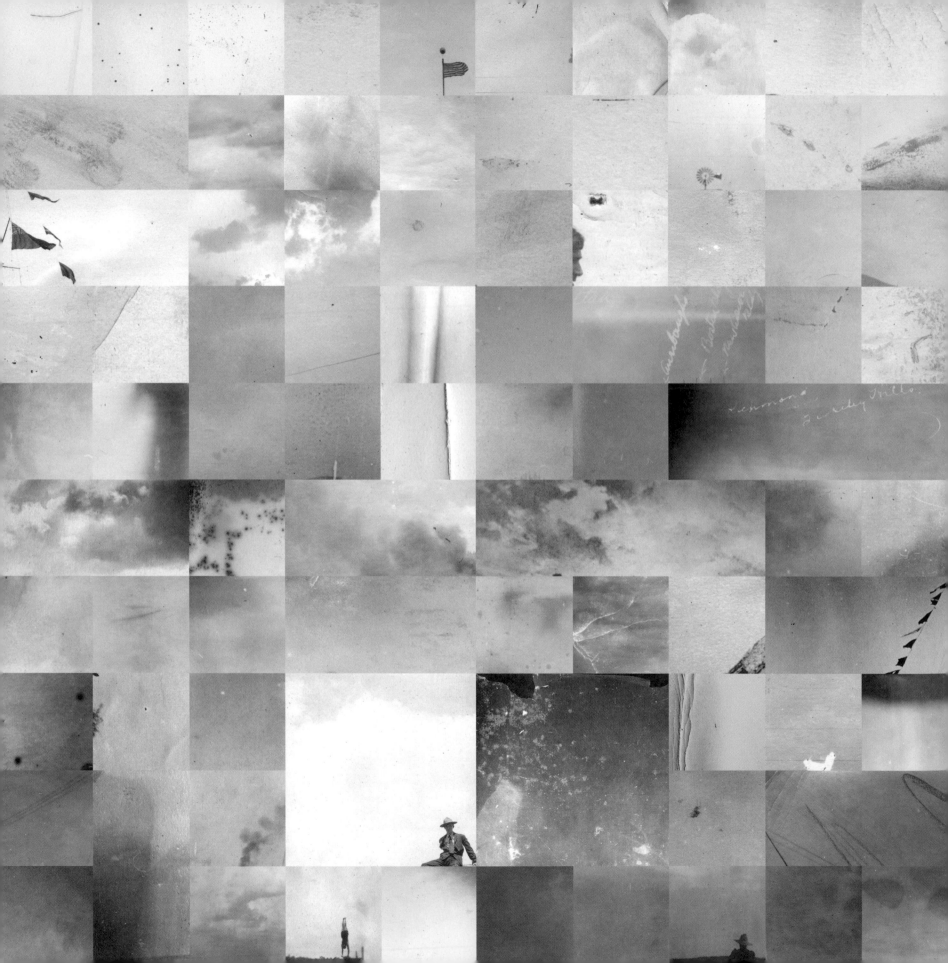

SNAPSHOT CHRONICLES

INVENTING THE AMERICAN PHOTO ALBUM

◇◇◇◇◇

BARBARA LEVINE *Curator*
STEPHANIE SNYDER *Director and Chief Curator,*
Douglas F. Cooley Memorial Art Gallery

From the collection of Barbara Levine

Princeton Architectural Press, New York
Douglas F. Cooley Memorial Art Gallery,
Reed College, Portland, Oregon

Co-published by

Princeton Architectural Press *and*
37 East Seventh Street
New York, New York 10003
www.papress.com

For a free catalog of
Princeton Architectural Press books,
call 1.800.722.6657.

Douglas F. Cooley Memorial Art Gallery
Reed College
3203 SE Woodstock Boulevard
Portland, Oregon 97202
web.reed.edu/gallery

◇◇◇◇◇

◇◇◇◇◇

Editing
Jennifer N. Thompson

Design
Martin Venezky/Appetite Engineers,
Los Angeles, California

Special thanks to
Nettie Aljian
Dorothy Ball
Nicola Bednarek
Janet Behning
Megan Carey
Penny (Yuen Pik) Chu
Russell Fernandez
Jan Haux
Clare Jacobson
John King
Mark Lamster
Nancy Eklund Later
Linda Lee
Katharine Myers
Lauren Nelson
Jane Sheinman
Scott Tennent
Paul Wagner
Joe Weston and
Deb Wood of Princeton Architectural Press
—Kevin C. Lippert, publisher

This book is being published on the occasion of
the exhibition

SNAPSHOT CHRONICLES:
INVENTING THE AMERICAN
PHOTO ALBUM
Douglas F. Cooley Memorial Art Gallery,
Reed College, on view
May 24–July 11, 2005.

San Francisco Public Library
April 15–August 20, 2006.

The exhibition is curated and organized by
Stephanie Snyder, director and chief curator,
Douglas F. Cooley Memorial Art Gallery, Reed
College, and Barbara Levine, curator.

Library of Congress
Cataloging-in-Publication Data

Snapshot chronicles : inventing the American
photo album / [organized by] Barbara Levine,
Stephanie Snyder.—1st ed.
 p. cm.
 "From the collection of Barbara Levine."
 ISBN 1-56898-557-6 (hardcover : alk. paper)
 1. Photograph albums—United States. I. Levine,
Barbara, 1960- II. Snyder, Stephanie, 1964- III.
Douglas F. Cooley Memorial Art Gallery.

 TR501.S63 2006
 770'.973—dc22

 2005016969

CONTENTS

◇◇◇◇◇

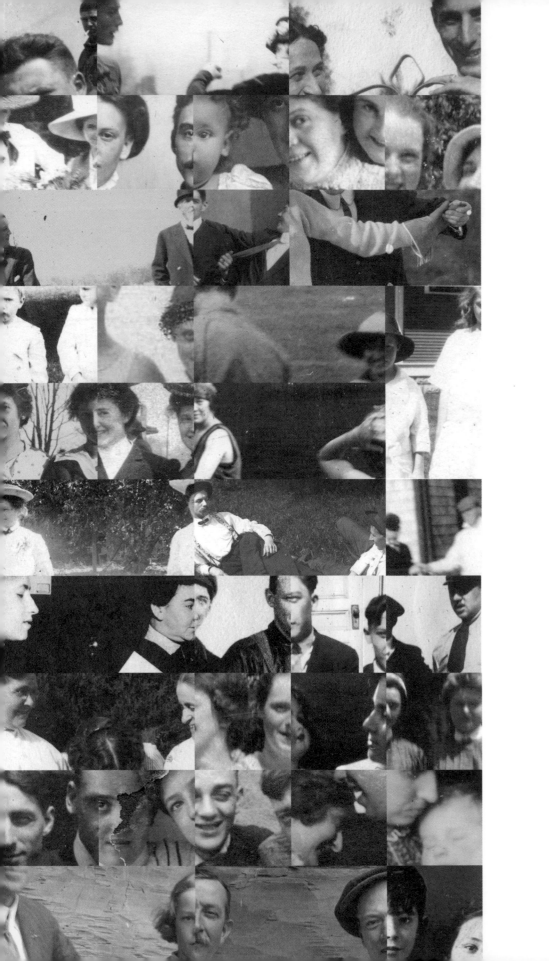

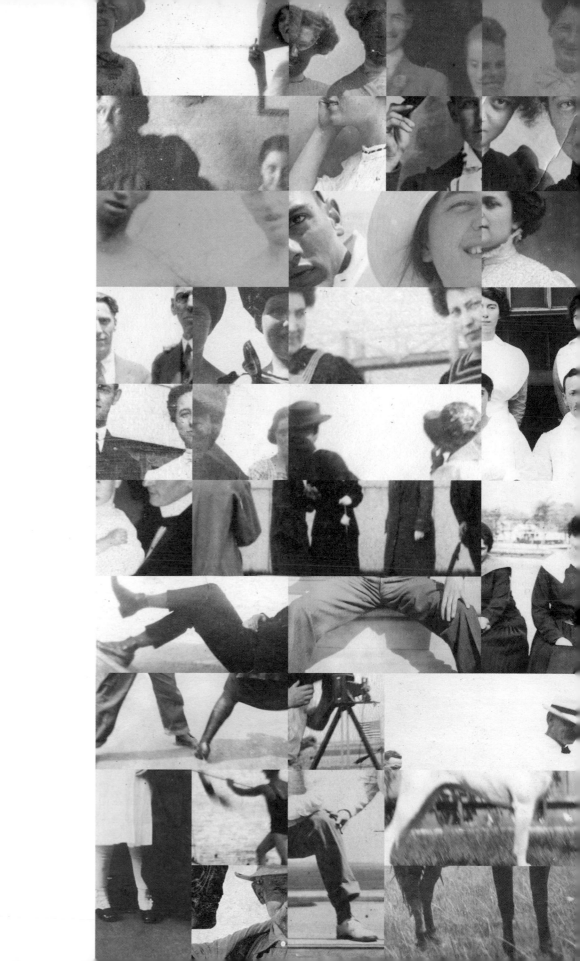

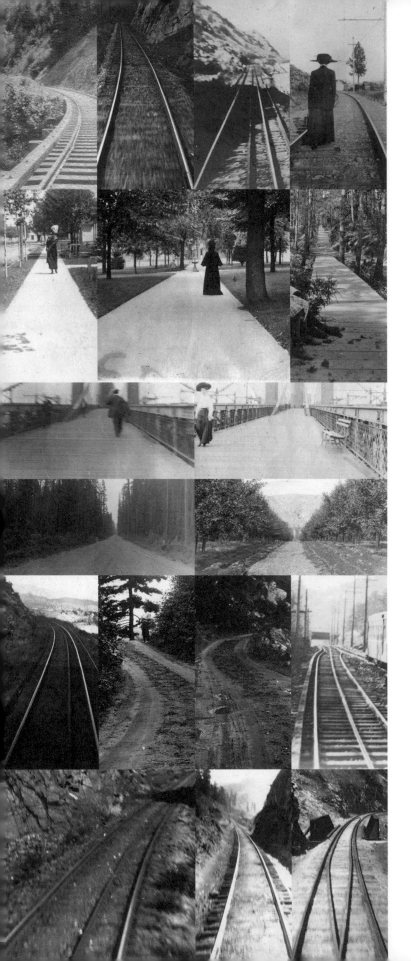

PREFACE

STEPHANIE SNYDER

◇◇◇◇◇

HETHER BY DESIGN OR BY ACCIDENT, those enraptured by the deeply personal and elegant imagery, luminous surfaces, and sensuous materiality of early vernacular photo albums are moved by an ineffable impulse to collect, organize, and narrate. Page after page, album after album, we embrace the artistry and creativity of this unique art form, awestruck by the remarkably inventive mélange of object, image, and text animating these precious yet rugged visual biographies. These albums were created by the first generation of Americans who possessed the ability to examine their lives photographically, immersing themselves in the medium on their own terms. Studying these albums through the lens of *our* moment, one in which technology is again shaping our storytelling abilities and altering the ways in which communities interact with one another, we are struck by the album makers' universal impulse to record, organize, and preserve their experiences and impressions. Album makers created lasting manifestations of both personal and communal memory, enveloping the past within the present, creating a sense of magic, authenticity, and hope for the future. Snap shooters consistently captured themselves in the act of image making, posing with their cameras. Such images functioned as proof of the photographer's authorship and competence, and as evidence of the individual's agency in a world increasingly organized by visual signs.

◇◇◇◇◇ As powerful a role as these authentic objects played in people's lives, it did not save them from estrangement, both from their creators and their descendents. Because these albums flourished in the domestic margins, removed from institutional authority and its protection, they were vulnerable to neglect and disappearance. Fortunately, in the case of the albums in this exhibition and book, an intervening force—collector Barbara Levine—arrested their trajectory

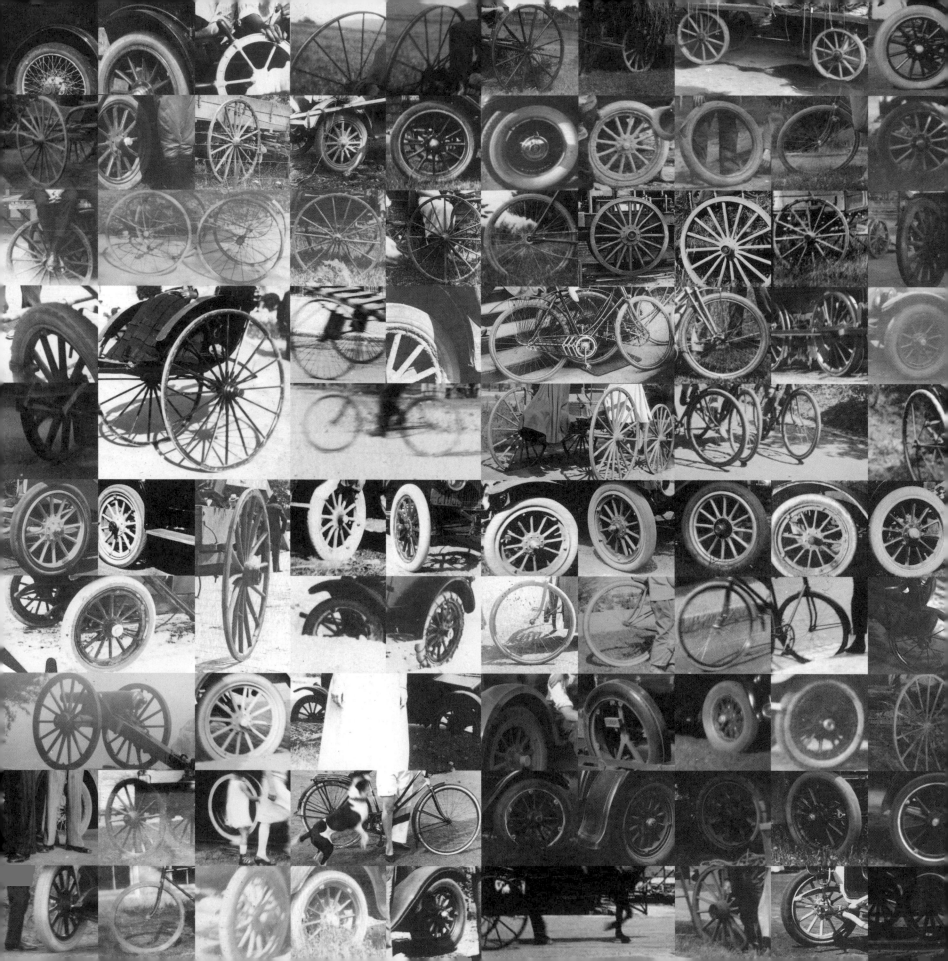

of loss, and brought these important objects into aesthetic and historical context with one another. I am very grateful to Barbara Levine for her generosity in allowing us all to study and present the works that have lived so long in her care. Over the course of two years, Barbara and I carefully curated the collection of albums represented in this exhibition and book. These albums embody the range of visual and material strategies employed by early album makers. Our installation at the Douglas F. Cooley Memorial Art Gallery at Reed College was informed by our investigations into the visual strategies of early album makers, externalized in dialogue with Martin Venezky's brilliant treatment of the material within this book. Barbara and I worked with designer Stephen Jaycox and Cooley Gallery assistant director Silas Cook and registrar Robin Richard in order to craft an exhibition design that echoed the interiority, whimsy, and universal experience found in the albums. To this end we incorporated ambient sound elements by composer Steven Feuer and virtual albums created by Stephen Jaycox. The virtual albums allow the reader to experience the seriality of the narrative, to meander back and forth in real time. These environmental elements created an immersive experience for the viewer.

◇◇◇◇◇ At Reed College many others contributed their valuable work on the exhibition. In the communications office I wish to thank Beth Sorenson, Amy H. Taylor, Paula Barclay and Tony Moreno. Many thanks to Reed College president Colin Diver, dean of faculty Peter Steinberger and vice president for college relations Hugh Porter for supporting the work of the Cooley Gallery, and to the Cooley family and the Gray family for their support of the arts at Reed. And we are very pleased that upon leaving Reed, the exhibition will travel to the San Francisco Public Library in the spring of 2006.

◇◇◇◇◇ Several years of discussing this astonishing material for the exhibition created the desire to produce a lasting document of the exhibition and of the collection—a volume that would further discourse on the subject and inspire others to consider the social history, narrative complexity, and material richness of vernacular photo albums. We were extremely fortunate to find Jennifer Thompson, our passionate collaborator at Princeton Architectural Press. In crafting our essays for this book, Barbara and I worked in complementary directions. Barbara elucidated her relationship to the material from the perspective of the collector—a passionate individual who has worked with vernacular material for twenty years— whereas I focused on the material from an art historical perspective informed by gender studies and the history of domestic home craft. We then invited two inspired and highly creative minds to put their intelligence to the material: Terry Toedtemeier, Curator of Photography at the Portland Art Museum and an avid vernacular collector and Matthew Stadler, novelist, Guggenheim Fellow, and the literary editor of *Nest Magazine*. Terry Toedtemeier's essay explores the historical conditions from which the snapshot and the vernacular photo album emerged. Matthew Stadler examines the material from a literary perspective, examining the ways in which photographs carry agency in the work of Marcel Proust. Many thanks also to Lauren Nemroff, Debra Rolfe, and Lena Lencek for their invaluable help with my essay, Melody Owen for her tireless production assistance, and Dana Davis, assisted by Dan Kvitka, for lovely catalog photography. And finally, I wish to thank my family—my parents Dr. Peter and Amalia Sakellaris, my in-laws Dr. David and Susan Snyder, and my husband Jonathan Snyder and my son Theo—for their care and understanding while I was engaged in this project.

◇◇◇◇◇ As with many forms of folk art, fine arts institutions have only recently embraced vernacular photo albums as objects of significant artistic merit. The reasons for this estrangement are complex. The value of the album is relational—based on the object's social function as a chronicle of individual and family experience. The humble album often has multiple authors and synthesizes different genres of artistic production thereby thwarting specialization. In contrast to the individual work of art, the album's genius resides in the interplay between material transformation and narrative chronology—between precision and accident. Within these albums, personal narratives are interwoven with studies of the commercial sphere and the public spectacle, expressing both the individualism and collectivity of American life—a *communitas* of representation. Within the vernacular photo album we find consistent reminders of the shared experiences transforming American life at the turn of the century. In so many respects, we share the same concerns today—family, work, home, play, beauty, war. Within our self-made chronicles, we externalize our concerns and our memories, our relationships and our desires; we preserve the past where we can see it and touch it in order to revisit it, in order to embrace it.

◇◇◇◇◇

13

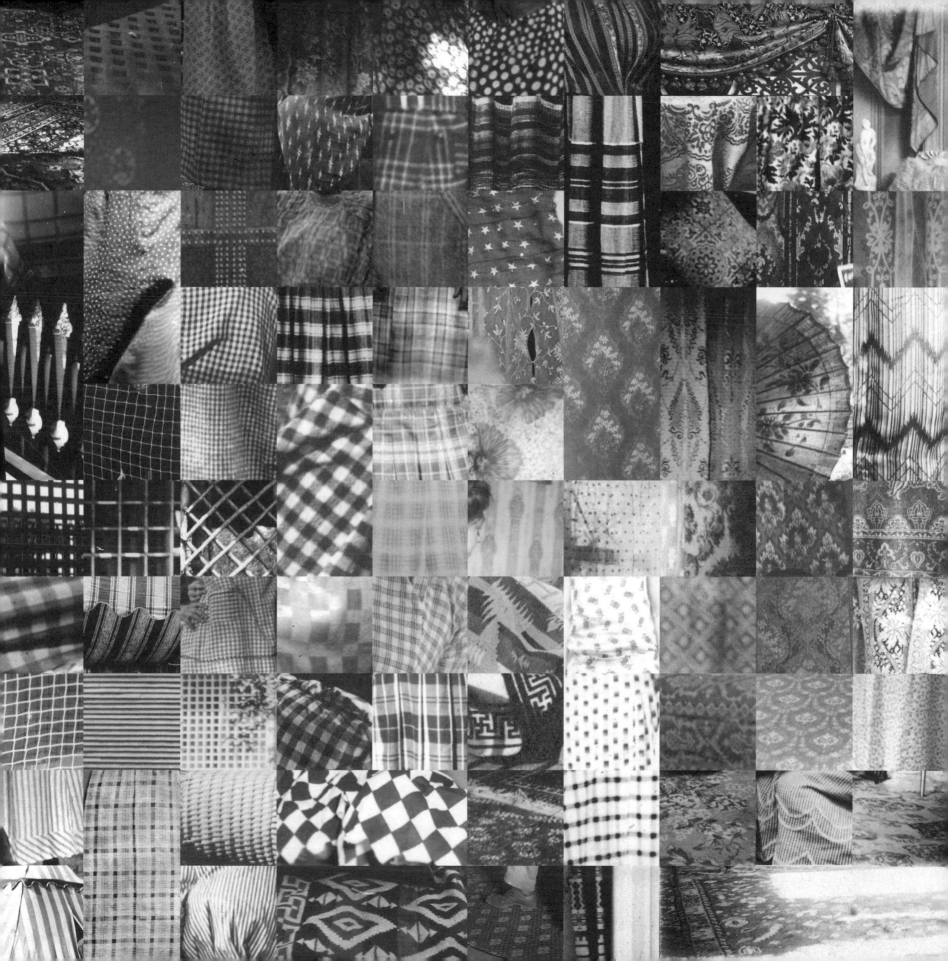

July 1916

Aug. 1927

Dec. 5 1911

Mass.

July 15, 19

July 7, 1934

1911 1912 1912 In the SPRING Age 11 Years

1933.

ONE 1916. 1908

Aug 17-19 Garden of the Gods 1920 chaperone Mich. A Snow Bird 1937

1909. Sunday + 1914

The 20th Century New York. 1910 In the good old days 1914

Oct. 1915 1924 1924 19 OCT. 14, 1911

1913 1914 School Base Ball 1907

July 10. STRIKINGLY BEAUTIFUL 1911 1916 1917

July 29. 1911 1912 1903 July 4th 1919

"Automobile 1915. Feby 1914 1917-

1915. Summer 1915. LONG AGO Oct. 24-25-26. 1926. After -1911- Sept 30 - 20

Summer 1926 + AGO out at May 1937.

1912 FAR AWAY Nov. 24, 191

Maine Clspler (1yr 2 m

1912 1903 - 1904. 1916. May 1934

COLLECTING PHOTO ALBUMS—
MUSINGS ON

BARBARA LEVINE
in conversation with Frisch Brandt

◇◇◇◇◇

OPEN THE COVER SLOWLY, feeling the rough nubbiness of the familiar (usually black) paper, sometimes crumbling in my hand. Photo albums are transformative. As soon as I open the cover there is a rush of feeling that something I was never meant to see is in my hands. As I turn the pages, I am activating a story. The pages of the album show the progression of time; they are not just about a single moment but rather they are about the accumulation of time. A narrative is building, faces are aging, and often there are words or drawings: someone is telling their story. When I turn the page I have no idea what to expect. There is a mysterious, intimate pleasure in seeing how others have preserved their lives.

◇◇◇◇◇ Sometimes the story is immediately predictable (child grows up, gets married, has own children); other albums tell an unexpected and unconventional story (a woman studying to be a doctor, a circus family on the road, photos shredded and collaged on album pages, a sailor's diary). While turning the pages of these more unusual albums, I enter voyeuristically into an unfamiliar world. As albums, they are really about the present, *that* present, made in real time and, as soon as that picture was on the page, it became the past. These albums are so essentially *human,* with their flaws and idiosyncrasies. Yet, it is all the inventive and personal ways in which people organized their pictures into page-turning stories that moves me the most.

◇◇◇◇◇ I have always been drawn to albums made from 1890 to 1930. There was the discovery, if not the actual invention, of a photographic-visual literacy. There was the slippage of time and styles from portraiture to pictorialism, and then pictorialism to modernism. Later we see many of the elements of invention at work photographically; however, before 1930 what was unconventional had not yet been accepted and integrated into the way we see pictures as it

UNTITLED, c. 1910

was, for example, in 1960, with the beginnings of the "snapshot aesthetic" (as in the early work of photographer Garry Winogrand). It is similar to the blur today where there are no real distinctions between commercial and non-commercial picture use.

◇◇◇◇◇ My childhood was lived through picture magazines and novelty mail-order catalogs. The home I grew up in was one in which children were to be seen and not heard (being an only child and second to my mother's perfect poodle didn't help either), and my survival tactic was to immerse myself in magazines such as *Life*, *Look*, *National Geographic*, *Vogue*, *Vanity Fair*, *Superman*, *People*, *Mad Magazine*, and catalogs like Johnson Smith Novelty, Shackman and Spencer Gifts. I was always looking at glossy advertising photographs, fashion pictures, edgy portraits, and black and white documentary pictures and ordering novelty tricks and magic supplies through the mail and always waiting anxiously for the packages and the latest magazines to arrive (a condition I am still afflicted with especially now with the internet and on-line stores). The foundation of my visual language was based on my love of all kinds of photographs and advertising and pictures promising big things in small packages. In particular, I was attracted to the way that photographs, well-composed and arranged artfully on the page, could create illusions and tell amazing stories.

◇◇◇◇◇ I come from a family of collectors. My mom's idea of a fun family day was for everyone to pile into her Thunderbird and go antiquing. As my mom and her mom were seriously hunting for china soup tureens and sterling silver compacts, I was mooning over cameras, intrigued with them as magical objects and flipping through photo albums and rifling through piles of snapshots and cabinet cards. I was particularly taken with the fact that you could hold in your hand a photo album—a personal story—in the same way that you would a comic book or a catalog. I marveled at the anonymous familiarity of a face or an evocative landscape, and I felt like I had an illusion in my hands much in the same way I held the secret of having in my pocket the fake black eye and the magic money changer, tricks I had ordered from the back of my comic books. It wasn't that I wanted to know the person or go to that place in the picture or pretend that I had a black eye (though I did pretend I had a broken arm for a month with a fake cast), it was the idea of it, the *thingness* of it and the evoking of time and illusion.

◇◇◇◇◇ Learning about forms and visual language followed, first as a student at the San Francisco Art Institute and then when I went on to work at the San Francisco Museum of Modern Art. Throughout those years, my interest in the tracking of time and my ever-growing collecting habit led me to give more attention to the photo albums at

flea markets (where I spent most of my weekends). One album in particular caught my attention. It was a small album with a cut out illustration of a bride and groom on the first page and in black neat handwriting, was written "Mrs Wayman's Album, 1910." In a good number of pages there were seemingly redundant pictures of her with her Brownie box camera. Individually, the pictures themselves weren't terribly interesting, but when you see five pictures on a page—basically the same image, this woman with her camera—she's made a point of wanting us to know that she was into her camera and photography. As I turned the page, I found myself looking then at something completely different: an intimate picture of Mrs. Wayman reclining, napping—with a particular sense of casualness caused by the less-than-perfect blurred light source in the background. On the next page, figures are cut out and animated using collage techniques. There is a moodiness and variety in both the compositions of the photos and the placement and sequencing on the page. You just don't know if it was naiveté or a kind of sophistication at work. It was all invention at the time. There were no photo books, no archetypes, or matrices. Each person was a lone ranger, compiling their own story by way of photographs.

◇◇◇◇◇ Of course since Mrs. Wayman's time, we've seen a lot of artists think in terms of layering and repetition—it's become one of the calling cards of photography, particularly in the advent of faster films and motor drives. But in 1910 this was the point of origin. For example, there is the page in her album in which she has pasted two identical pictures (the only difference is that one photo is larger than the other) of a man and a woman, presumably her, on the same page. She's written under them respectively "Big Us" "Little Us." Is she unable to decide which is the better print size? Is she trying to make us laugh? Or is she addressing a conceptual question? It raises again my favorite question of photographic and visual literacy: how and when did it take shape? At the end of the nineteenth century, people, lots of people (and there is virtually nothing other than an amateur in this instance), had a camera in their own hands. This is the birth of photographic literacy, and in this relatively short time, a time that might include, if we're lucky, merely four generations, the subject and questions of photographic literacy have exploded around us.

◇◇◇◇◇ By the time photograph albums emerged in 1900, just after the Brownie Camera became popular, people became less precious about photography. They started having fun with it, taking their cameras on picnics, on trips, to the farm, and to bed. Photography gradually became ubiquitous. But few people are schooled in making pictures. Mistakes happen and are preserved. Film, unlike painted portraiture, is cheap. Some of these accidents are through the eyes of the

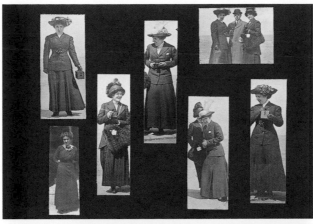

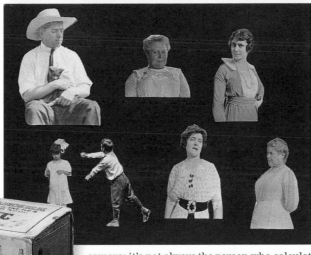

camera; it's not always the person who calculated the particular "thing" that makes a picture curious, fetching, humorous. But it is the maker of the album—the one who has preserved it and woven moments together—that creates an illustrated story. These are, for all intents and purposes, pre-cinematic efforts.

◇◇◇◇◇ People so loved their pictures that you can see the same one pasted again and again on a page. Unlike other media, they would even rip, shred, or draw across their pictures. That is fantastic, especially when you consider how unconventional that was. At the same time, George Eastman and his company, Kodak, were relentless in proffering just how pictures were to be taken. They did this by way of advertising and their monthly publication, *Kodakery*. It was only with time, lots of time, and forgiveness that people (and not all people) came to appreciate the unexpected. Because it was a hobby *and* a business, encouraging people to be creative became the norm.

◇◇◇◇◇ One of the reasons I am so committed to this material is that, unlike many album collectors, my interest is not in a particular subject matter or geographic region. I am looking for examples where the voice of the maker is palpable. I look for albums that contain compelling photo-

graphs and interesting subject matter. Sometimes, you are not sure if you are looking through the eyes of the maker, the camera, or both. But what is most important is what the person did *with* the photographs.

◇◇◇◇◇ Unlike an individual photograph, an album presents a design challenge. The page doesn't dictate where those pictures are to go. I'm interested in where the maker put the pictures and how they sequenced them on the page and on the pages thereafter. In an album you are looking at so many things simultaneously—what the photographer sees, what the camera sees, and what the maker of the album sees. There are all kinds of albums, so many of them dearly conventional, but what I consider to be distinctive about my collection is the presence and expression of the unconventional imaginative voice.

◇◇◇◇◇ Take for example "The Great Wonder Circus" album. The Great Wonder Circus was a traveling family circus (mostly women) in 1910. This album records both their personal life and their circus life on the road. The first page in the album shows women dressed in clown and witch costumes and on facing pages are the same women dressed in men's clothing, dancing with each other. On another the maker created a checkerboard pattern made out of small square portraits. There are views of family members setting up the tents alternating with dramatic, elegant portraits (often in profile) of various men and women. On many of the pages are tiny cutouts of people pasted between photographs that punctuate and animate the album.

◇◇◇◇◇ Long before this project took shape, I thought I would make a photo album out of my family pictures. I bought a nice unused vintage album and I made one, and like most people, I put it away. A couple of years ago, at the beginning of this project, I remembered that album. I unearthed it, and, I confess, it was dull and very conventional. There weren't any of the qualities in my homemade album that I seek out in albums for my collection. I was quite struck by the fact that when it came to making my own album—even given my art-school background and my intimate exposure to a wide range of photographers of our time—there was nothing innovative or idiosyncratic about it. This experience gave me more of an appreciation for the untutored methods people implemented in the early 1900s.

◇◇◇◇◇ People, myself included, are much more self-editing now. We have a visual literacy and a language that is, while broad and nuanced, very specific. Factoring in the full spectrum of new technologies and the very different ways in which photographic thinking has infiltrated our every moment, it has become increasingly dir e to study these albums, ponder their creative reasons, and to save them. The early family-photograph albums show ideas of self-expression in their fledgling state that appear now

19

everywhere, including digital technologies and bountiful blogs.

◇◇◇◇◇ In the last few years in order to afford the photo albums, which are no longer selling at flea market prices, I started selling off images in my twenty-five-year-old collection of snapshots through my website (projectb.com). In doing so I have become exposed to a wide variety of individual collectors whose interests are both inspiring and eccentric: the ones who collect pictures of babies in peril; those who collect pictures of men, women, and children pointing guns at each other; and a whole base of people who collect specific breeds of dogs (there are more people who collect pictures of Boston terriers than I could possibly have imagined). And there are the collectors who hunt for snapshots of dime-store cowboys, masks (especially gas masks), shadows, men in tight pants, and women with extremely long hair. Now there are even people who collect the Kodacolor snaps for the bizarre color shifts. It's endless.

◇◇◇◇◇ Always though, upon learning that I collect photo albums, collectors of snapshots and others, will ask, "do you know the people in the albums?"; Have you contacted their families?"; "Isn't it weird to own other people's albums?" There is an unspoken sense that albums are passed on within families through generations and that it is sad or an unspoken violation when an album lands in a stranger's hands (never mind that most snapshots were once in a photo album and part of a larger story). Naturally, I don't feel this way. I don't know the people in the albums, nor have I tried to contact their families. I am not interested in genealogy. I'm interested in these albums as objects, as visual explorations, as storytelling, and as visual concepts. In so far as I realize it's meaningful that these things have wound up in my hands, I know full well that photo albums are the first thing people seek when fleeing a burning house. The irony is not lost on me—including the fact that there are endless amounts of photographs and family albums to be found at flea markets and at online auction sites. And so how and why is it that these are coming into my hands? I think of it as a wonderful recycling, a repurposing. Once the albums are removed from their intended circle they become anonymous and invite a retelling of the story. I'm appreciating them and going one step forward: I'm putting a language to that appreciation.

◇◇◇◇◇ These are, in fact, the sources, to which the new technology that surrounds us—that at times invades us—is tipping its hat, Photoshop and beyond. The albums made between 1890 and 1930 are the source material that I want to preserve and consider. They are the first generation of photographic storytelling—evidence that you don't need machinery to think inventively.

◇◇◇◇◇ What really is the difference between the Kodak Brownie's arrival in 1900 and the arrival one hundred years later of the digital age? As I see it, these albums have evolved, or devolved, into what we know today as shameless self-chronicling (i.e. reality television, webcams, and blogs). It is technology, ever changing and new, that has allowed our stories to be broadcast far and wide. But here, in these albums people sought new ways to represent themselves, their stories, and their lives. It wasn't for commercial reasons; it wasn't for fame or recognition. It was, if anything, for themselves and maybe, on a good day, for posterity. We are that posterity.

◇◇◇◇◇

20

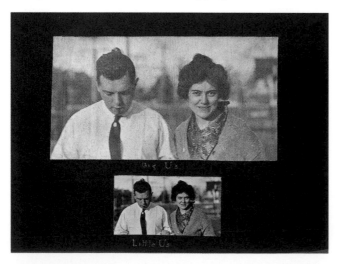

BIG US, LITTLE US, 1910

opposite
MRS. WAYMAN NAPPING, 1910

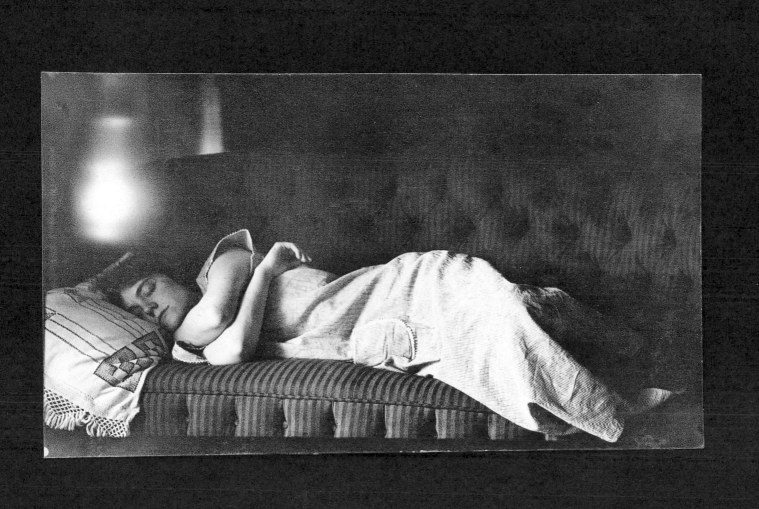

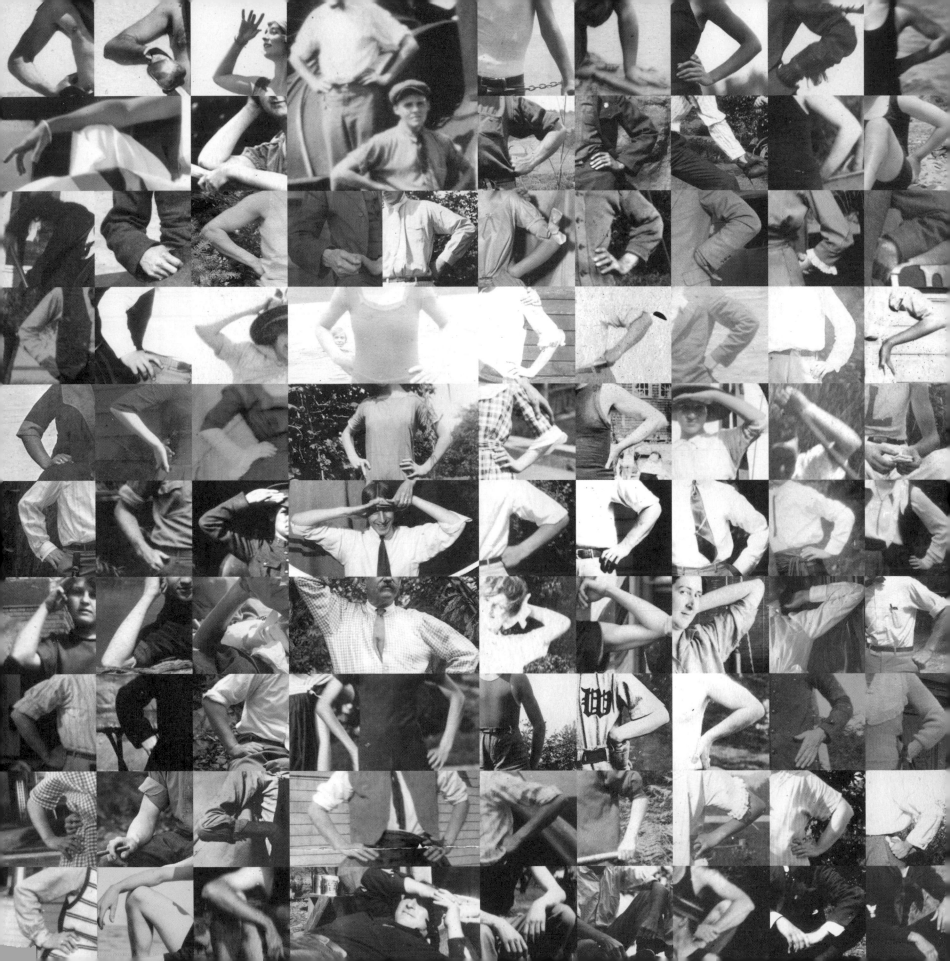

EDNA, RUTH, 1924, TILL

SEACIEL, 1924 EDNA, F

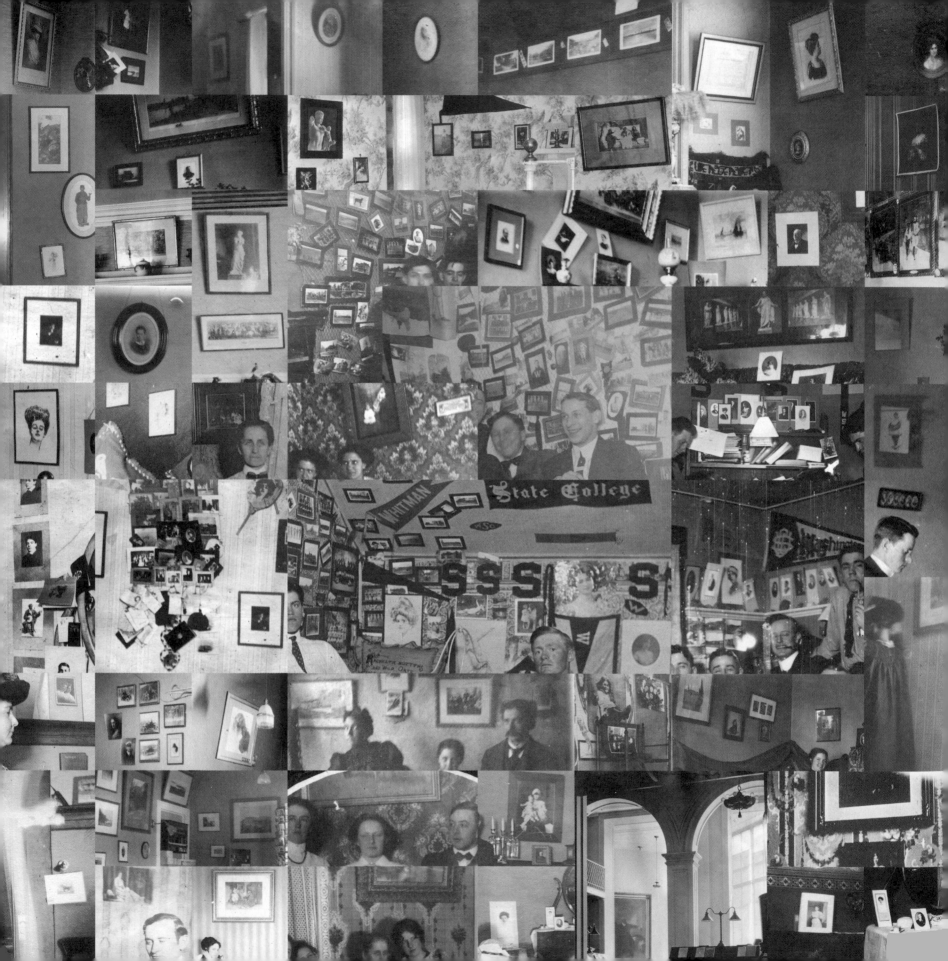

THE VERNACULAR PHOTO ALBUM:
ITS ORIGINS AND GENIUS

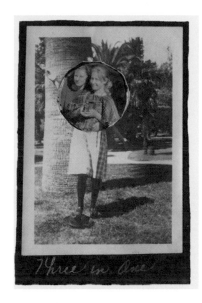

STEPHANIE SNYDER

◇◇◇◇◇

SNAPSHOT CHRONICLES: *Inventing the American Photo Album* explores the origins and genius of the vernacular American photo album during the first forty years of its growth as an unprecedented cultural phenomenon, from 1888 to 1935. The albums in this exhibition and collection are the inspired creations of everyday photographers both affectionately and disparagingly known as "snap shooters." Everyday photographers deployed the mass-produced cameras that Kodak marketed to Americans beginning in the late 1880s, blossoming into a new genus of American folk artist. The vernacular photo album came of age amid profound changes shaping turn-of-the-century American life. Within these albums—crafted primarily by women—one encounters war, industrialization, immigration, family life, and public rituals (such as World's Fairs and tourism) interwoven into idiosyncratic narratives that are highly personal yet reflect and embody the culture.

◇◇◇◇◇ Equal parts visual diary, lay ethnography, family history, and reportage, the vernacular photo albums in *Snapshot Chronicles* are sites where art, culture, history, and private life intersect. In just one album, the viewer moves through the 1906 San Francisco earthquake, an ocean-side picnic, a child's first steps, a husband's machine shop, a drawing room interior, a political rally, and the death of a loved one. Although the camera made this unique art form possible, it is critical to understand these eclectic, emotive objects in the context of the domestic material traditions that women employed to organize, memorialize, and extend their experiences. The photo albums in *Snapshot Chronicles* are the direct descendents of the quilt, the autograph book, and the embroidered sampler. These early folk artists inscribed their albums with deep interior significance and personal history, energetically responding to the fragmentation and dismemberment inherent in the photographic medium, and producing authentic forms of self-representation during a time of rapid change and technological advancement.

UNTITLED, c. 1925

◇◇◇◇◇ During its first wave, from 1840 to 1880, photography rapidly became a large-scale economic and cultural engine through the institutions of the studio and the itinerant, or wandering, photographer. In New York City alone, two million studio portraits were taken annually from 1860 to 1870. Women, children, and their families were also involved in studio portraiture through cottage industry. An 1885 *Harper's Magazine* contains an advertisement soliciting women to hand color cabinet cards from home—cabinet cards were portraits, primarily, mounted on thick decorative stock, often housed in wooden cabinets (hence the name) but also nestled in luxurious albums and fancy handmade ornaments interlaced with fabric and ribbon. As photography became industrialized, large numbers of people were employed for the studios' specialized tasks. Mass production required tremendous amounts of natural resources as well. In 1870, the largest albumen print studio in the world consumed over twenty million fresh eggs annually. Girls spent day after day separating egg whites for use in the potassium bromide and acetic acid solution that covered the photographic paper employed in the albumen process.

◇◇◇◇◇ In both urban and rural communities, professional photographers created treasured daguerreotypes and other photographic objects that sanctified their subjects.[1] Compositions were derived from a fairly limited set of pictorial conventions appropriated from the higher arts of painting and drawing. Around 1856, however, representational conventions loosened, however, becoming more informal and idiomatic after the creation of the inexpensive tintype. From 1860 onward, almost any American could afford the fee a professional photographer charged to create a miniature likeness to be preserved and adored. As Frances Ozur describes in *Lost and Found: Discovering Early Photographic Processes*: "Rejecting the preordained genteel poses of the commercial studio in favor of simulating a more active image, tintypists strove for a wide range of facial expressions and postures."[2] Tintype examples from this period embody the spontaneity and humor that would become characteristics of the vernacular snapshot. When Kodak introduced the Brownie in 1900, a family that had previously cherished a small collection of tintypes, *cartes des visites*, and cabinet cards, suddenly possessed the means to generate hundreds, if not thousands, of photographic paper prints in a short amount of time. American consumers paid twenty-five dollars for a Kodak camera preloaded with a roll of film for 100 images, received informational literature about picture taking, and, once the film was shot, returned the entire camera to Kodak for processing and reloading for an additional ten dollars.

◇◇◇◇◇ In 1907, the German educator Alfred Lichtwark remarked: "There is no work of art in our age so attentively viewed as the portrait photography of oneself, one's closest friends, and relatives, one's beloved."[3] By 1915, photography saturated both domestic and commercial realms; the body of material generated by amateur photographers was estimated at 1.5 million annual photographs. How did snap shooters cognize the mass of material that began to infiltrate their lives? How did they negotiate the boundaries between lived experience and the incessant reproduction of daily life? Like everyone involved with photography, snap shooters were subject to the medium's inherent dilemmas: most acutely, the rift between the photograph's indexicality and the manner in which it arrests experience. For although a photograph, as a direct chemical imprint, is a likeness of its subject (and is real in this sense), the detailed finiteness with which a photograph captures its subject severs the subject from the natural order of time, leaving the photographic likeness decontextualized, and effectively stranded.

◇◇◇◇◇ In *A Short History of Photography*, Walter Benjamin explored the estrangement of the photograph in relation to the magical aura of the singular, non-reproduced work of art. Benjamin saw that photographs could be accumulated and transformed, constructively, in ways that brought them into the tactile, material realm, and closer to creative experience. Benjamin described this cumulative activity as "building something up, something artistic, created."[4] Snap shooters transformed their photographs in precisely the manner described by Benjamin: layering, splicing, and shaping their material into unique, "built-up" forms.[5] Album makers embraced the intimate, serial form of the book as the space in which to enact this activity. Such forms of photographic accumulation presented individuals with an opportunity to symbolically master the impositions of modernization through the camera's potential for, and promise of, democratic participation. Photography presented itself as a vehicle for asserting the emerging bourgeois self. As Susan Sontag describes in *On Photography*, "The subsequent industrialization of camera technology only carried out a promise inherent in photography from its very beginning: to democratize all experiences by translating them into images."[6] Unlike professional and fine art photographers of the time, snap shooters explored the representational possibilities of photography through wild juxtapositions and material experimentation. Vernacular photographers preceded European and American avante garde artists in using the snapshot as raw material to be taken apart and reconfigured to describe the self. As curator Doug Nickel states in the San Francisco Museum of Modern Art's *Snapshots* exhibition catalog: "The means by which people regarded their own histories also changed; the way lives were lived became entangled in the ways lives were now represented."[7]

1 This concept is elucidated by Susan Stewart in her work *On Longing: Narratives of the Miniature, the Gigantic, the Souvenir, the Collection* (Maryland: Johns Hopkins University Press, 1993).

2 Frances Ozur, "Early Masters of Illusion," in *Lost and Found: Discovering Early Photographic Processes* (Los Angeles, CA: Fisher Gallery, University of Southern California, 2001), 14.

3 Quoted in Walter Benjamin, "A Short History of Photography," in *Classic Essays on Photography*, ed. Alan Trachtenberg (New Haven: Leete's Island Books, 1980), 211.

4 Ibid., 214.

5 Ibid., 214.

6 Susan Sontag, *On Photography* (New York: Farrar, Straus, and Giroux, 1978), 7.

7 Douglas Nichol, *Snapshots* (San Francisco: San Francisco Museum of Modern Art, 1998), 11.

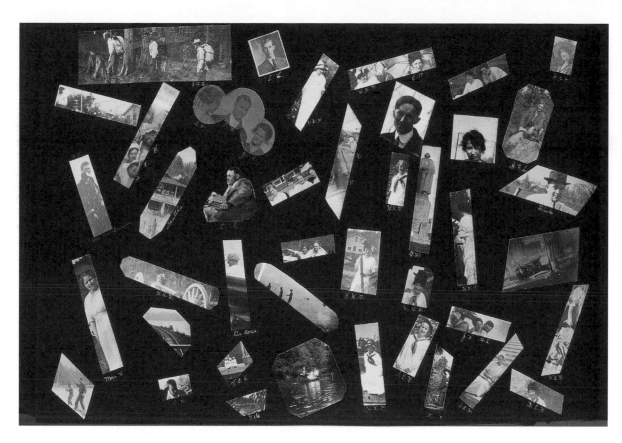

◇◇◇◇◇ A poignant example of the early snap shooter's re-imagined, photographic self is captured in a small image dating from the early 1900s. In this tiny gem, images of three women, culled from two photographs, are collaged to form an enigmatic hybridized creature. The handwritten caption below the image reads "Three in One." We see in this cre ation the bodies of three women but the heads of only two, a chimera. The headed women were grafted onto the trunk of the other by means of a carefully inserted oculus. The chimera holds a camera directed at us, her two heads smile coyly—as if issuing the viewer a polite invitation to assimi- late herself into this transformed, phantasmagorical body. The work's pieced-together subject complicates the viewer's ability to grasp with whom and with what to identify. What we do grasp most immediately is the technical production that led to the creation of the image. The collage embodies the problems and possibilities of self-representation and identification in a new age of technology.

◇◇◇◇◇ A very different conception of the new photo- graphic self emerges in Kodak's ad campaigns. As cameras were heavily marketed to women and their children, the ma- jority of Kodak's ads featured women in the act of picture- taking. Kodak marketed a female self to women in the form of the "Kodak Girl" and the older family matriarch who preserves her family's memories. A 1914 advertisement in *Harper's Magazine* depicts a prosperous woman reclining in a comfortable chair in a tastefully appointed drawing room. Gazing with affection at an object cradled in her hands, she is locked in a visual embrace with her camera. Because the advertisement is linked to Christmas, the viewer is invited to read the scene through the nativity image of the sacred Virgin Mary cradling the infant Jesus. There is a disturb- ing element of narcissism in the relationship between the woman and her camera, at once the intimate object of her attention as well as the vehicle—just as a child might be—of her immortality. It is easy to forget the fact that the woman in the advertisement is not taking a picture. Instead, she is communing with the object of her desire; photographic technology is presented as a vehicle for understanding the self introspectively, through established religious tradi- tions. In contrast to the preceding collage of the chimera in which the self is problematized and re-configured through technology, here the self is represented as being completed by technology. These two examples illustrate the radical dif- ference between the everyday photographer's exploratory impulse and Kodak's commercial agenda to market a com- plete new form of living.

◇◇◇◇◇ As Nichol rightly notes, photography's techno- logical origins were decidedly masculine, but the material antecedents of the vernacular photo album were clearly feminine: emerging out of the traditions of the Victorian scrapbook, folk art, and home craft. In eighteenth-century Europe, albums containing signatures, sentimental decla- rations, poetic fragments, epigrams, and drawings were the fashionable pursuit of young women of social standing. But by the nineteenth century, advances in printing technology

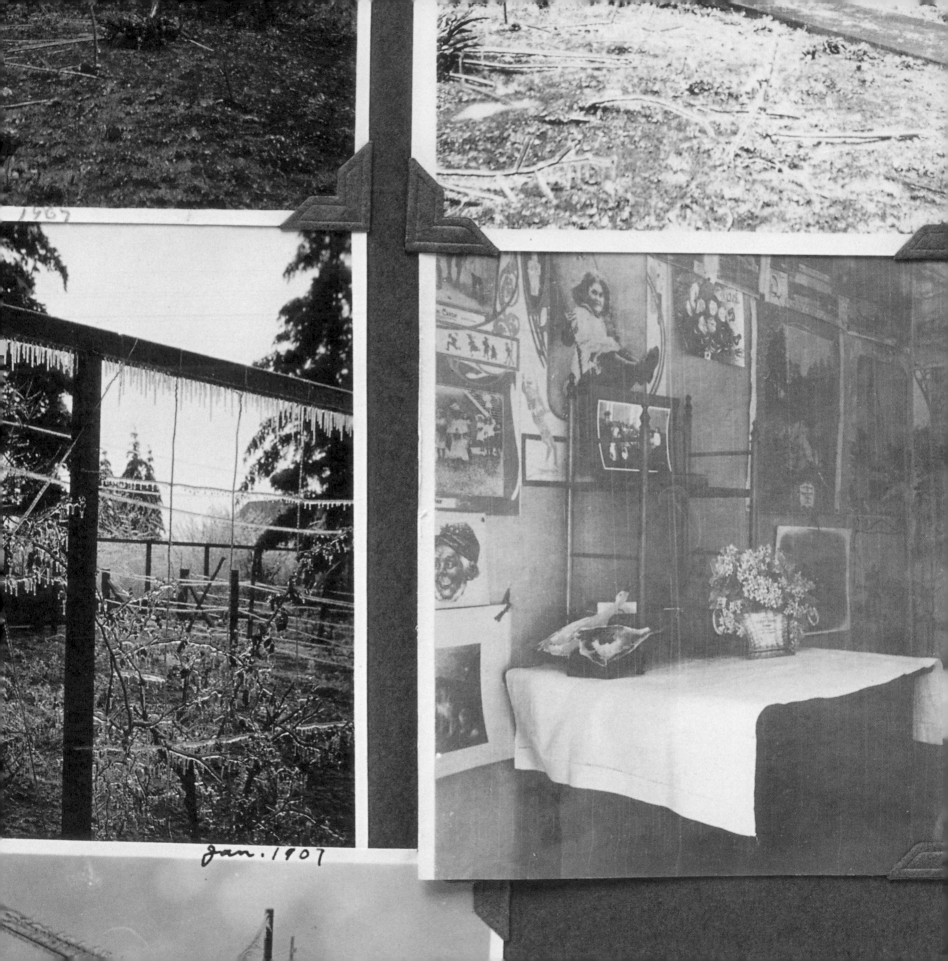

Jan. 1907

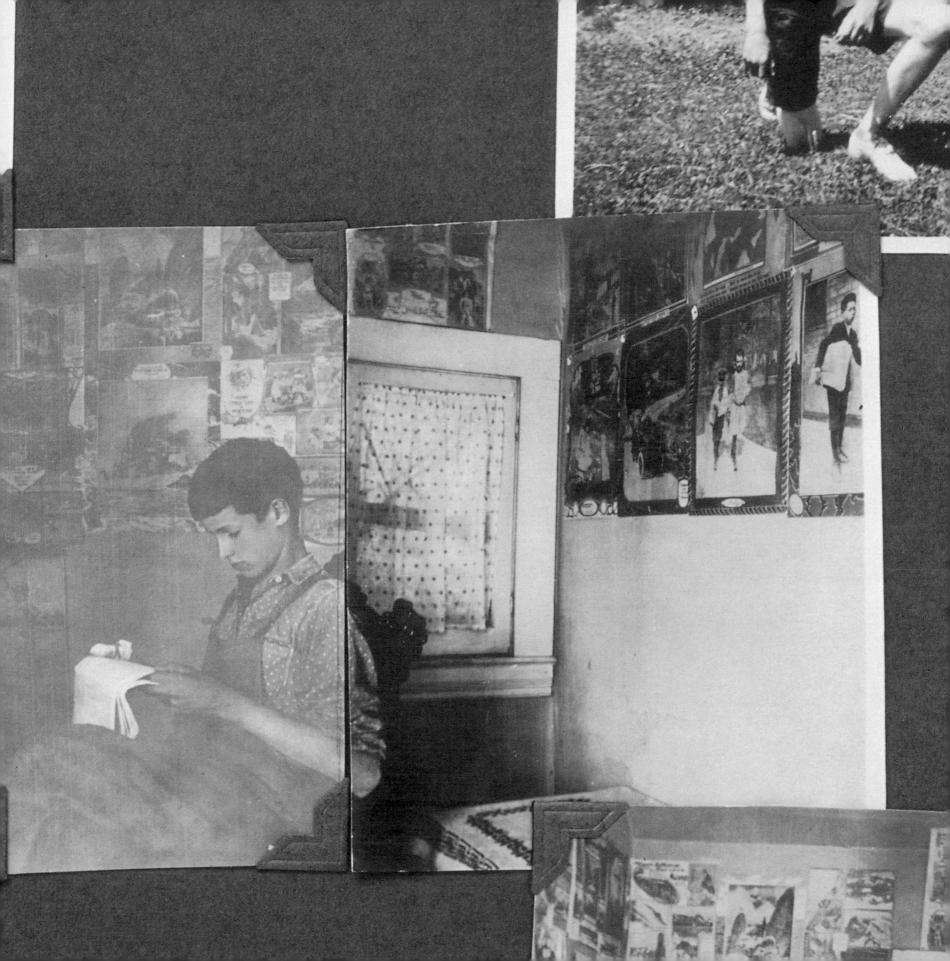

made illustrations in newspapers and magazines common, and arranging mass-produced ephemera in scrapbooks became a widespread practice that crossed class lines. In the late 1880s, the Prang Company in Boston (the same company that marketed the first color public school art textbooks in the early 1900s) marketed the first color lithographic Christmas card. Thanks to the proliferation of chromolithography in the late 1800s, sheets of fanciful characters and printed sentiments could be bought at the grocer, the stationer, and the baker. Valentines, holiday cards, trade cards (beautifully illustrated color lithographic cards advertising commercial goods), studio photographs, locks of hair, ribbons, and fabric scraps were collaged into scrapbooks and combined with photography by women and girls in nineteenth-century America. *Godey's Lady's Book*—one of the nineteenth century's most influential women's magazines containing stories, recipes, and moral and material instruction—contained a regular section called the "Work Table" that instructed women to make folios, frames, and fanciful containers for their studio photographs. Thus pictures were transformed into objects of remembrance and aesthetic significance. Such early photographic objects have been elegantly explored by Geoffrey Batchen in his exhibition and book *Forget Me Not*.[8]

30 ◇◇◇◇◇ In March 1891, alongside the "Child's Knitted Gaiter" and "Fissure Work on Cardboard," *Godey's* featured instructions for the "Tambourine Photograph Frame," an elaborate ribbon-clad wall hanging in which portrait photographs were revealed behind diamond shapes cut from "a piece of old kid or embroidery." By 1911, *Godey's* also instructed women in the creation of photo-album covers and accordion-folded pocket books for housing snapshots. Vernacular photography was also integrated into young girls' annuals such as *The American Girl's Handy Book*. By 1915, the *Handy Book* contained instructions for binding small volumes that combined snapshots with morally edifying expressions and poetic fragments. Girls were encouraged to express and preserve memories alongside family values. Domestic intimacy was also expressed photographically in forms other than books. By means of the cyanotype (invented by Sir John Herschel in 1841), women transferred striking blue imagery onto diverse fabrics, creating curtains, pillows, and drapes. Such sensuously tactile objects, like the velvety black pages of the store-bought album, were evidence of photography's integration into American home life. Batchen describes such photographic objects as giving photography ". . . substance and texture, making them touchable and warm, and allowing past and present to cohabit in everyday domestic life."[9]

◇◇◇◇◇ *Snapshot Chronicles* contains a number of young women's handmade albums, which bridge the tradition of

the remembrance book with the vernacular photo album. In one charming example that couples image with textual description, a young woman created a six-by-four-inch album out of thin, blue onionskin paper, printing the end papers with Arts and Crafts–style geometric forms, using, as school children still do, carved potatoes to carry the ink (pages 58–59). After mounting the photographs, the young maker carefully penciled captions that establish her relationships to the objects and people in the album. In a particularly evocative spread, one page contains an image of a country house accompanied by the words, "Our Home" across from a group of chickens with the words, "Our Chickens." The inscriptions are simple and direct, and the possessive voice suggests inclusiveness and pride of ownership.

◇◇◇◇◇ In dialogue with home craft traditions, Kodak targeted female consumers by placing the entire process of picture making squarely into their hands. Not long after the Brownie, Kodak released portable self-developing and printing devices. The entire photographic cycle could now be enacted in the domestic sphere. It is fascinating to imagine women developing and printing their family photographs in their kitchens or in makeshift workrooms. In 1910, in the *Cosmopolitan Magazine,* Kodak printed an eight-page pamphlet on home developing entitled "The Dark-Room Abolished." In this serious manifesto, complete with an afterword by male authorities, well-dressed women were depicted as domestic scientists, mixing developing solutions and staring intently at strips of negatives raised in front of their faces. Mastering the process of creating one's photographs from start to finish was positioned as being essential to understanding the mysteries of photography. The pamphlet declares, "When one has selected his own point of view for the exposure, has developed the negative and has finished the print—has produced by his own handiwork, through every stage of its growth, the perfect and satisfying picture—then, and not until then, will he appreciate to its full extent the witchery of Kodakery."[10]

◇◇◇◇◇ Women were encouraged to master each stage of the photographic process and, as other pamphlets from the time demonstrate, they were encouraged to work collaboratively, supporting and enriching each other's work while improvising and experimenting in order to arrive at unique, individualized results. Following the conventions of the time, "The Dark-Room Abolished" was written using masculine pronouns, but the terms "handiwork" and "witchery" clearly reference women's realms. The term "witchery" in particular draws the connection between photography and magic, which was present in the earliest writings on photography and in practices such as "spirit photography," a popular practice in nineteenth-century séance culture. In 1879 the French novelist Honoré de Balzac published a treatise on the spiritual

If it isn't an Eastman, it isn't a Kodak.

The Story of the

KODAK ALBUM

It's the intimate, personal story of the home—a picture story that interests every member of the family. And the older it grows, the more it expands, the stronger its grip becomes; the greater its fascination.

Ask your dealer or write us for "At Home with a Kodak."

EASTMAN KODAK COMPANY,
ROCHESTER, N. Y., *The Kodak City.*

8 Geoffrey Batchen, *Forget Me Not* (New York: Princeton Architectural Press, 2002).

9 Batchen, *Forget Me Not*, 31.

10 Eastman Kodak Company, "The Darkroom Abolished," *The Cosmopolitan Magazine* [1910].

11 Rosalind Krauss, "Tracing Nadar," in *Illuminations: Women Writing on Photography from the 1850s to the Present* (Durham, NC: Duke University Press, 1996), 39.

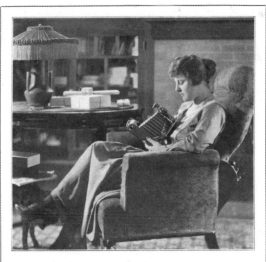

A happy Christmas thought—

KODAK

The gift that adds to the good times at the moment; that indoors and out gives zest to the merry making *and then*—preserves the happy picture story of all that goes to make the day a merry one.

The Kodak catalogue, free at your dealer's, or by mail, tells in detail about the various Kodak and Brownie cameras—from $1.25 upward. Photography is really *very* simple and inexpensive. Kodak has made it so.

EASTMAN KODAK CO., ROCHESTER, N. Y., *The Kodak City.*

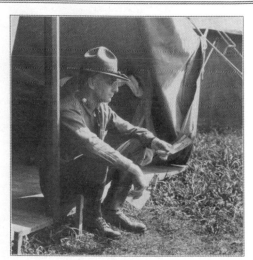

The Picture From Home

EASTMAN KODAK COMPANY,
ROCHESTER, N. Y., *The Kodak City.*

KODAK ADVERTISEMENTS, 1914–1917; *Reproduced courtesy of the George Eastman House*

foundations of photography entitled *The Theory of the Spectors*. Balzac believed that photographing a person stripped away a tiny "spectral layer" from their body, transferring it to the photograph.[11] Such metaphysical perspectives were advanced alongside the scientific pursuit of photography and the development of photography as a commercial enterprise, the latter so completely realized in America.

◇◇◇◇◇ Just as photographic technology was brought into the domestic realm, the visual and material strategies employed within the album were extended out of the album format and into the spaces of the home. The domestic environment was delineated and imbued with meaning through the addition of photographic and ephemeral visual material. We discover this in images of interiors from the albums in this exhibition. In photographs of parlors, we see mantles and end tables containing formal studio photographs that display the new bourgeois self; on the walls of living rooms and kitchens we see the type of dignified, photographic home-craft objects described in *Godey's Lady's Book;* in pantries, children's bedrooms, and transitional spaces we see snapshots, advertisements, and newspapers tacked onto walls. In an album from 1889, a young boy is pictured in profile, in a homemade panoramic photograph, reading in a room festooned with printed ephemera. In another album we see a young college student, relaxing in front of a large wall-mounted fishing net that contains many small framed photos like so many captured fish. These images reveal the instantaneous incorporation of self-generated photographs and other printed material into everyday life. Photographs were deployed to memorialize the past—as in the display of photographs of deceased loved ones in the honorific space of the parlor. But they were also used to reflect the vitality of the present, and the promise of the future—as reflected in the display of material in kitchens and children's rooms.

◇◇◇◇◇ In weaving photographs into albums, makers experimented so freely with material and created such diverse chronologies that to attempt to create a definitive system of classification around the albums is unproductive. One must, instead, search for the presence of similarities and distinctions—qualities and traits that make some albums more like one than another. In searching for these shared qualities, careful examination reveals the presence of albums with three distinguishing areas of overlap: albums that contain highly unusual imagery and photographic experimentation often combined in strange and compelling juxtapositions; albums that are distinguished by highly unusual textual narratives and sequential chronologies; and lastly, albums that contain inventive collage techniques and other unusual material inventions.

◇◇◇◇◇ In relation to the first of these points of entry—the juxtaposition of imagery—many of *Snapshot Chronicles'*

31

albums contain sequences of imagery influenced by fine art traditions such as the still life and portraiture. Photographers filled such albums with carefully composed images, sometimes separating them with large areas of deep negative space, beautifully hand-painted borders, and other material embellishments. In one example, an album maker created a thoughtful photographic essay of the interior of a large industrial power plant. The transformers, electrical grids, and switching networks are as elegantly portrayed as if they were elements within a nineteenth-century still-life painting. The same album contains carefully shot sequential photographs of the erection of an electrical tower and a surveyor working in the field. The sequential imagery evokes the early photographic experiments of Eedweard Muybridge and precinematic forms of illusion such as the Zoetrope. The photographer paired this exploration of sequential imagery with a group portrait of happy young women nestled together, relaxing outdoors.

◇◇◇◇◇ In another example of the power of contrasting imagery, a World War I soldier compiled an entire notebook of juxtaposed images of equal size all shot with the Kodak Vest Pocket Brownie, a remarkably small, portable camera, even by current standards. The soldier assembled page after page of photographs, contrasting one against the other, intermingling the mundane and the horrific, and employing a personal system that is based on formal resemblances such as tall vertical elements or mounds of objects. On the same page, one finds a derelict news kiosk, the Eiffel Tower, and buddies standing on each other's shoulders. In the album, images of the horror of the trenches are intermixed with pictures of babies, beautiful young women, and picnics with friends. The album ends with a photograph of a beautiful young woman reclining on a large rock in a bucolic setting. She smiles coyly, looking down slightly at her hand, which holds a gun. Here the juxtaposition of the erotic, violent imagery, and the harsh realities of war are both riveting and disturbing. The album's narrative unfolds in the infinite interplay of signs among the images.

◇◇◇◇◇ In relation to the second point of entry—the rich interweaving of text and imagery in sequential narratives—a beautiful example exists in an album from 1925 that chronicles the first years of a marriage between "Bon Bon" and her new husband "Pa Pa." The custom embossed cover reads "The Riddles," a simple declaration of the subject matter within. The album, one of a two-part series, follows the newlyweds through the beginnings of their lives together in Southern California: the sparse apartments, romantic dinners, and camping trips to Big Sur with Bon Bon's mother-in-law. The album also delves into Bon Bon's career as an actress and dancer. Albums such as these are remarkable demonstrations of the ability of serial narratives to capture loving and erotic relationships. Crafted by Bon Bon, this album is amazing for the humorous intimacy of the stories, such as in the picture of Bon Bon undressing in the woods with the caption, "Ouch! Those pine needles and cones are tough on Bon Bon's bare footies. Getting ready for bed." In the same spread, Bon Bon also demonstrates the use of the personal camera to capture subjects who are unaware that they are being photographed. Atop an image of Pa Pa sleeping, the caption reads, "Sleeping in earnest. Bon Bon got up first and shot it (umbrella to keep out sun)." In such albums, photographs are not treated as raw material to be cut and repurposed, but as short moments of repose along a seamless visual journey that reinforces the intimacy of its subjects. Following the delicacy of Bon Bon's handwriting through page after page of narrative, the reader is thoroughly embraced by her presence.

◇◇◇◇◇ In the last grouping where albums contain richly experimental collage practices, makers cut, tore, and spliced their photographs into astonishing objects and environments, creating letterforms and patterns of the type usually found in the most fanciful quilts and embroidery. Photographs are refashioned into flowers, clocks, hearts, stars, animals, and, of course, people. Like the acclaimed quilters of Gee's Bend, Alabama, many early album makers used even the tiniest photographic scraps for their collages—incorporating duplicate and damaged photographs so as not to waste precious material. In an example from 1916, a spread of hand-torn photographic "rocks" depicts bathers at the seashore and in the water. The space around the sculpted fragments creates a cinematic flow between each individual moment of action, and the spacing of the torn "rocks" coheres the individual pieces into an organic pattern. Other pages contain individual fragments of hands, arms, heads, or shoes placed within large areas of negative space, offering the fragment as an object of contemplation—a metaphor for the whole person—imitative of the manner in which photography, and the human eye, crops and eroticizes the body. In other albums, one discovers the complete obliteration of negative space—pages are entirely covered with photographs overlapped, taped, glued, woven, and sewn together. The strategies makers employed to accumulate and craft materials into irreproducible, unique objects are endless.

◇◇◇◇◇ In her work on nostalgia and memory, Susan Stewart describes the manner in which such hand-crafted objects deny mechanical processes: "You can not make a copy of a scrapbook without being painfully aware that you possess a mere representation of the original. The original will always supplant the copy in a way that is not open to the processes of mechanical reproduction. Thus, while the personal memento is of little material worth, often arising, for example, amid the salvage crafts such as quilt-making

WILBUR KNIES, 1918

and embroidery, it is of great worth to its possessor. Because of its connection to biography and its place in constituting the individual life, the memento becomes emblematic of the worth of that life and of the self's capacity to generate worthiness."[12] Like the mementos described by Stewart, the vernacular photo album accrues significance through its connection to its maker. The photo album is the site of a process of creation that often extends over a lengthy period of time. The album cannot be duplicated though its existence is predicated on a technology of reproduction.

◇◇◇◇◇ Ultimately, touch is what creates the context for the vernacular album's existence, through the album's creation, wear, and maintenance. As with clothing, quilts, and other domestic artifacts, women regularly repaired albums against the damage inflicted by their use (affectionate caresses, negligence, and violence). The album is animated by the act of reading, brought into play with the rhythms of the body. And through this reading, the reader imprints herself within the album. The bent corners, stains, defacements, tears, and crumbling pages in *Snapshot Chronicles'* albums are a seminal aspect of the archaeology of this significant art form. Such physical traces are manifestations of the presence of, and the relationship between, maker and reader. Removed from their original contexts and brought into the form of a collection, the albums in *Snapshot Chronicles* continue to offer us a means for exploring the lives of individuals and families thrust into a constantly changing world of technological self-representation and reproduction from which we have yet to emerge.

◇◇◇◇◇

12 Susan Stewart, *On Longing: Narratives of the Miniature, the Gigantic, the Souvenir, the Collection* (Durham, NC: Duke University Press, 1993), 139.

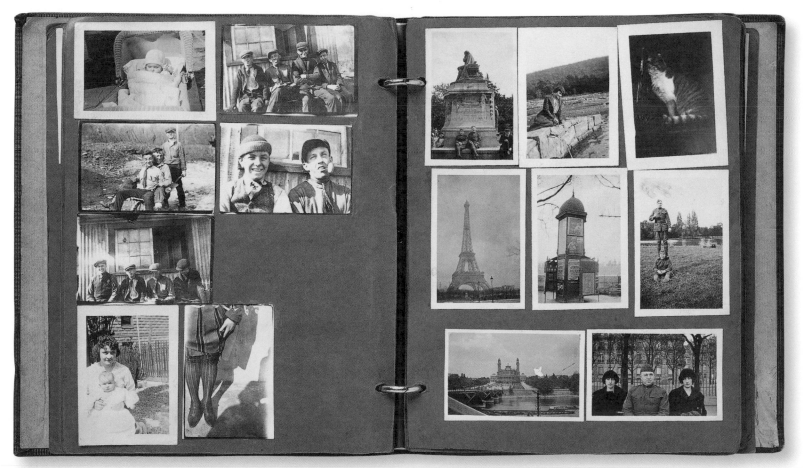

Picture
Tell the Story

PHOTOGRAPH'S

Album of Photographs

PHOTOGRAPHS

Photographs

Photographs

◇◇◇◇◇

SIMILAR TO TODAY, **early snapshot albums ranged from elaborate and embossed to simple and string-bound with cardboard covers. After the introduction in 1900 of inexpensive cameras and developing services, more and more people enjoyed taking photographs of their lives and loved ones. Snapshot albums were manufactured for the growing photography hobby market in a variety of sizes and designs. For many, albums were used to keep photographs safe and organized, but for others they offered an opportunity to explore the visual possibilities of telling their own personal stories.**

◇◇◇◇◇ Building upon the tradition of the Victorian scrapbook and fine and folk art practices, men and women employed a variety of strategies in working with their photographs. Early album makers experimented with using photographs as raw material, cutting, tearing, and arranging photographs into designs and letterforms reminiscent of richly patterned quilts and embroidery. Careful attention was also paid to visual sequencing; people constructed homemade panoramas, conducted motion experiments, and animated the figures in their photographs by placing them in odd and unexpected juxtapositions. Text was also used to create a unique perspective on photographs and stories and witty captions, diaristic entries, and poetic fragments were often placed near and even on the photographs.

◇◇◇◇◇ The following pages contain anonymous photograph albums made between 1889 and 1935. These outstanding examples illustrate the ways in which snapshooters used inventive collage techniques, surprising visual sequencing, and evocative text to construct biographical picture stories that speak as passionately to us today as they did to their creators so many years ago.

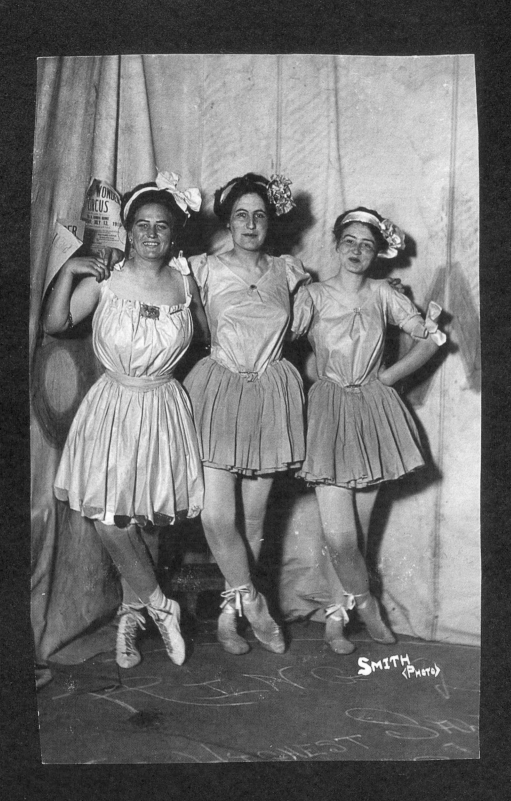

Photographs

This unusual album tells the story of the Great Wonder Circus, an all-woman circus traveling the country at the turn of the 20th century. Moving through the album we meet: *"Mary Palmer Sampson, Strongest of the Strong," "Irma Purman, Python Fairest of the Fair in her Wonderful Graceful Serpentine Dances,"* and *"Mary Frances Smyth, Child Wonder Tight Rope Artist."* A poster tucked inside the album reads: *"The management is doubly fortunate in having secured for the season the services of Miss Minnie Conners Barnum, Ring Master. Under direction of this skilled entertainer will appear talent unsurpassed."* Throughout the album the personal and professional lives of the performers and their families are intermingled in an intimate, unstudied fashion. Many pages are distinguished by the maker's interesting juxtapositions of images creating moody, painterly, and almost surreal page compositions.

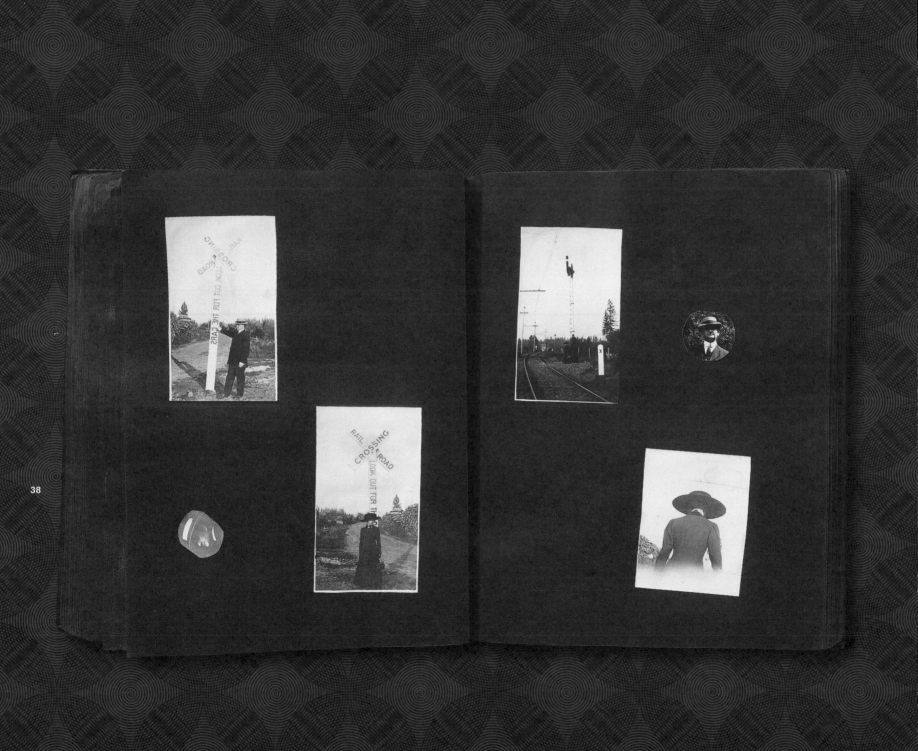

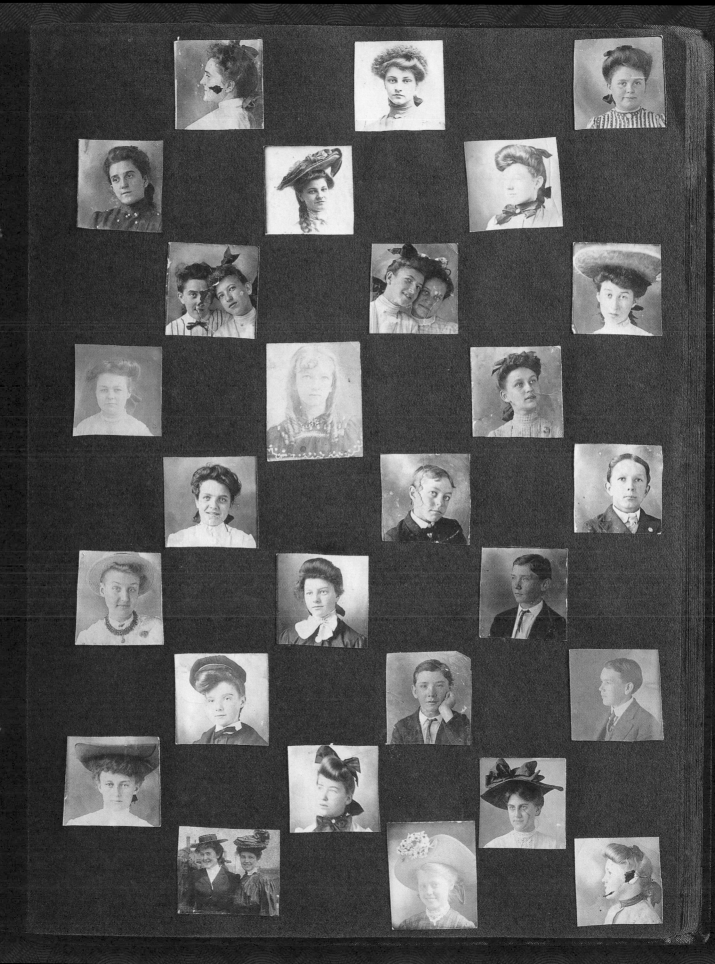

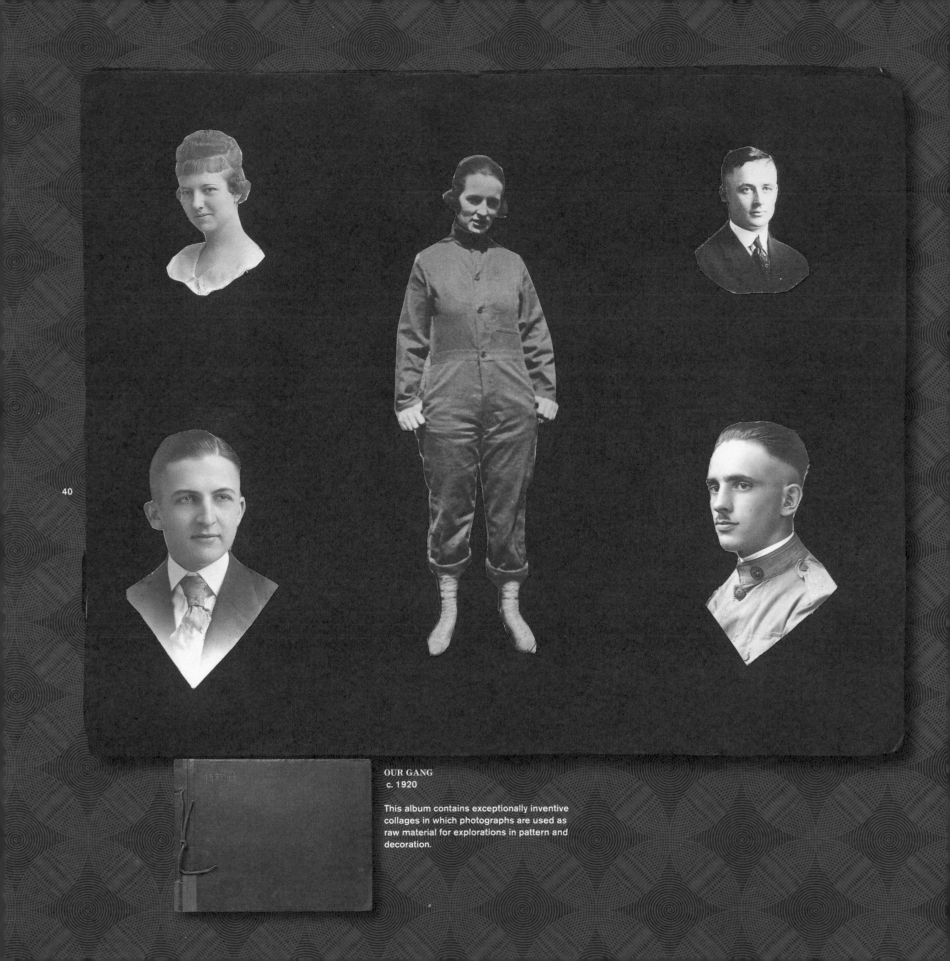

OUR GANG
c. 1920

This album contains exceptionally inventive
collages in which photographs are used as
raw material for explorations in pattern and
decoration.

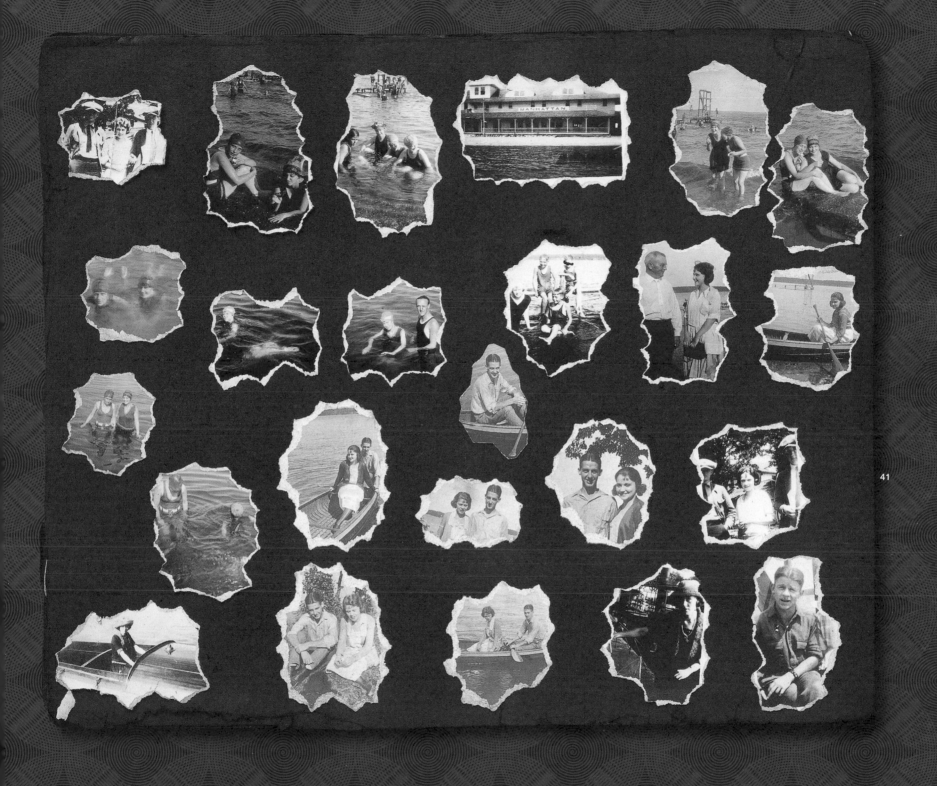

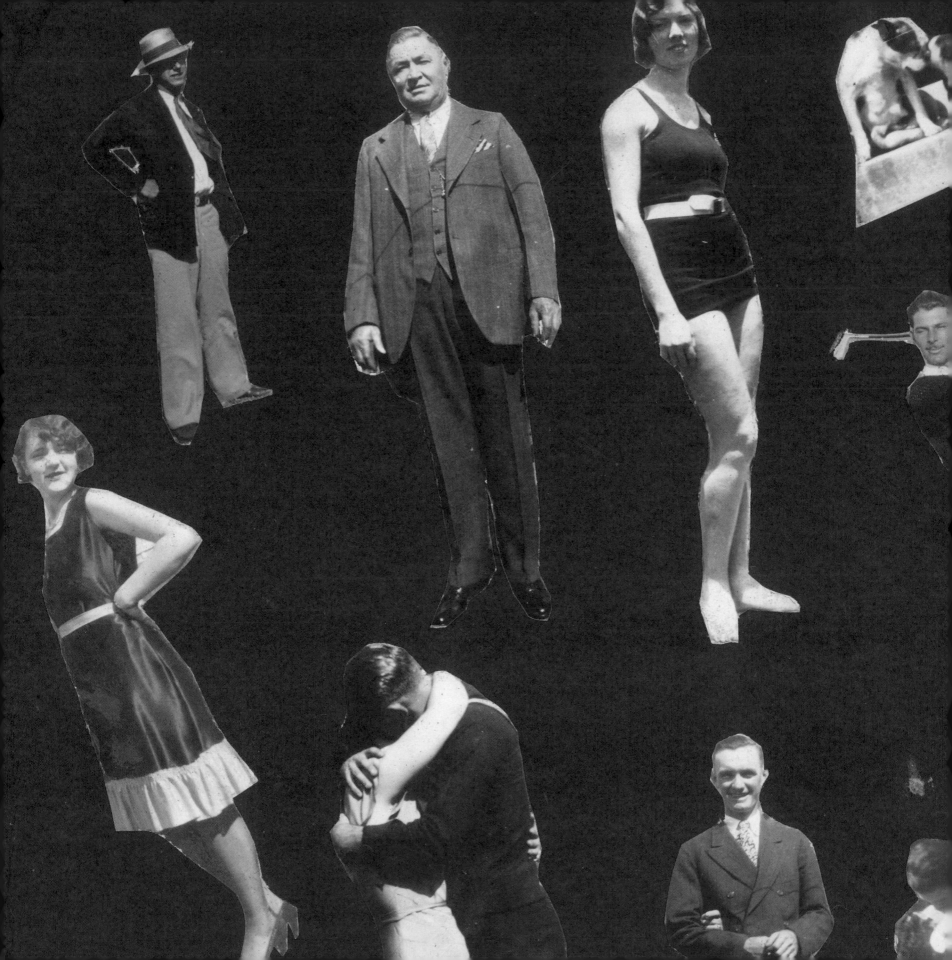

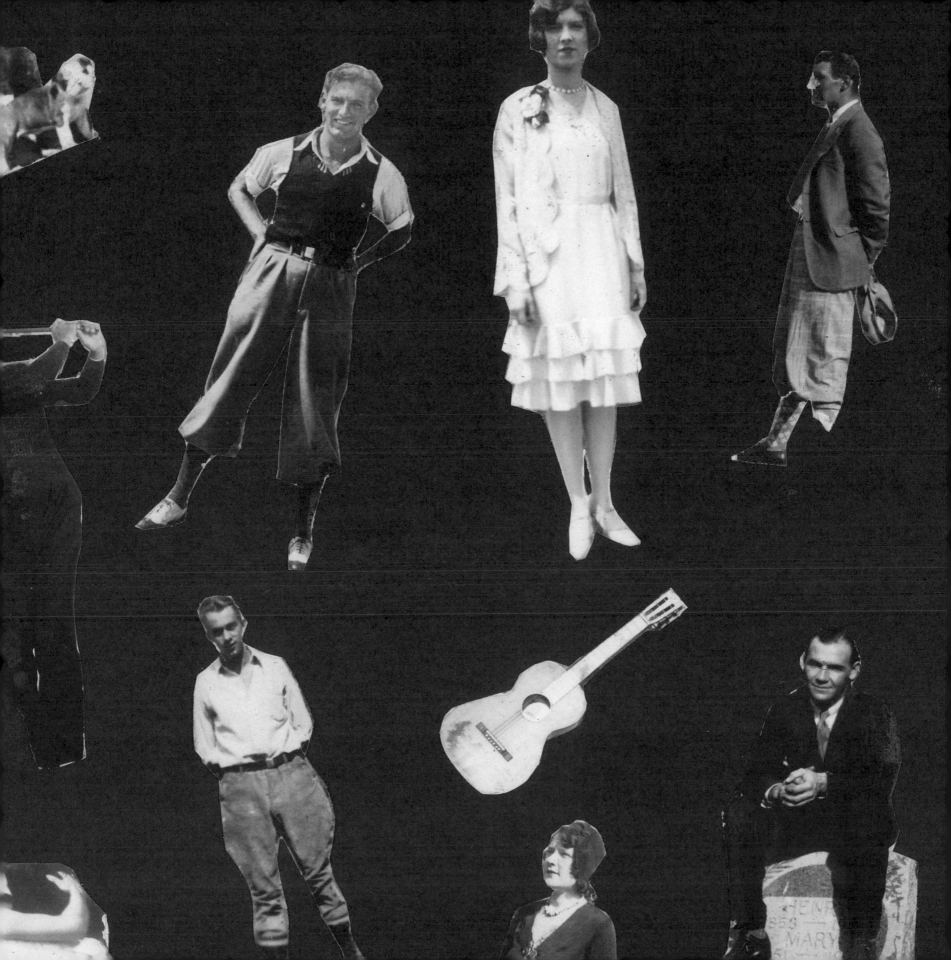

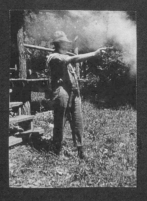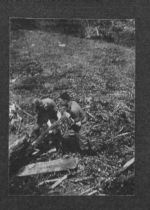

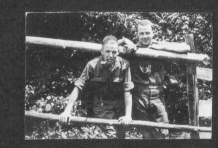

44

CHETUCK
c. 1910

This album is distinguished by page after page of unusual collages. The maker cut and positioned photos in shapes and patterns reminiscent of quilts and embroidery, also transforming photographs into letterforms. In the cut out word "CHETUCK" for example, we see the way in which the maker carefully cut out the letters to preserve the faces of the subjects within the pictures. The letterforms take on the quality of miniature portraits.

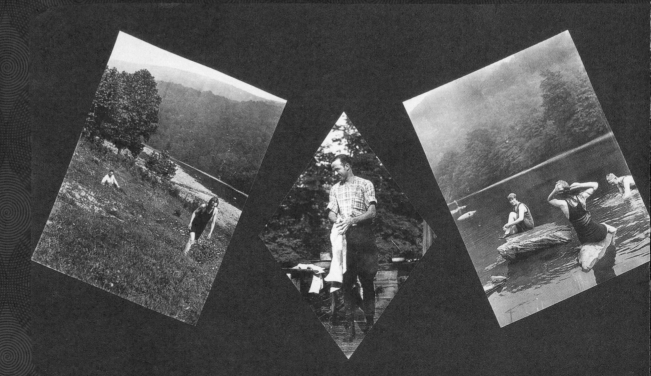

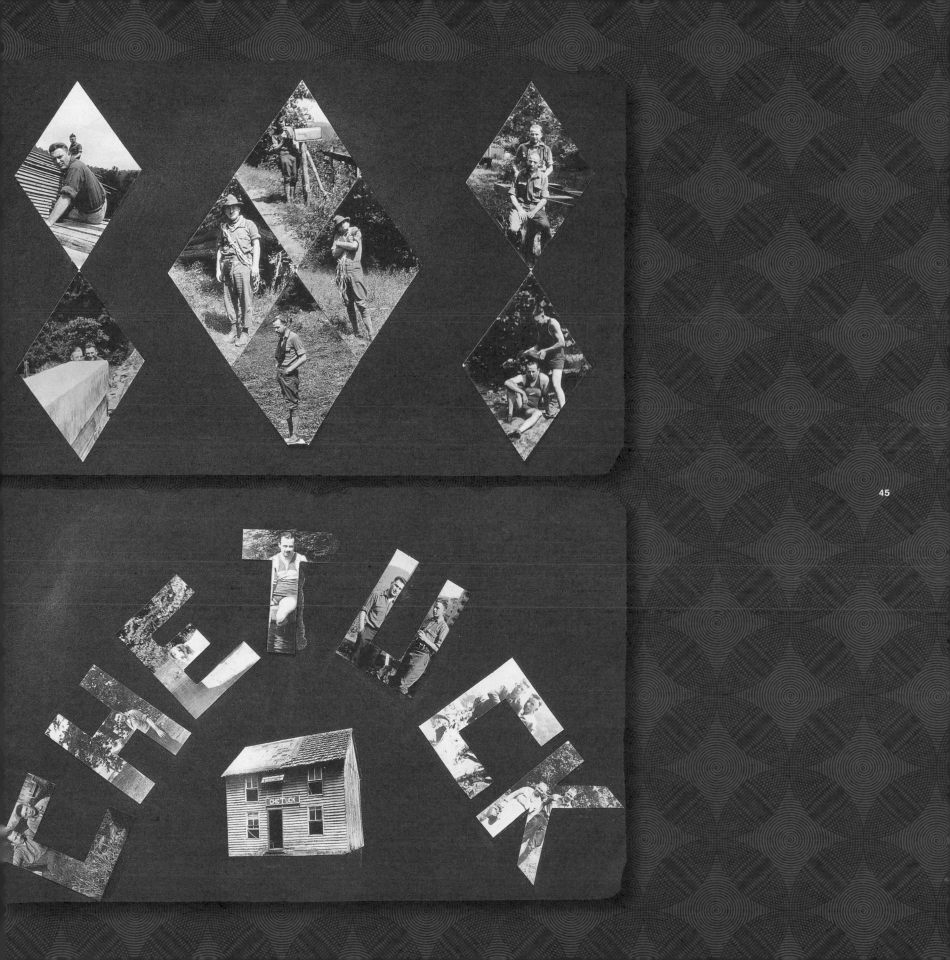

AUTOGRAPH BOOK
1911

This delicate album was made with a pocket-sized autograph book, and contains primarily photo strip images: the most inexpensive form of democratic multiple available from studio and itinerant photographers. Such multiple exposure images were the precursor of the self-contained photo booth machine invented by Anatol Josepho in 1925. The maker of this album kept many of the images in strip format, placing them in dynamic configurations on the pages in ways that suggest short animated films.

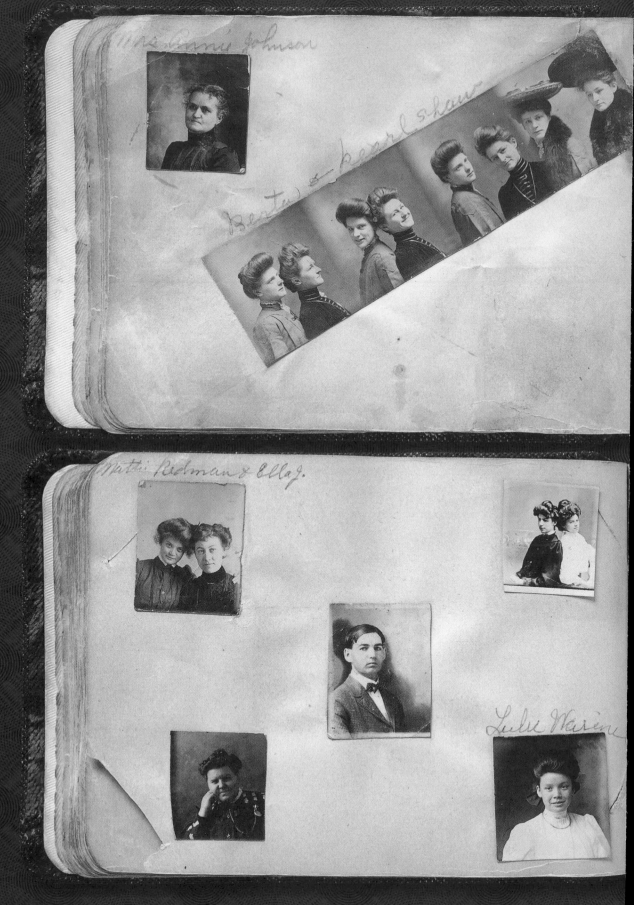

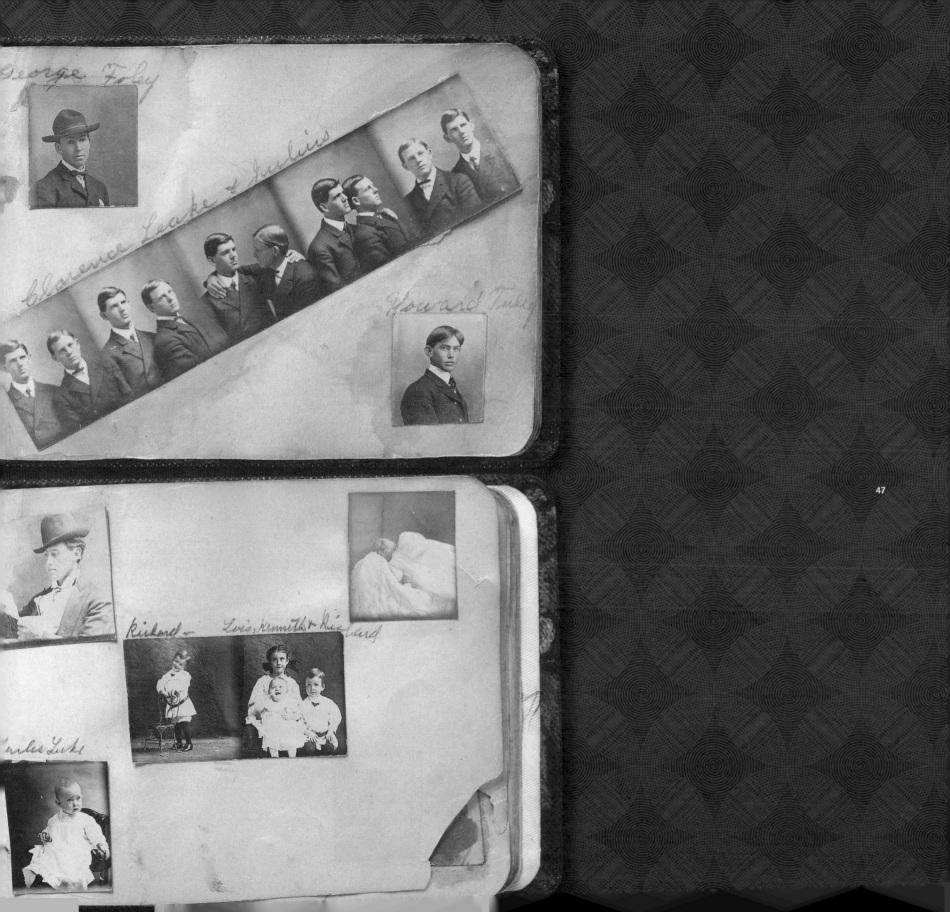

George Foley

Clarence Leake & Julius

Howard Tuley

Richard — Lois, Kenneth & Richard

Charles Leake

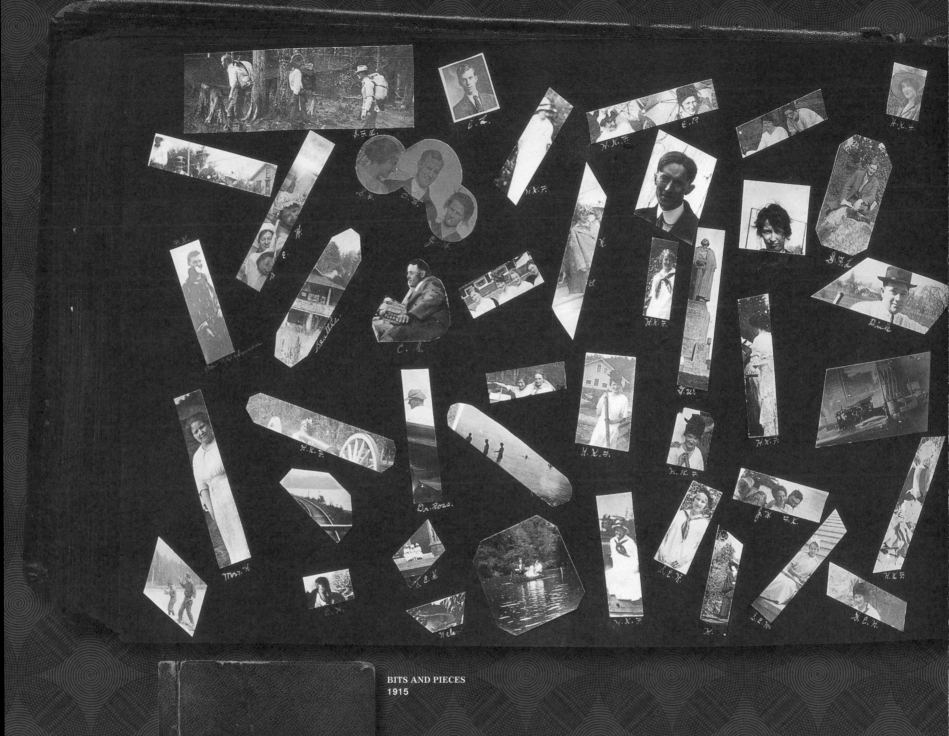

BITS AND PIECES
1915

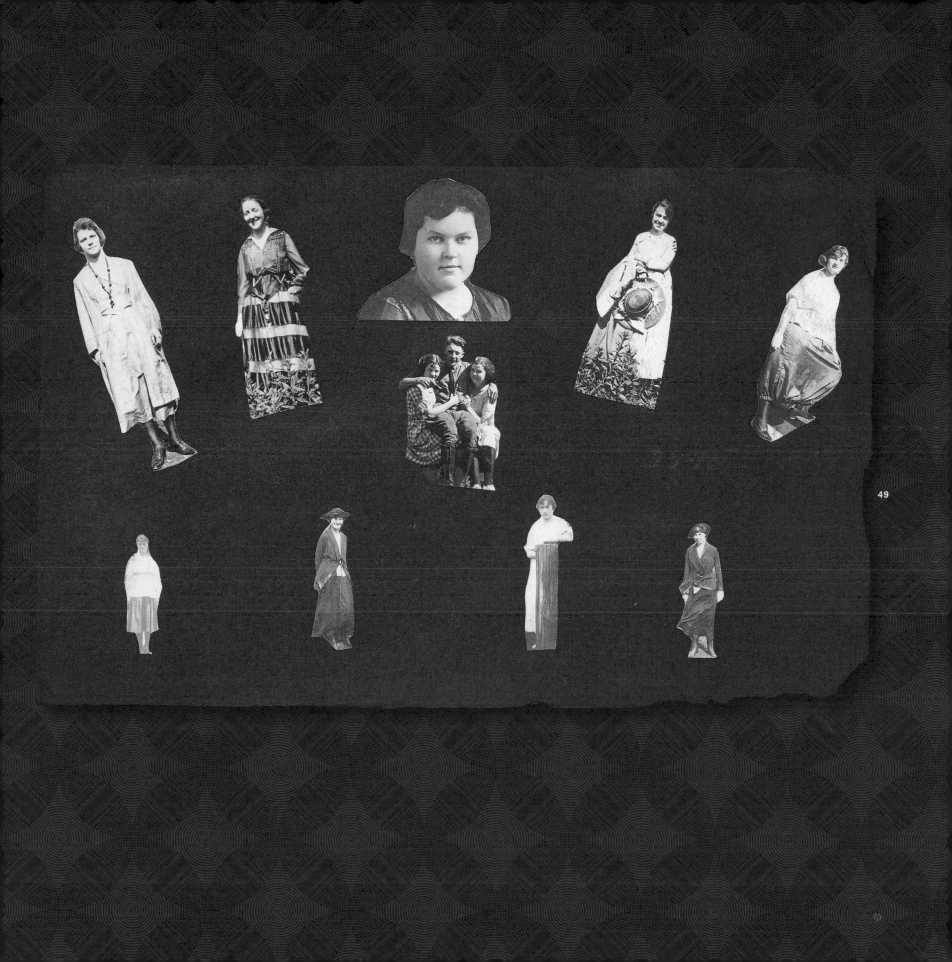

49

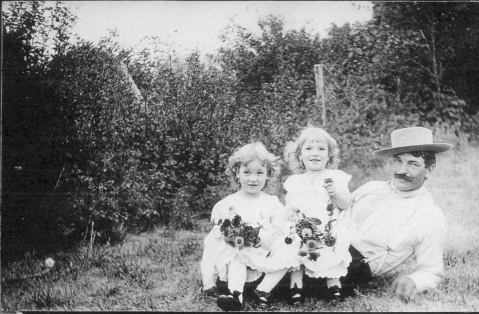

I can't see, 1909 –
the birdie

O How we love our Daddy!

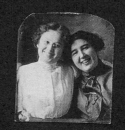

I Love them
both.

Before
– 1909 –

After
– 1911 –

No more Training School .

Photographs

DELIA, KANSAS
c. 1906–11

This album chronicles several generations of
a Swedish immigrant family in Delia, Kansas
and contains compelling combinations of
image and text. Portraits of family members
are closely cropped, and the photographs
are nestled near one another on the page,
evoking intimacy and family piety. The voice
of the album is witty and tender, and the
album is annotated in Swedish and English.

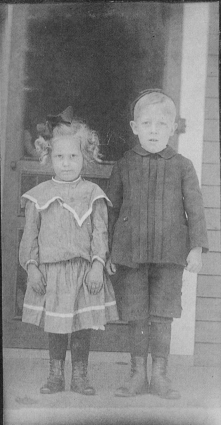

Mother, Glenus and Milan

51

Yes, I am on my vacation.

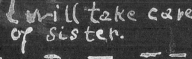

I will take care of sister.

— — — —

Srčik Konzik a Anik

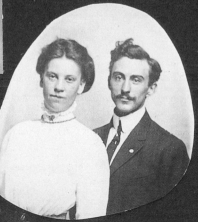

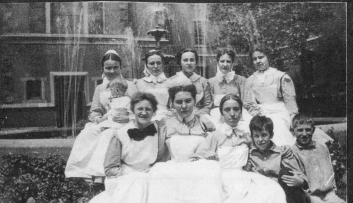

Gen. Hospital – Few of them.
Phil. –1911–

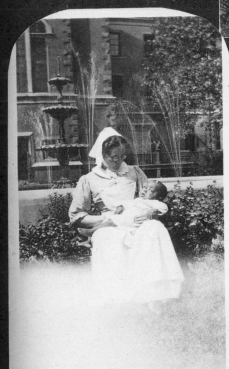

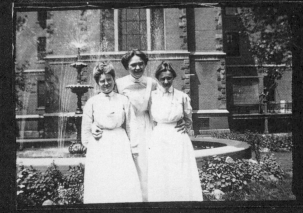

I am getting well!
"Luth. Sister"

Dear little black
baby-Children Hosp.

Three Presbyterians –
Phil.-1911-

Phil.

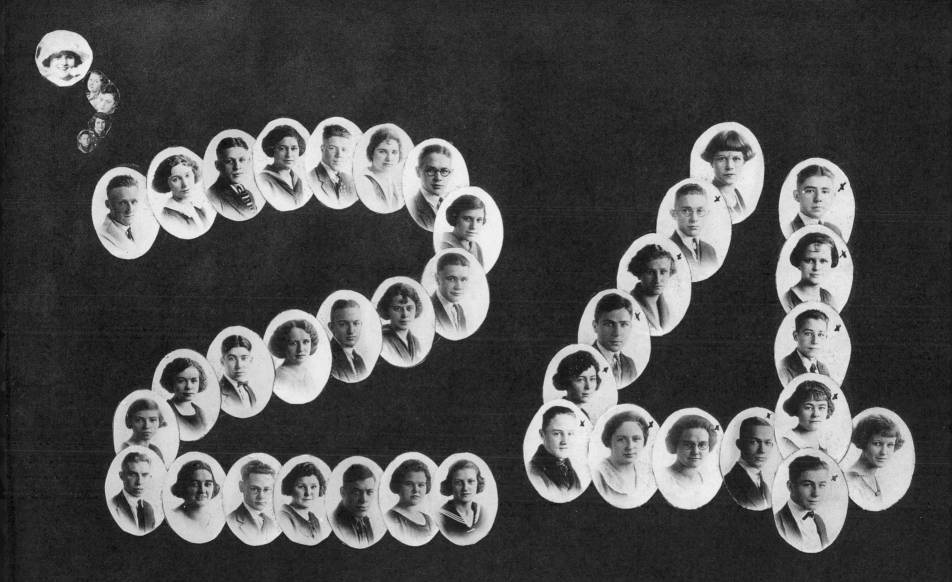

TWENTY-FOUR
1921–29

Eleanor Marsh

Ethel Bowie

Eleanor Hass

Mary Solomon
Dorothy Edward

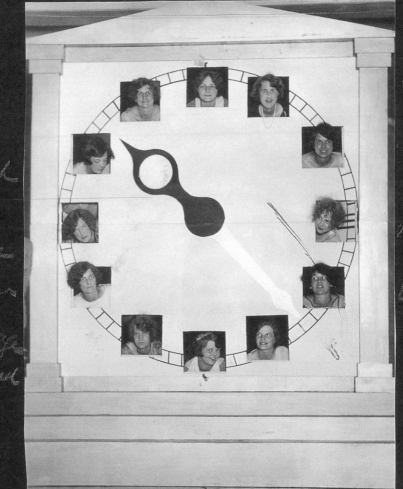

Betty Germain

Betty Green

Florence Rogers

Helen Payson

Ermelita Duncan

Phyllis Barnes

SUMMER CAMP TO COLLEGE
c.1920

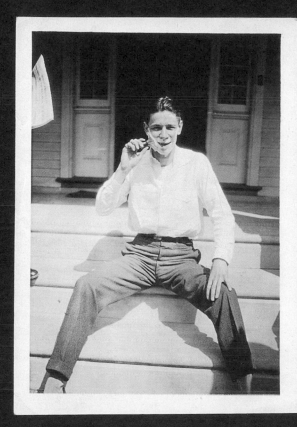

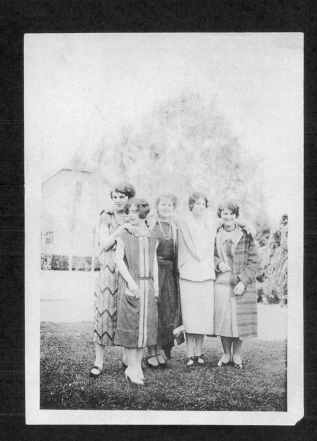

55

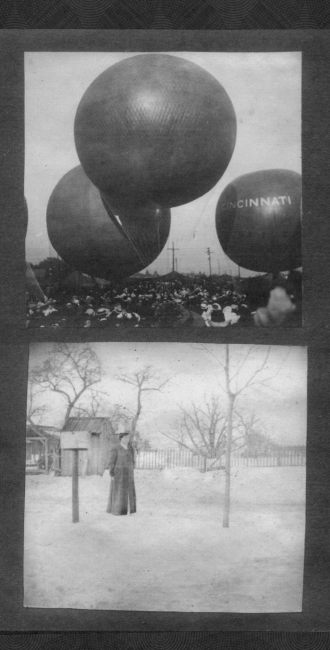

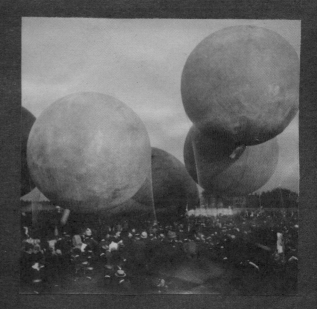

56

FIRST ALBUM
c. 1920

This handsome album with no covers was
found at a flea market in Sausalito, California
in 1980 and was the first in what would be-
come a life-long passion of looking for and
collecting vintage anonymous photograph
albums. The album contains unusual juxta-

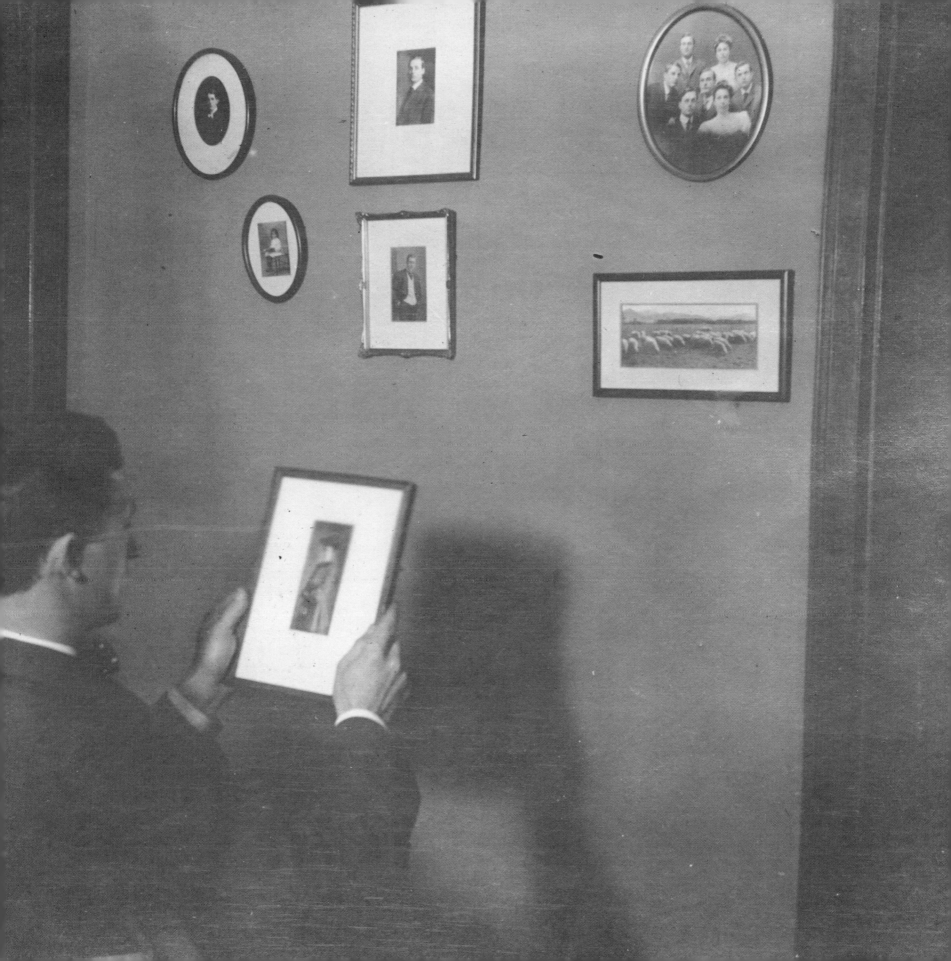

OUR CHICKENS, OUR HOME
c. 1910

This handmade album was created by a
young woman and chronicles her everyday
life: family, friends, home, farm animals,
and pets. The album is made with delicate
onionskin paper surrounded by a simple
board cover. Inside the board cover is a
potato print pattern. It is a lovely example
of the handmade journals, scrapbooks, and
autograph books that young women had
been making since the late 1700s. After the
introduction of photography, young women
assimilated the medium into this rich
book-arts tradition, encouraged by lady's
craft journals such as *Godey's Lady's Book*
published from 1840–92.

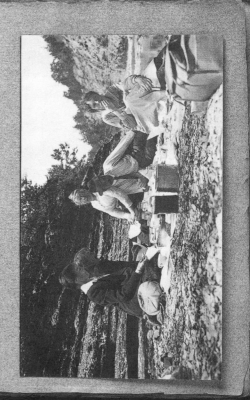

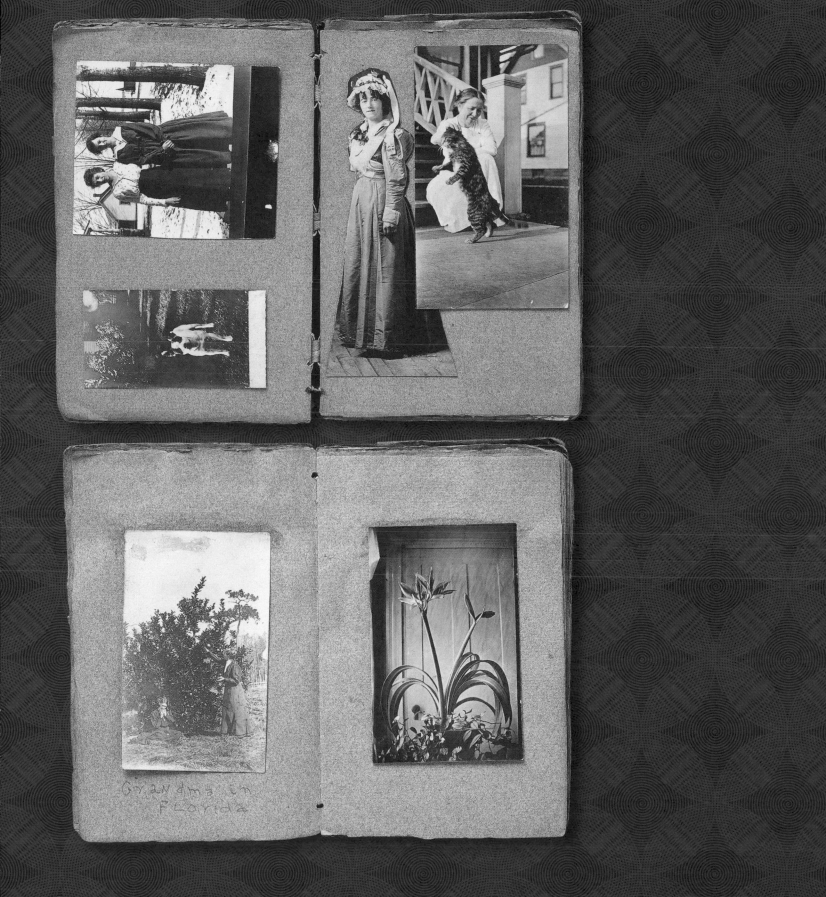

Grandma in
Florida

The Telltale Book

**MARRIED OR
GOING TO BE?** Coral

THINK WHAT THIS MEANS!

1912

I'm on the way.

1911

Model

Brand-New. Appledale

Uncle Aaron's Home.

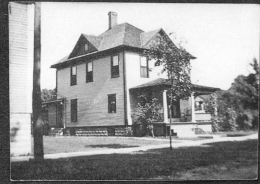

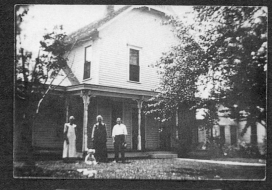

Bryan BEATS THEM ALL Ohio.

Here's the Place

Stryker, O. Mrs. Colon's.

THE TELLTALE BOOK
1912

62

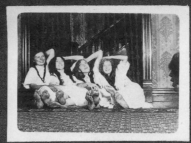

We Must Admit Our Faults

Slumber parties
Bryan

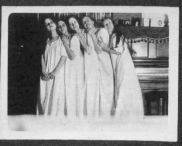

From Head to Foot

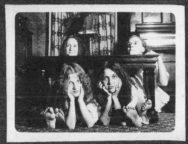

Woman is So Curious!

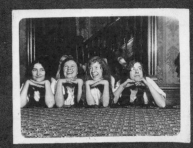

Ladies!

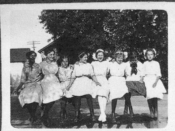

Samples

Bryan.

Looking Over the Ground

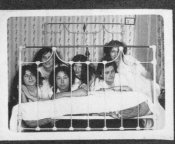

JUST OUT

Stryker
girls

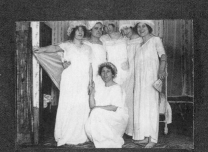

Woman votes in some states; she rules everywhere.

MARSHALL

From Real Life

A GENTLEMAN

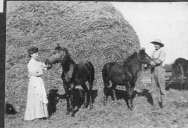

Peytons

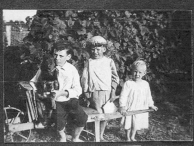

Paul, Homer, **YOUNGPEOPLE** Marion Sharp

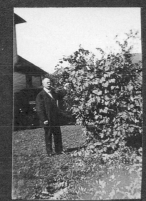

The Best

(To be continued.)

No. B
FORUM ALBUM
Price 50c each
Eastman Kodak Co.
Rochester, N. Y.

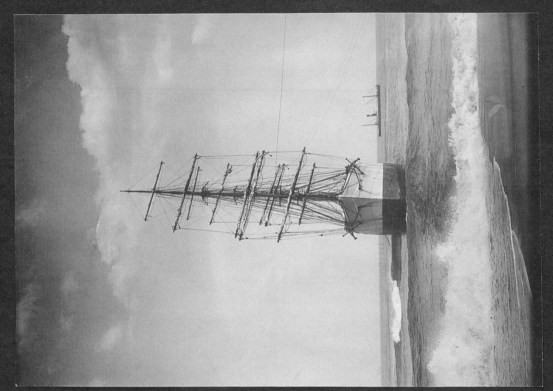

Near Barnegat City — 1915

MARJORIE PARKER
1906–17

Photographs

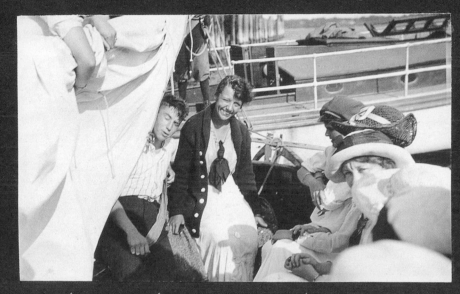

We had such a "good" time - until
Isabel and Pete fell overboard.

Shelter - Island N.Y. - Labor Day 1915

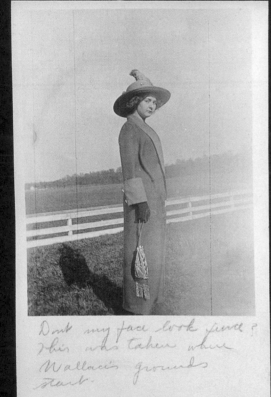

Dont my face look fine?
This was taken where
Wallace's grounds
start.

Peru

Indiana

1912

—May 7—

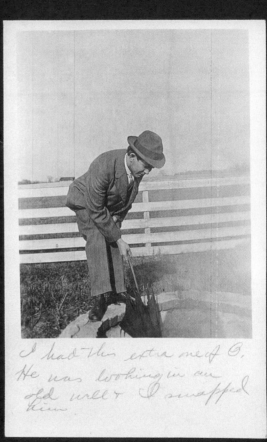

I had this extra one of O.
He was looking in an
old well & I snapped
him.

PERU, INDIANA
1912

-May 7-1912-

Peru

This is terrible but
I want you to see the
back of the coat.
It's a disgrace to send
it -

68

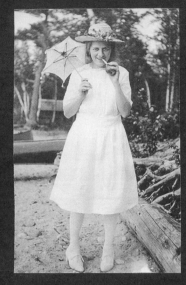
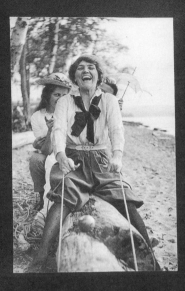

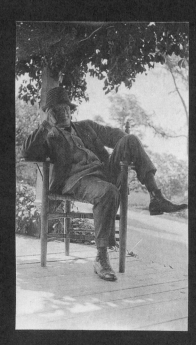

FAMILY PORTRAITS
1900

This album is distinguished by the maker's interest in portraiture and sensitive mastery of the photographic medium. Pages of the album contain alternating interior and exterior views co-mingled with intimate portraits of family members and friends. Some album spreads contain still life compositions and interior views that clearly reference fine art conventions. The maker then combined these studied, carefully composed images in eclectic ways, contrasting interior and exte-

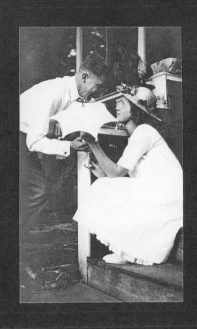
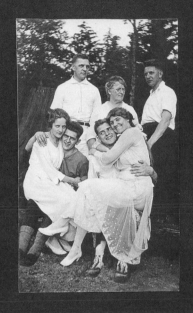
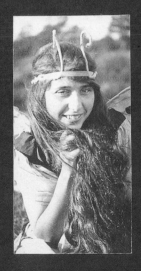

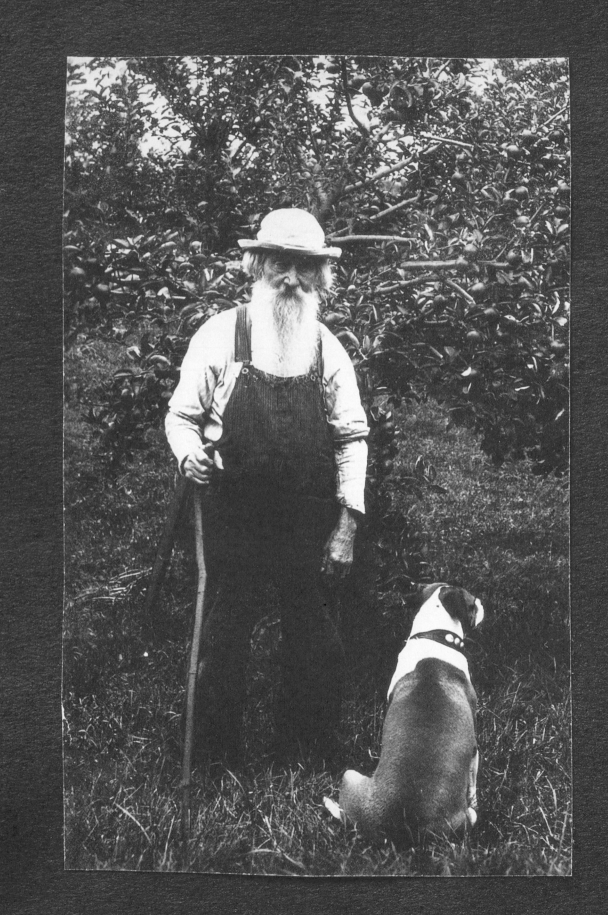

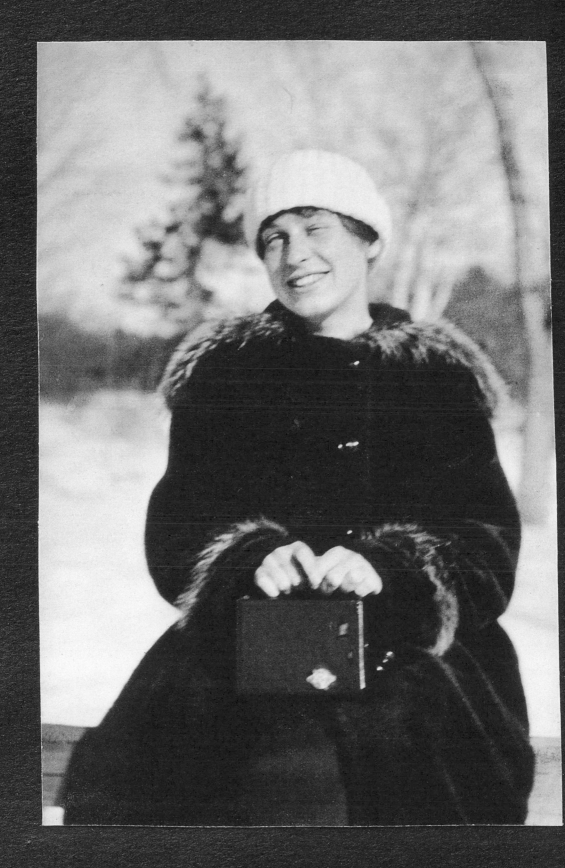

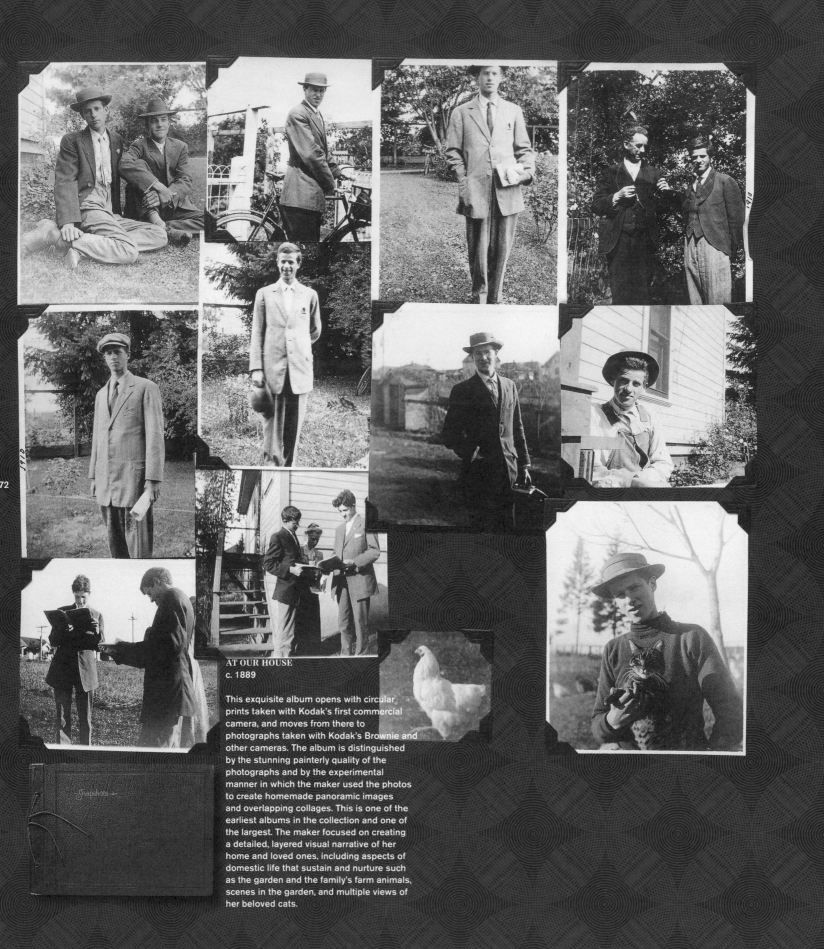

AT OUR HOUSE
c. 1889

This exquisite album opens with circular prints taken with Kodak's first commercial camera, and moves from there to photographs taken with Kodak's Brownie and other cameras. The album is distinguished by the stunning painterly quality of the photographs and by the experimental manner in which the maker used the photos to create homemade panoramic images and overlapping collages. This is one of the earliest albums in the collection and one of the largest. The maker focused on creating a detailed, layered visual narrative of her home and loved ones, including aspects of domestic life that sustain and nurture such as the garden and the family's farm animals, scenes in the garden, and multiple views of her beloved cats.

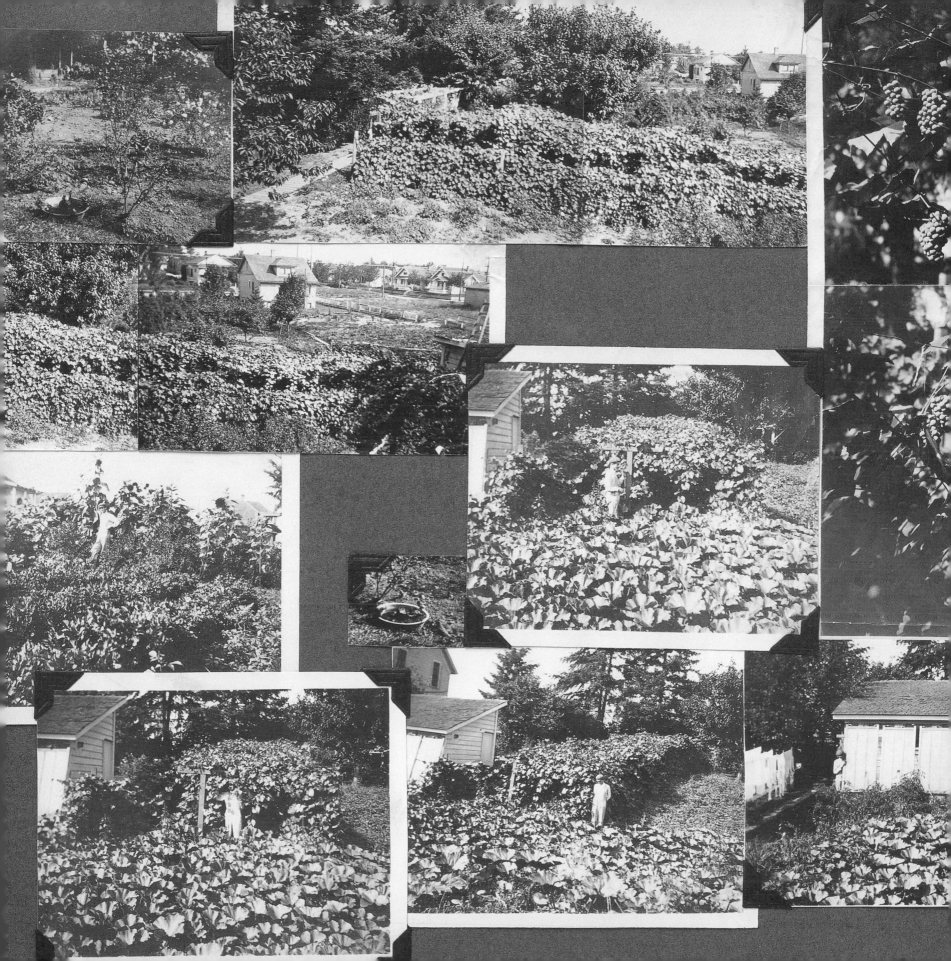

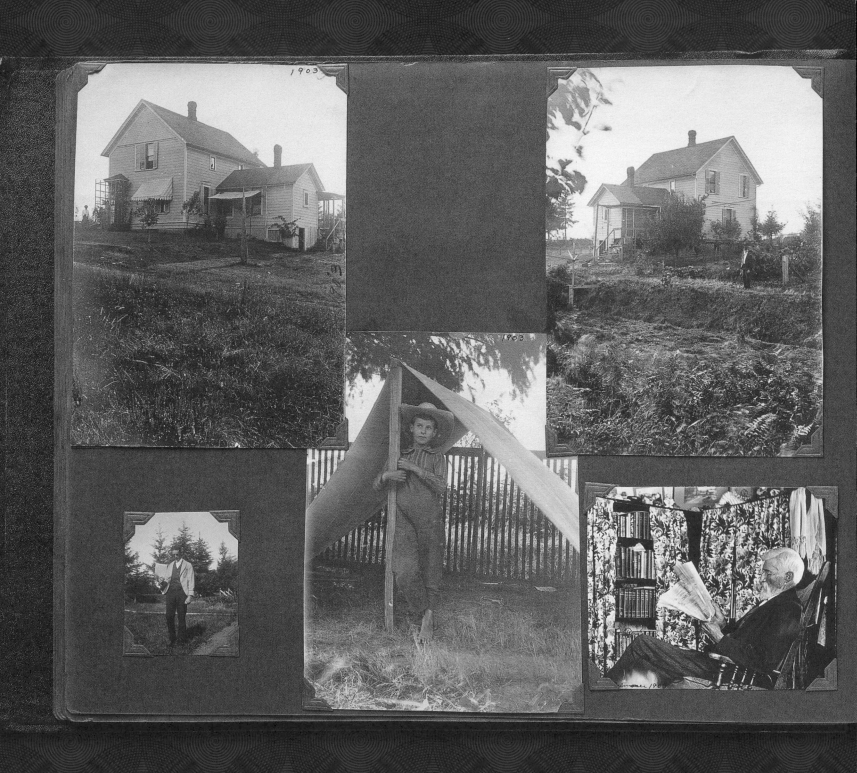

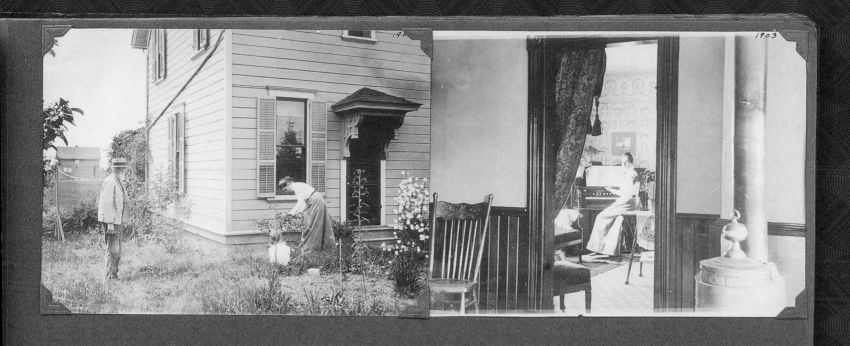

1903

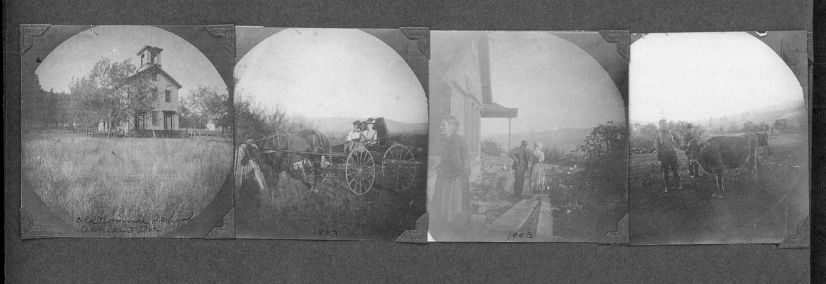

Old Normal School
Ashland Ore

1903

1903

Muggins No. 1 1907

1907

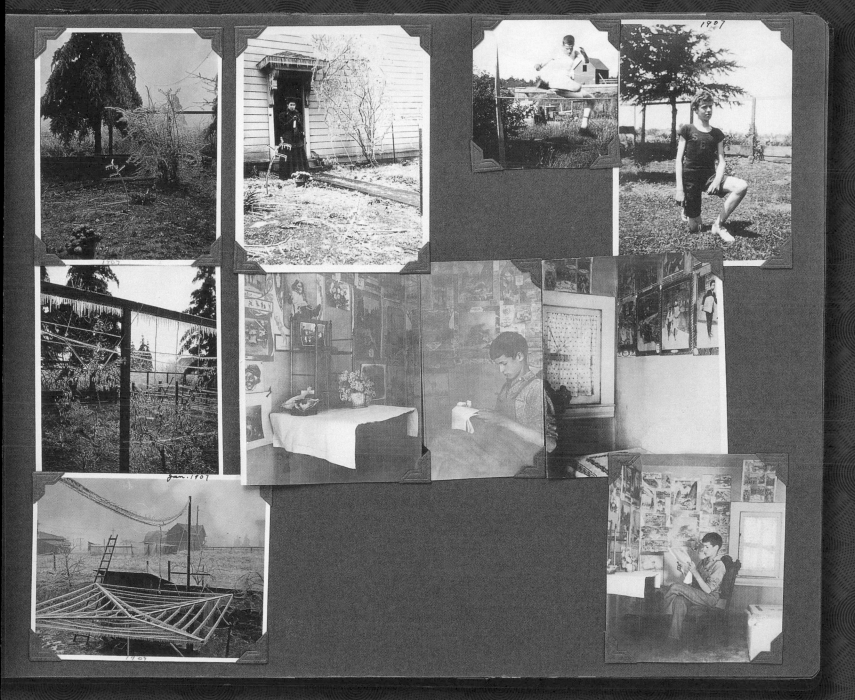

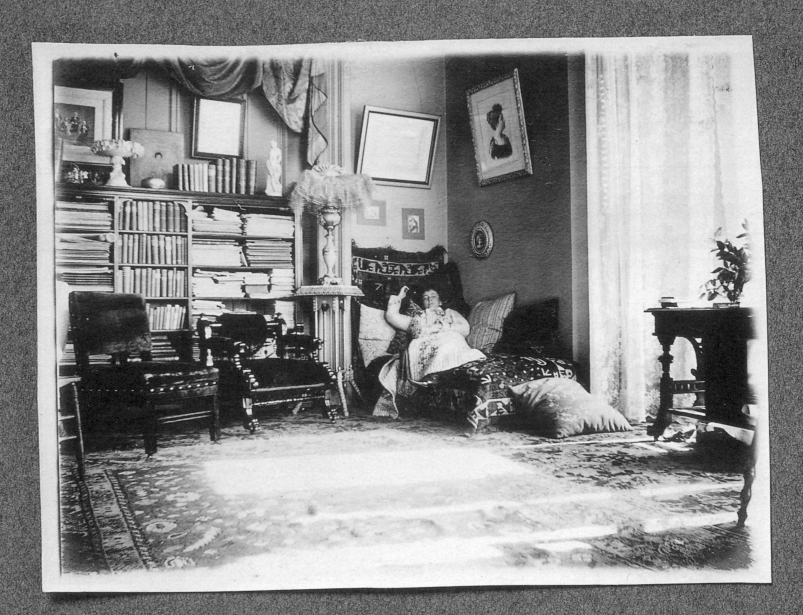

OREGON
c. 1900

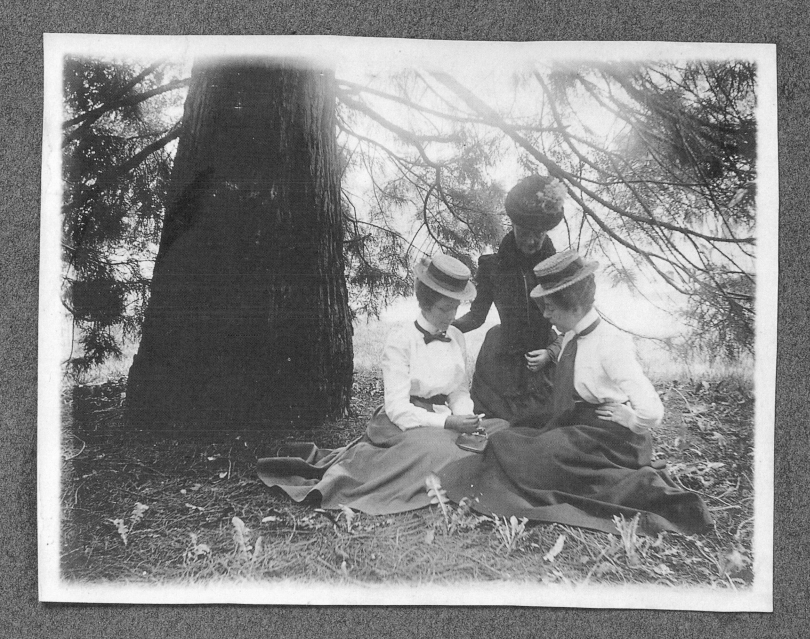

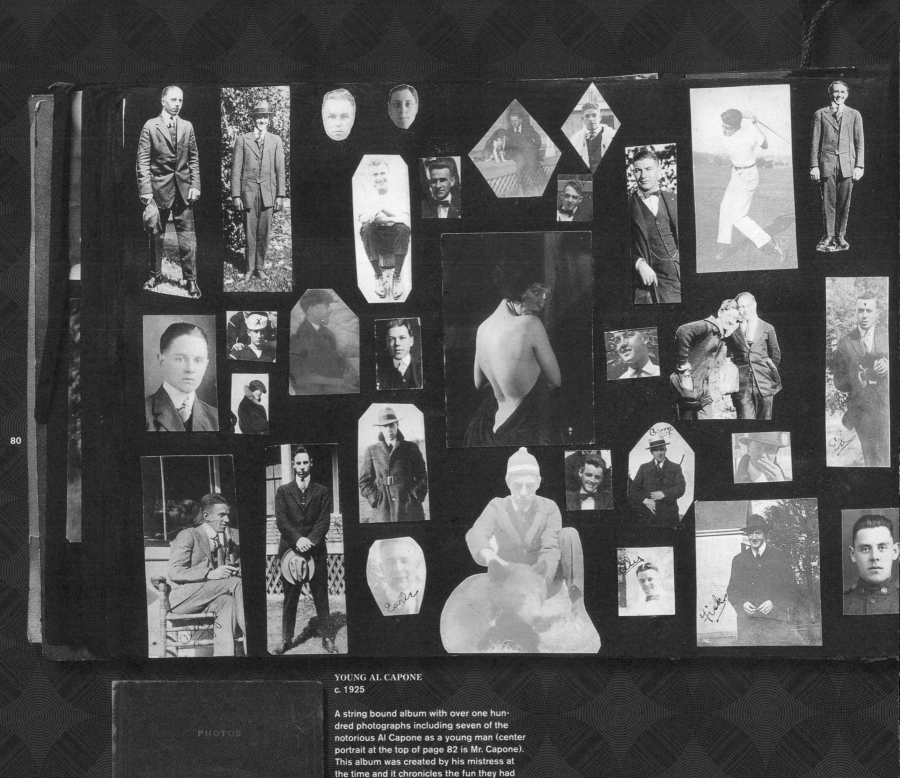

YOUNG AL CAPONE
c. 1925

A string bound album with over one hundred photographs including seven of the notorious Al Capone as a young man (center portrait at the top of page 82 is Mr. Capone). This album was created by his mistress at the time and it chronicles the fun they had together. The album is an interesting mix of formal portraits and bold collages and this heightens the contrast between what we know about Capone's crimes committed later in life as compared to these photographs which show him at a younger and more innocent time.

PHOTOS

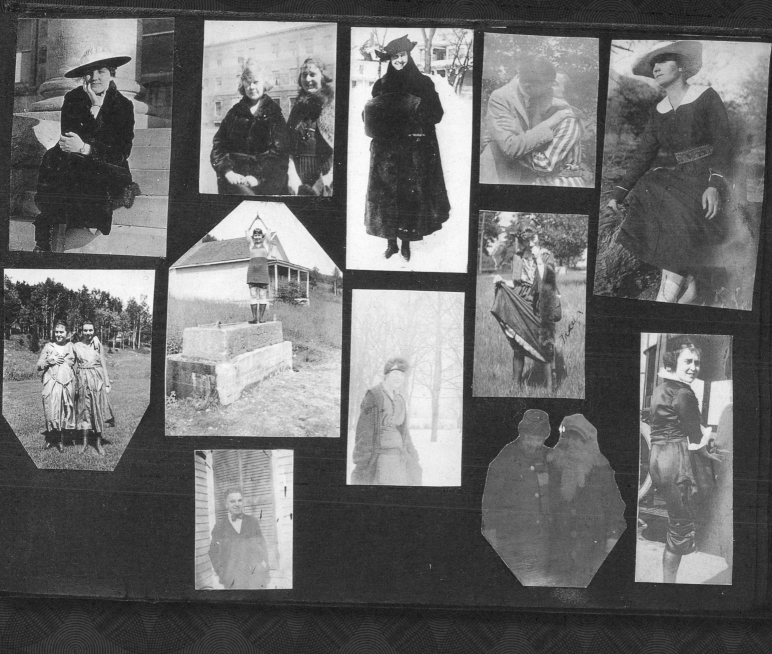

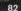

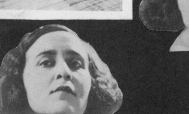
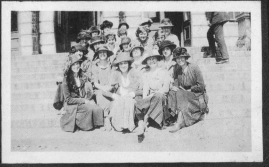

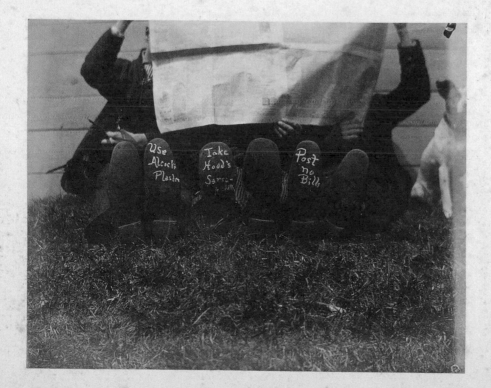

SIMPLE PLEASURES
c.1900

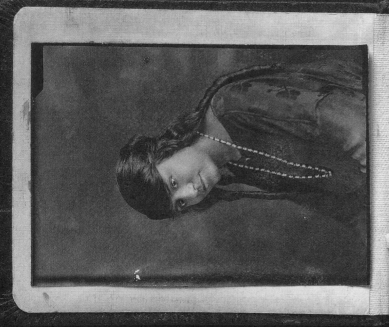

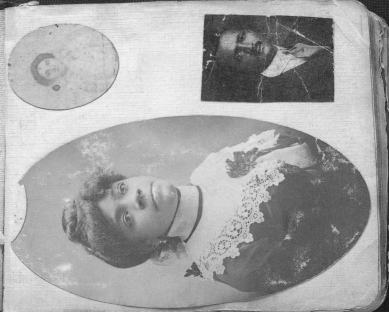

AUTOGRAPH BOOK
c. 1912

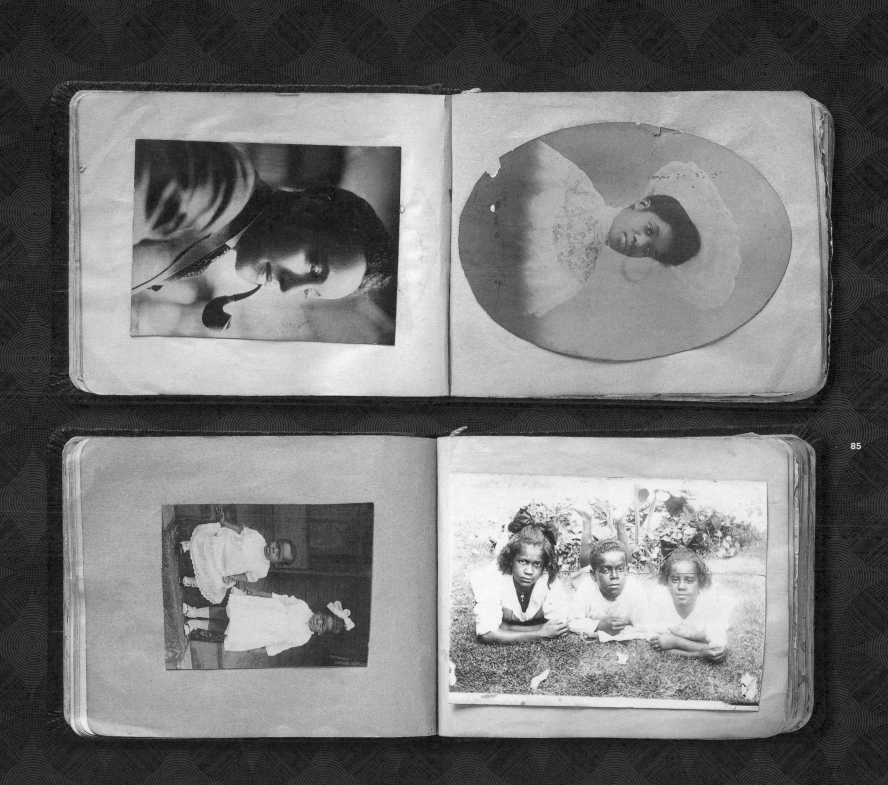

86

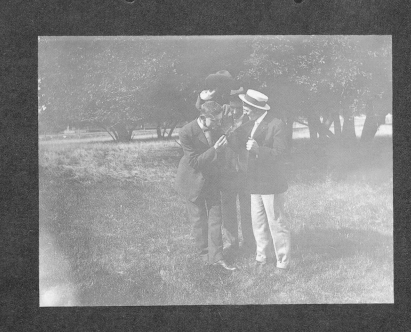

MOCK WEDDING
c. 1900

This delicate, handmade album is a record of a "mock" wedding ceremony. All of the participants in the wedding are women and each photograph looks staged as if participants are performing a theatrical production.

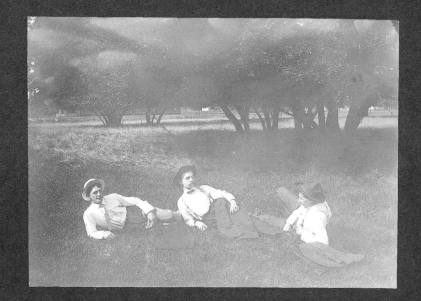

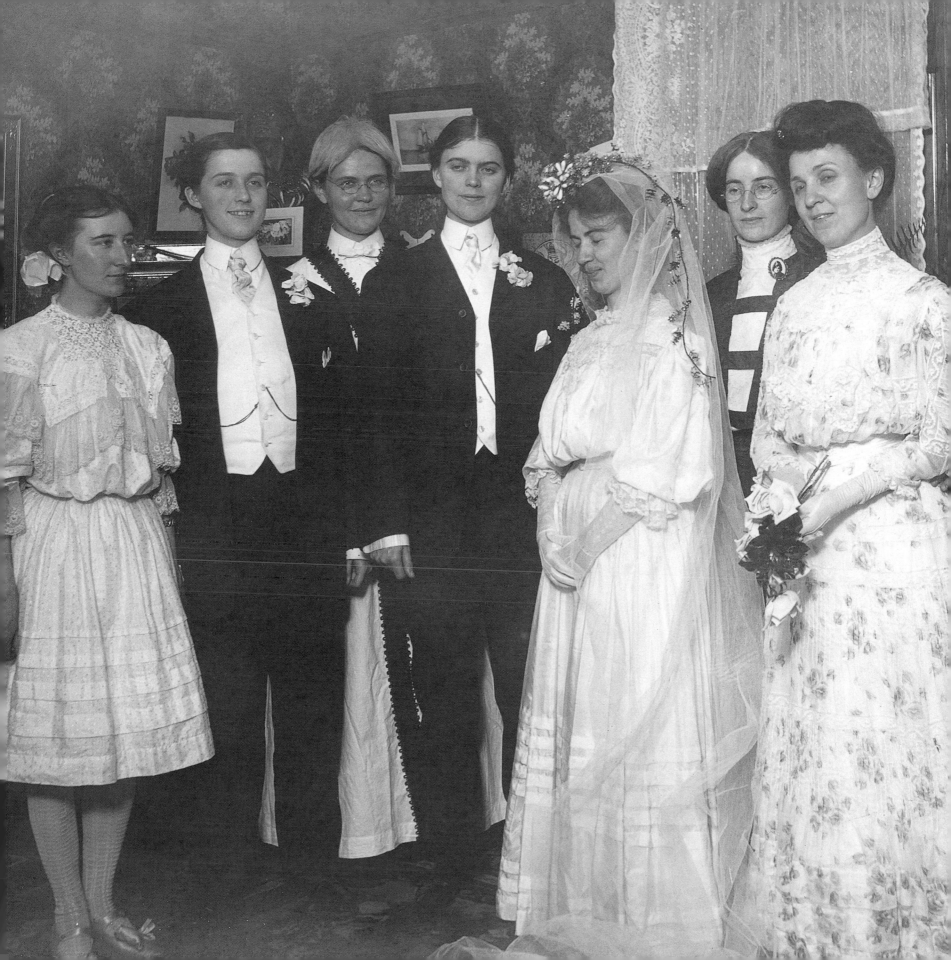

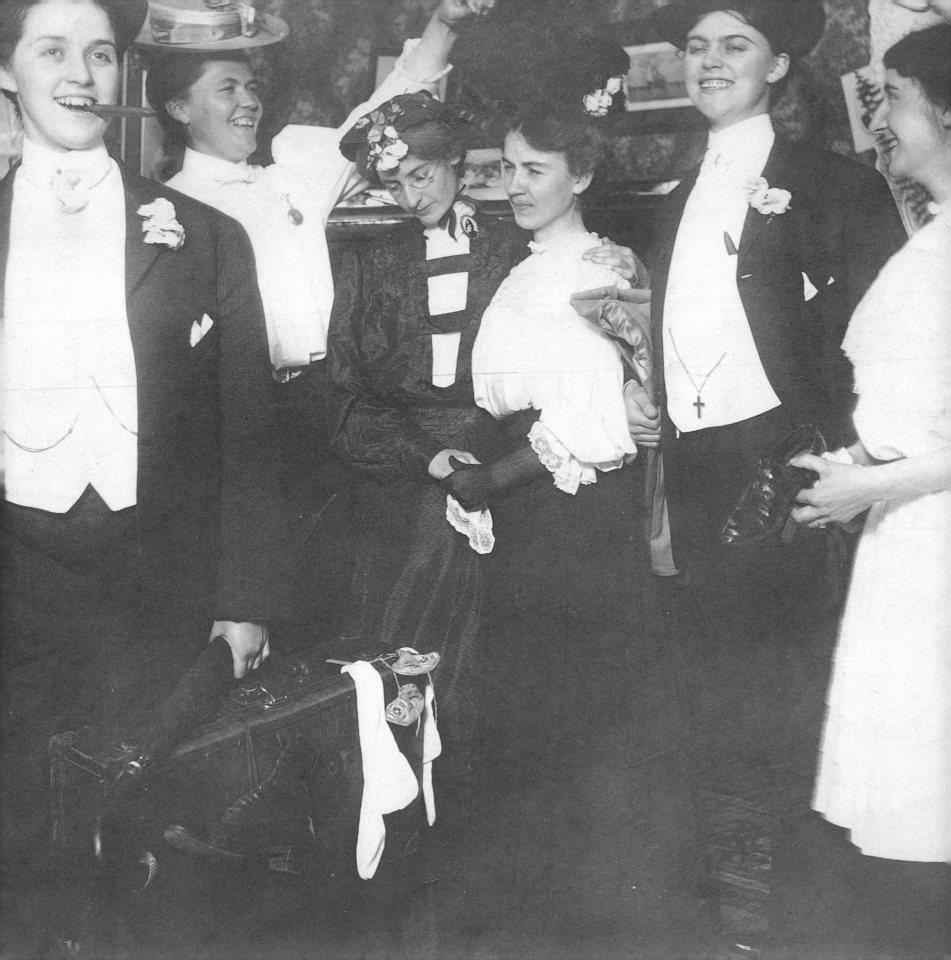

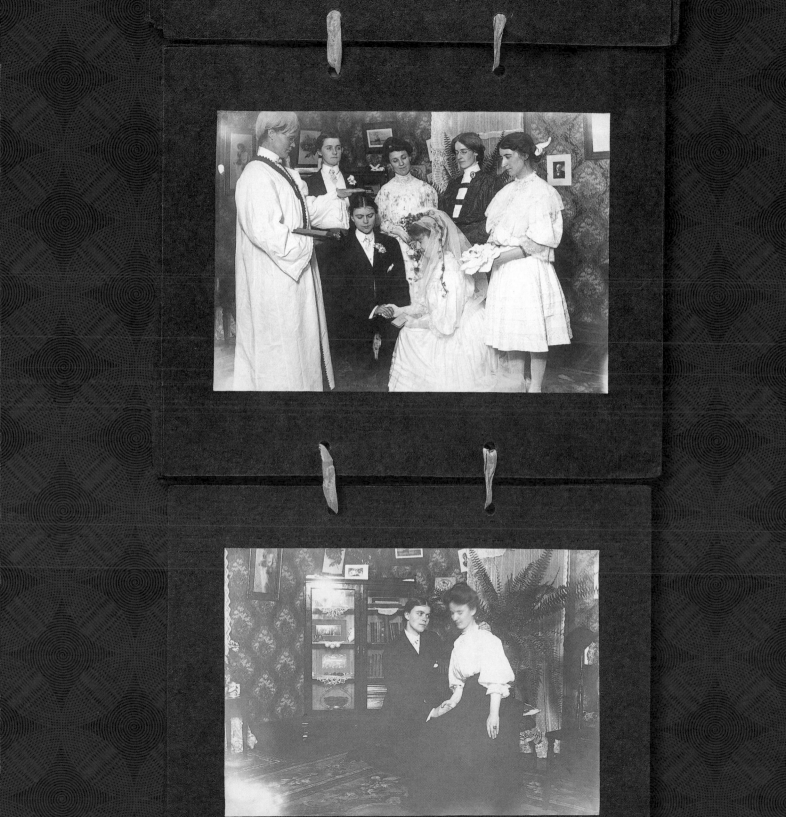

September 1929

Sent from Alaska

Taken at midnight Point Barrow

John Vickery – Siberia
Russian soldiers
inspecting the ship

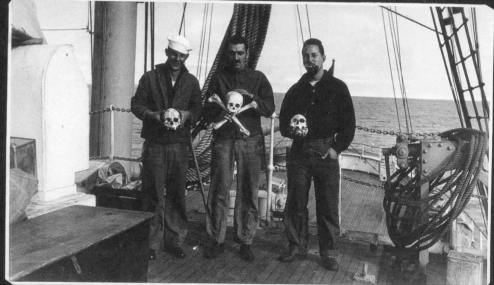

"Grave robbers" *George Gordon*

Photographs

Natives killing
Walrus - "Captain's
Orders" On the way
down from Point
Barrow

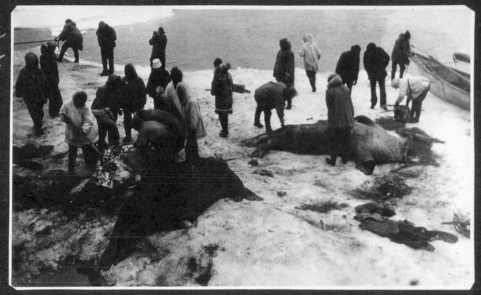

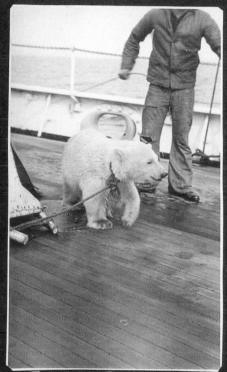

John Vickery
with his head
cut off.

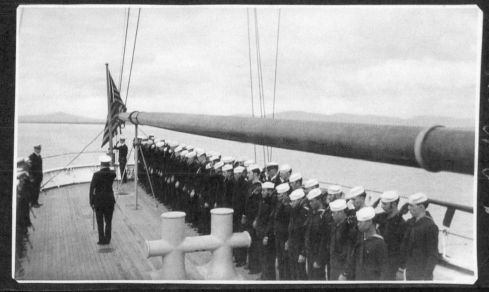

General Quarters
Nome Alaska
Sept 1917

93

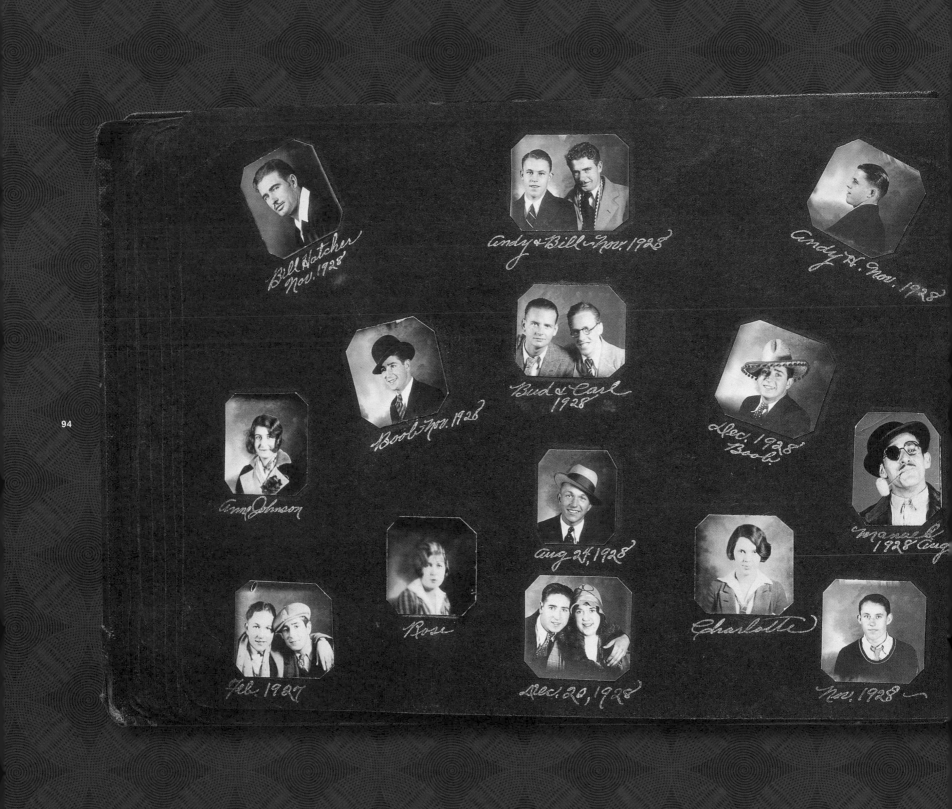

94

Bill Hatcher
Nov. 1928

Andy & Bill Nov. 1928

Andy H. Nov. 1928

Bud & Carl
1928

Bool Nov. 1928

Dec. 1928
Bool

Anna Johnson

Manuel
1928 Aug

Aug. 27, 1928

Feb. 1927

Rose

Dec. 20, 1928

Charlotte

Nov. 1928

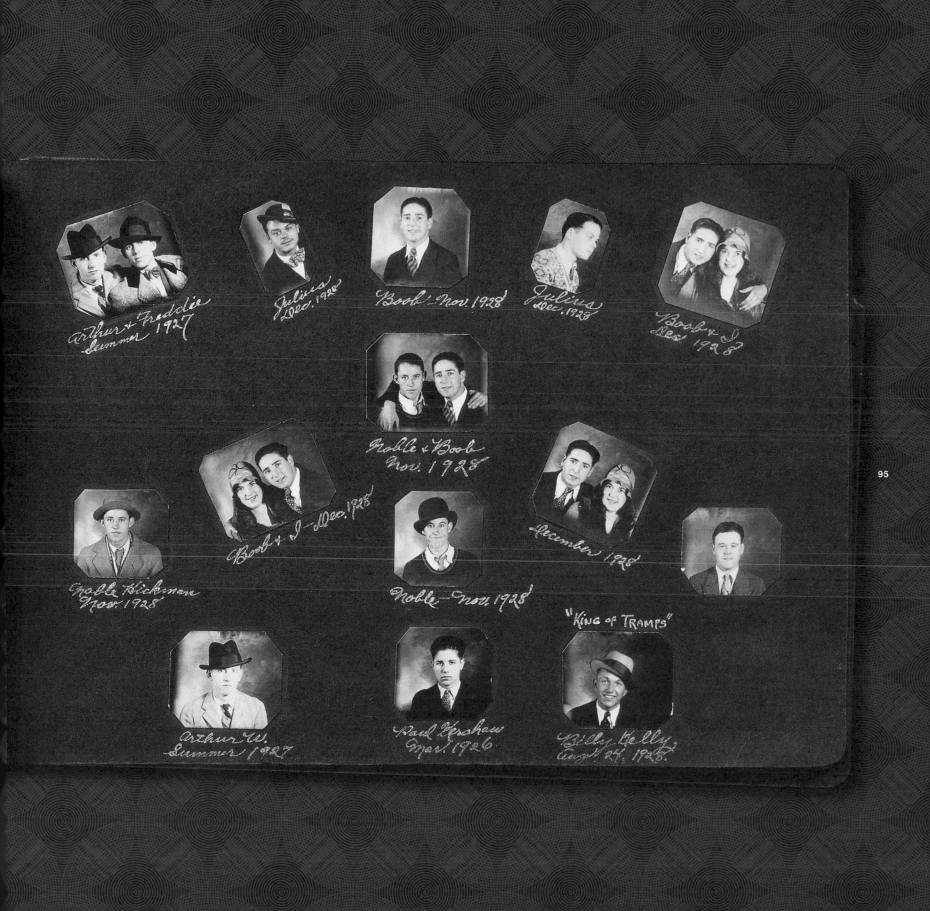

Arthur & Freddie
Summer 1927

Julius
Dec. 1928

Boob - Nov. 1928

Julius
Dec. 1928

Boob & I
Dec. 1928

Noble & Boob
Nov. 1928

Noble Hickman
Nov. 1928

Boob & I - Dec. 1928

Noble - Nov. 1928

December 1928

"KING OF TRAMPS"

Arthur W.
Summer 1927

Paul Kershaw
Mar. 1926

Billy Kelly
Aug. 24, 1928.

97

THE LOGGER ALBUM
c. 1900

This unique album chronicles a young
man's journey through college, his time
in the military, and his job in a logging
camp. The rawhide cover is secured with
a rugged bootlace, likely belonging to the
maker. Across pages, beautiful photos are
carefully arranged by subject and location,
often cut and shaped with exact precision
to fit one another. In addition to the unusual
placement of the pictures, the photographs
are embellished with the maker's delicate
line drawings in white ink of ornamental
borders and flora. At times, the photographs
and album pages of fire-ravaged areas
of the forest are so beautiful that you are
not sure if the photographer is making an
aesthetic record or commenting on the
devastation.

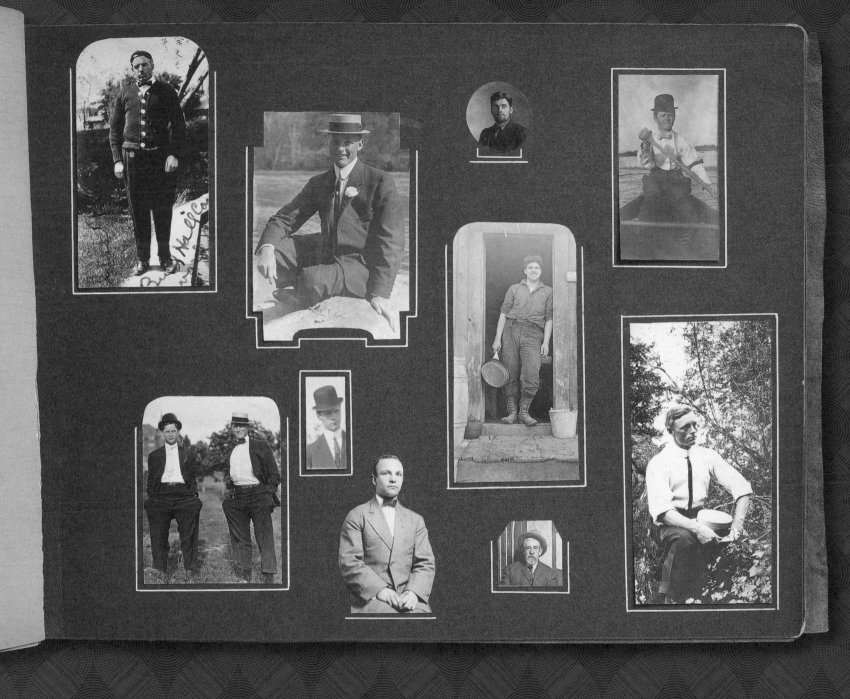

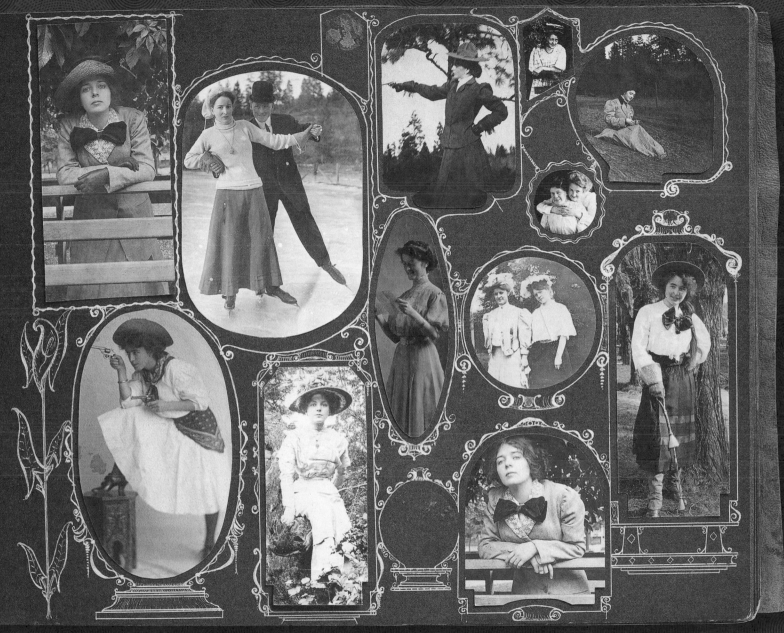

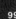

Nelson, W.S.C. 1st Martin, W.C. 2nd Coe, W.S.C. 3rd

Coe, W.S.C. Lowry, W.S.C. Martin, W.C. Nelson, W.S.C. Wilson, W.C.

Coe, W.S.C. Lowry, W.S.C. Wilson, W.C. Martin, W.C. Nelson, W.S.C.

Copyright 1909 by Burns.

W.S.C. 99 W.C. 23" May 29, 09.
Nelson breaking N.W. and Equalling Worlds' Record.
100 yd Dash. Time 9 3/5 sec.

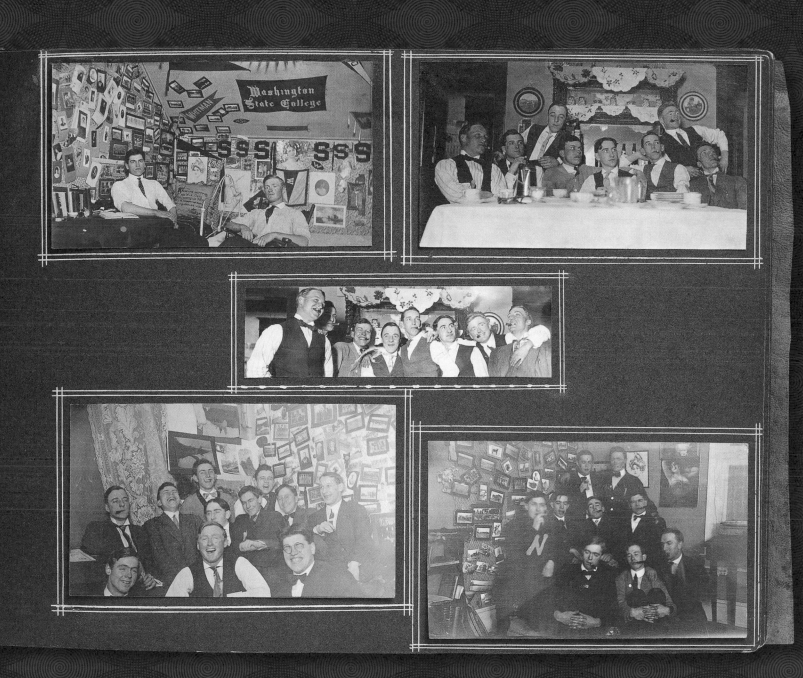

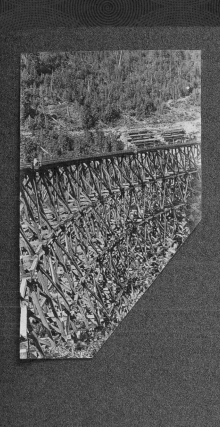

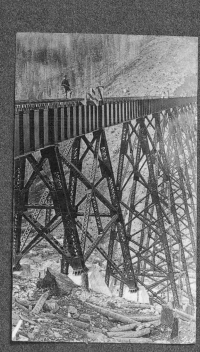

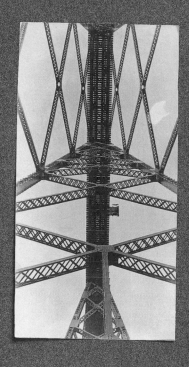

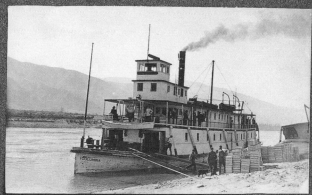

103

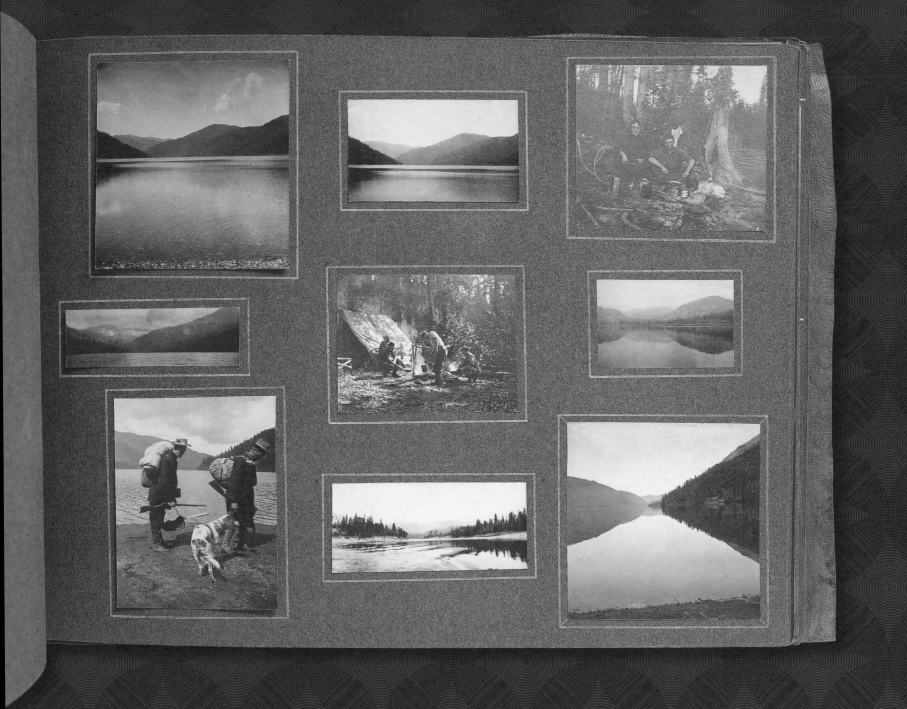

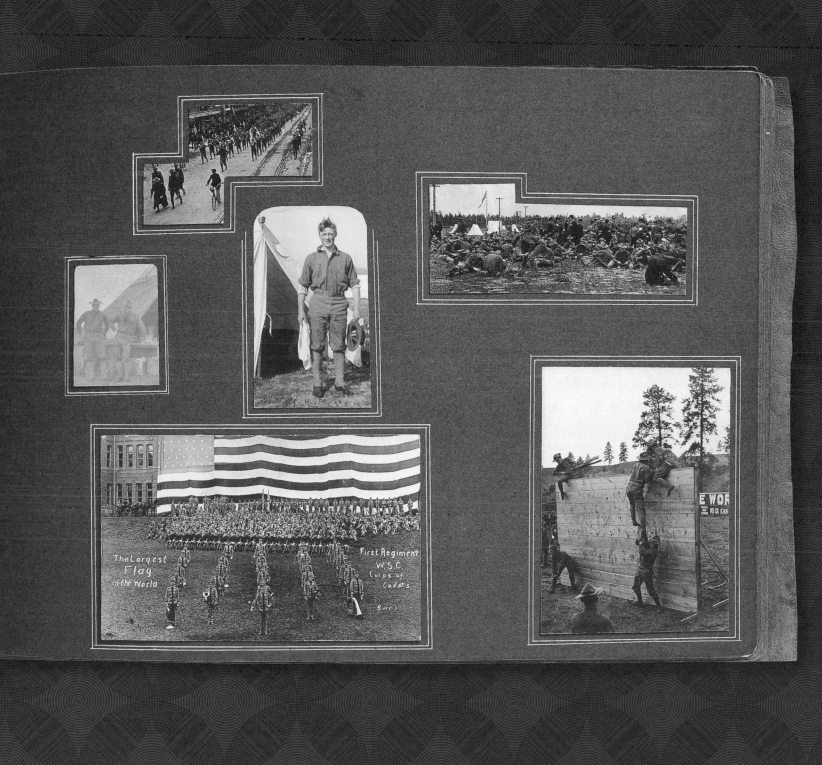

The Largest
Flag
in the World

First Regiment
W.S.C.
Corps of
Cadets

Burns

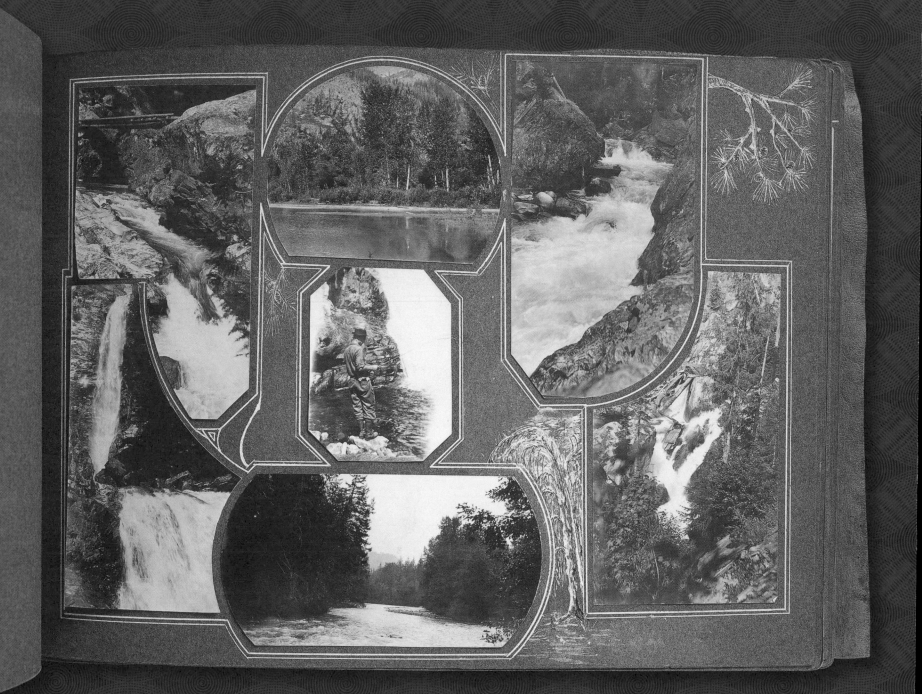

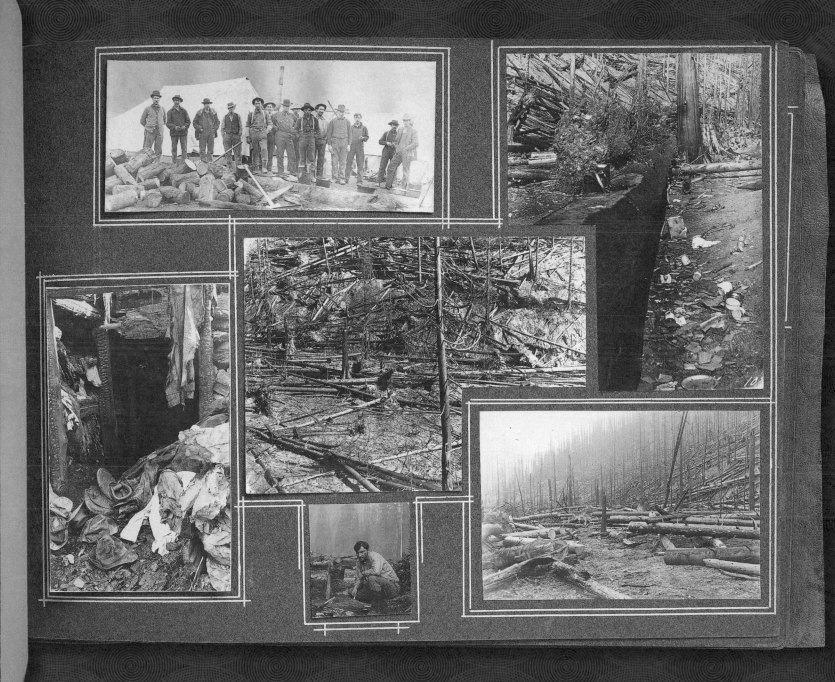

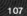

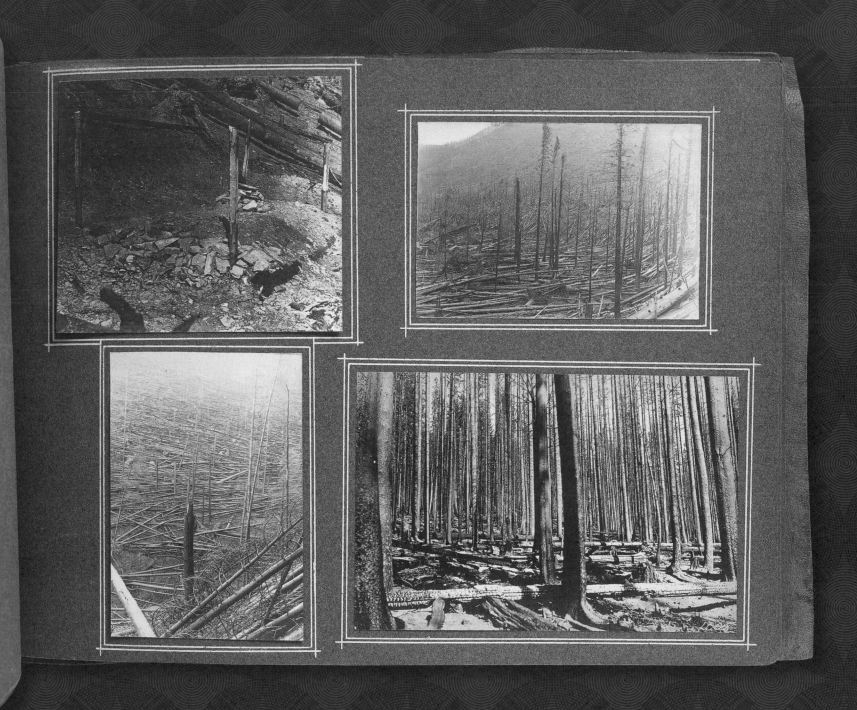

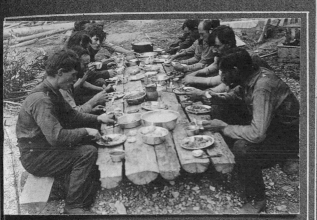

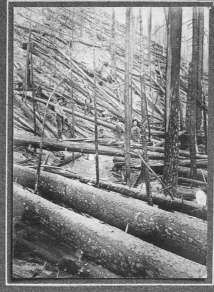

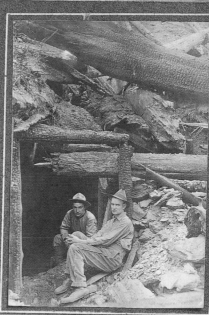

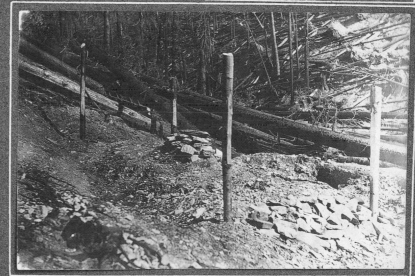

Photographs.

Photographs

Photographs

Snap Shots

Photographs

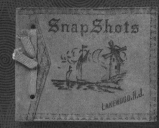

111

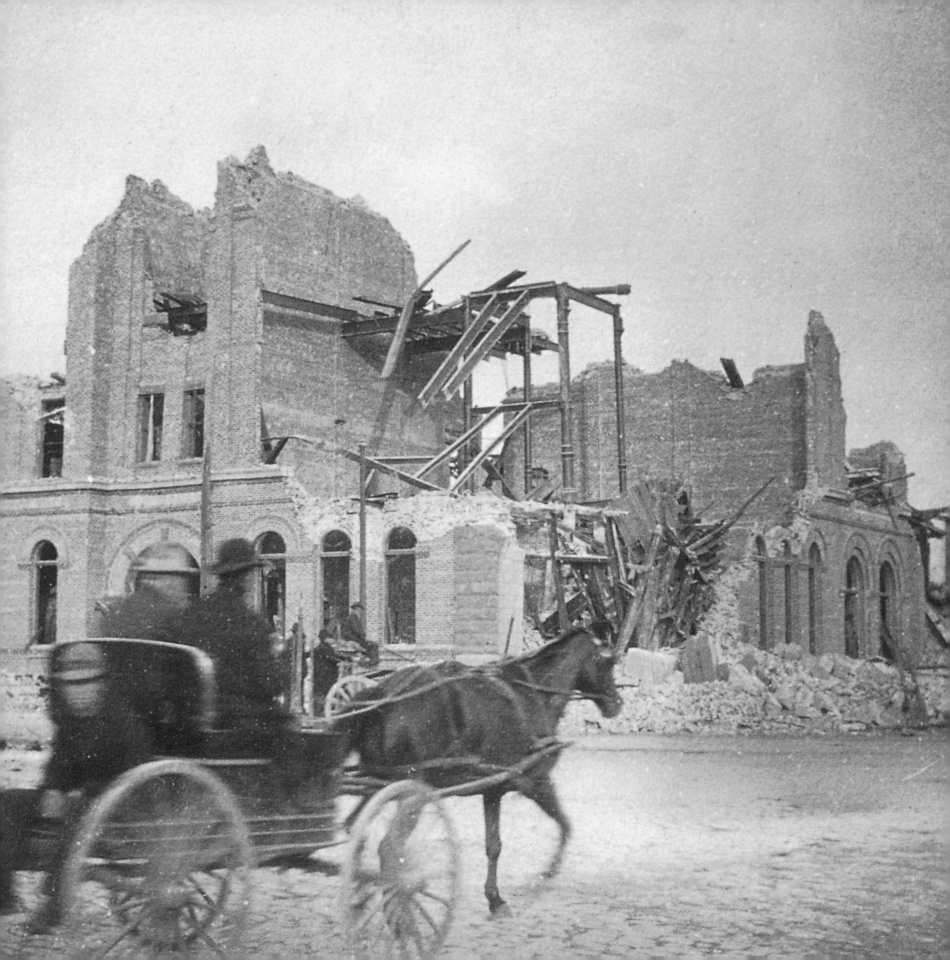

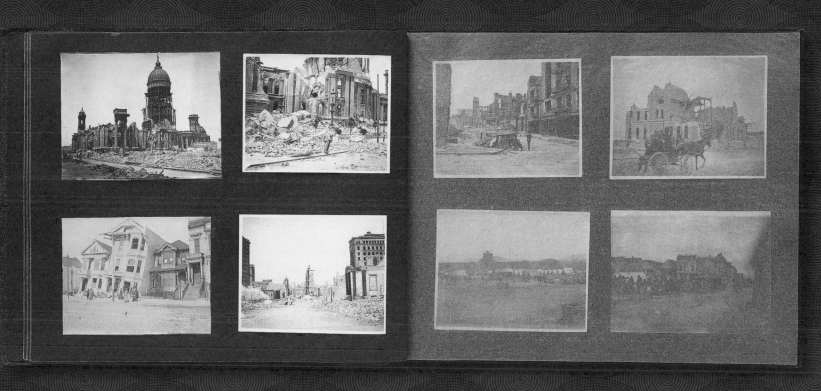

113

SAN FRANCISCO
1906

This album contains interesting sequences
and detailed perspectives of trains, railroad
life, and the devastation that occured in the
1906 San Francisco earthquake.

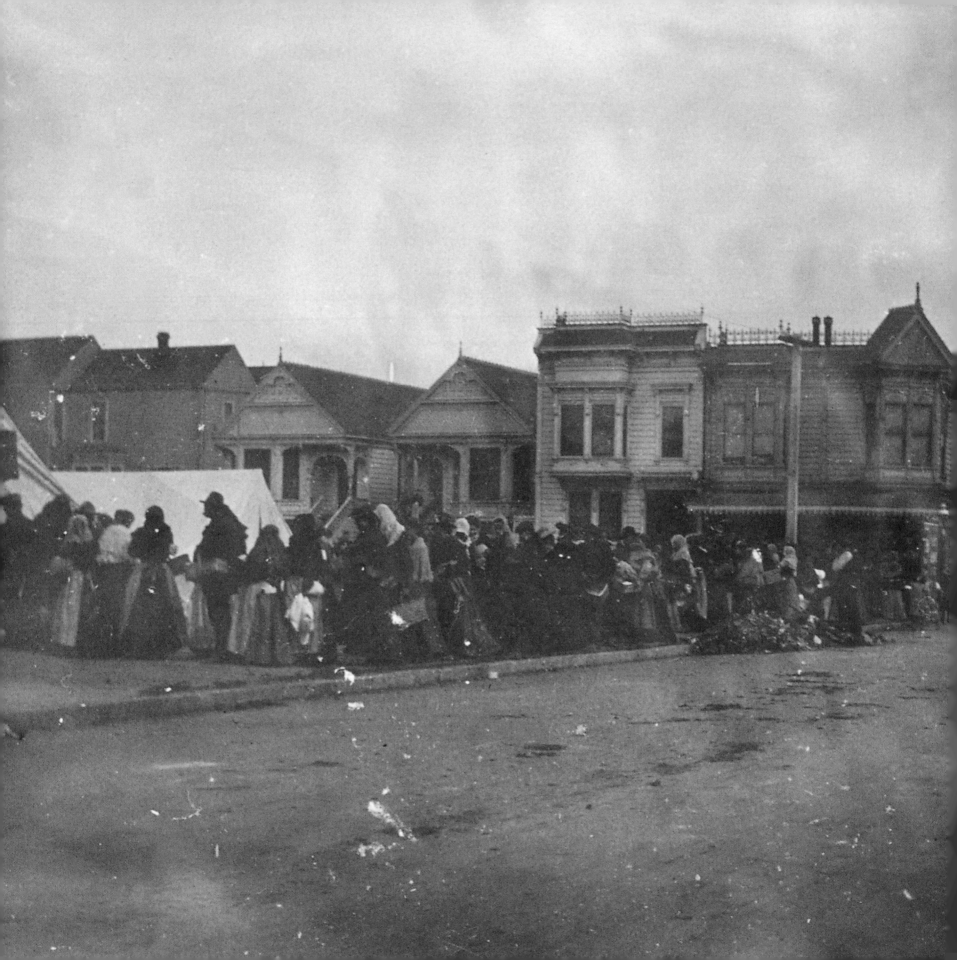

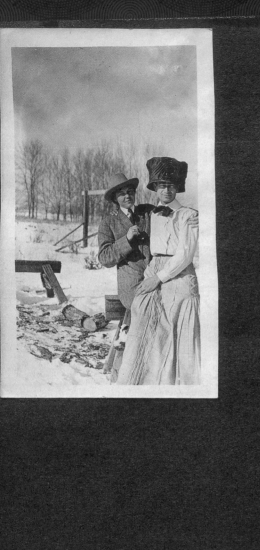

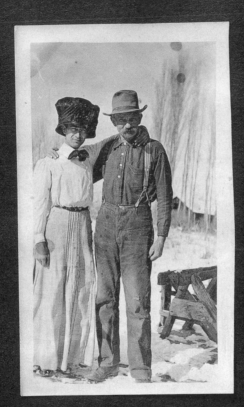

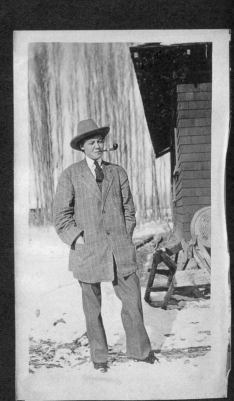

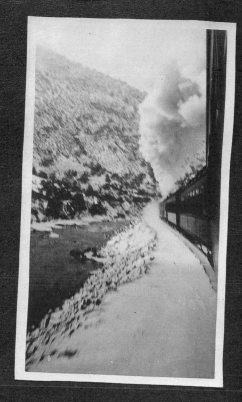

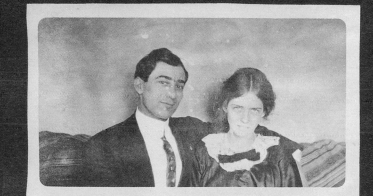

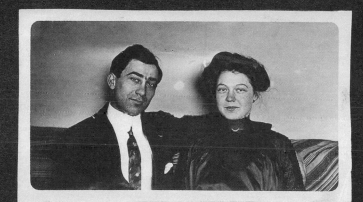

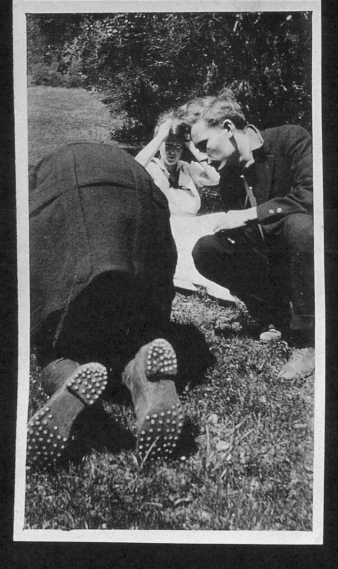

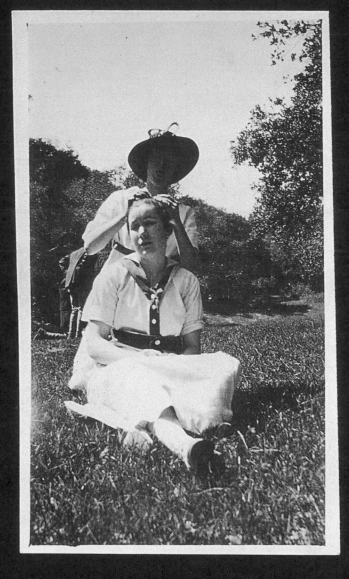

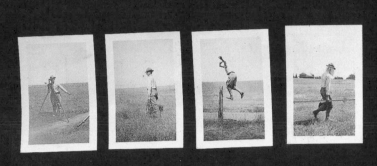

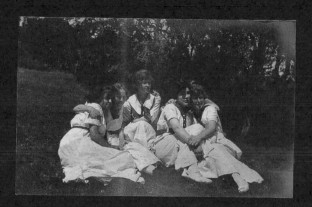

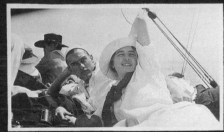

Earl and Viola.

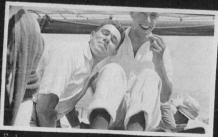

Bob and I.

COLORADO
c. 1917

Made in Colorado, this album contains
excellent examples of interesting sequences
and page compositions, such as the four
photographs showing a surveyor jumping
over a fence. Amateur photographers
and album makers often arranged single
photographs to show movement over time.
Such experiments evoke early cinematic
animation, the early work of Eadweard
Muybridge, and other forms of time-based art.

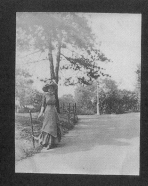

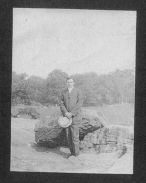

Central Park
New York
City.

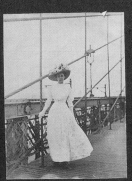

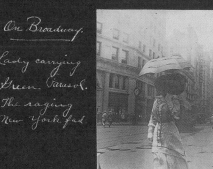

On Broadway.

Lady carrying
Green Parasol.
The raging
New York fad.

Grants Tomb.

TRAVEL ALBUM
c. 1910

Brooklyn Bridge.

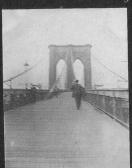

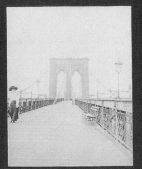

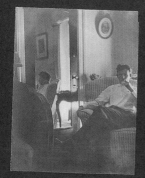

At home
Hotel
Knickerbocker
New York.
1910

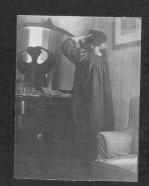

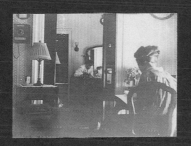

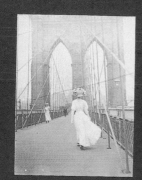

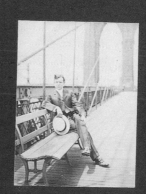

Brooklyn Bridge.

New
York
taken
from
Bridge.
East
and
west

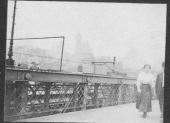

Finder Kindly Return
Wilbur B. Knies,
American Expeditionary Forces
Headquarters
Air Service
France

National "Simplex" Note Book
PATENTED

BOUND FULL CLOTH
Number 3802

Number	Size of Paper	REFILLS				
		Faint	Quad-rille	Un-ruled	Draw-ing	Cross Section
3800½	6 × 4					
3800	3¾ × 5¾	3770		3770½		
3801	4½ × 7¾	3771		3771½		
3801½	5 × 8					
3802	5¼ × 6¾	3772	3779½	3772½		
3802½	5¼ × 6½	3779	3772¼	3772½		
3803	5½ × 8½	3773	3773¼	3773½		
3804	6¾ × 7½	3774	3774¼	3774½	3774¼	3774C
3804½	6½ × 7½	3774	3774¼	3774½	3774¼	3774C
3805	7½ × 9½	3775	3775¼	3775½		
3806	10½ × 8	3776	3776½	3776½	3776¼	3776C
3806½	10½ × 8	3776	3776¼	3776½	3776¼	3776C
3807	4½ × 8½	3777	3777¼	3777½		
3808	5½ × 5½	3778	3778¼	3778½		
3808½	5½ × 5½	3778	3778¼	3778½		
3810	11 × 8½	3769	3769¼	3769½		
3812	13 × 8½	3760				
3812½	13 × 8½	3788				

NATIONAL LOOSE LEAF CO., LTD.
:: CANADIAN HOUSE ::
75-75A and 76 Little Britain LONDON, E. C.

MADE IN U.S.A.

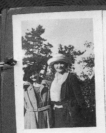

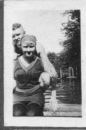

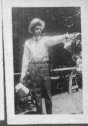
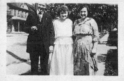
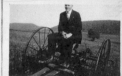

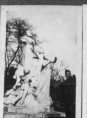

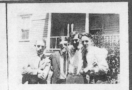
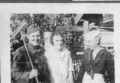

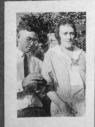
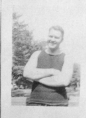
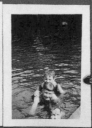
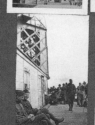

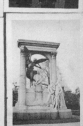

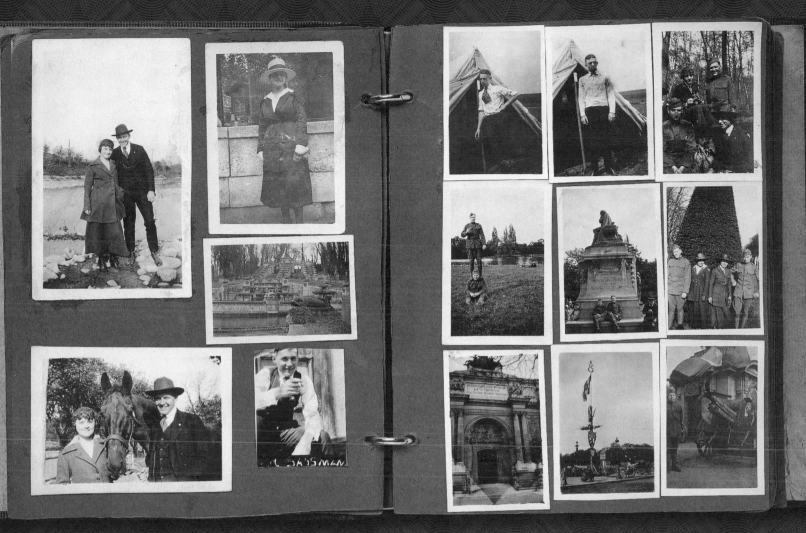

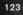

WILBUR KNIES
1918

Wilbur Knies was a soldier with the American Expeditionary Forces in France. His photo-filled notebook blends images from the war with family scenes often in disturbing juxtapositions. The effect is an album that seamlessly takes us back and forth between domestic and military life.

THIS ALBUM IS INTENDED TO BRING
BACK HAPPY MEMORIES

EASTER SUNDAY - APRIL 1, 1934

ELEANOR M. BRZNOWSKI.

125

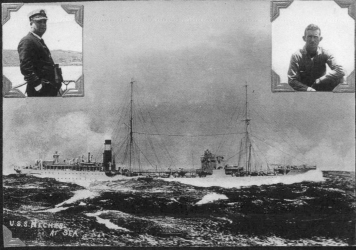

COMMANDER,
J.B. WILLSON,
SKIPPER.

L.E.HICKS,
QUARTERMASTER,
SECOND CLASS.

U.S.S.
NECHES.
AND
MY TOUR OF
DUTY ON BOARD.

U.S.S. NECHES
AT SEA

Auxiliary class, Fleet oiler, cargo 58,000 barrels, speed
14 knots per hour, length 475 feet, width 58 feet, draft 30 feet.
Crew 120 men, 3 and 5 inch guns.

aying smoke

War game maneuvers.

26

**SAILOR'S LOG
1933**

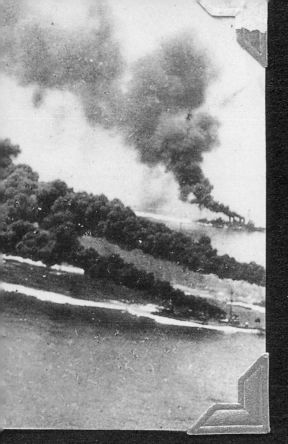

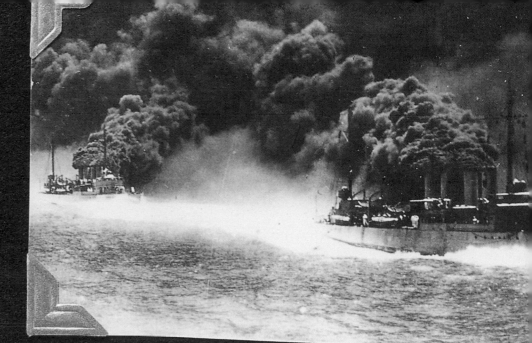

More Smoke Screens

screens during

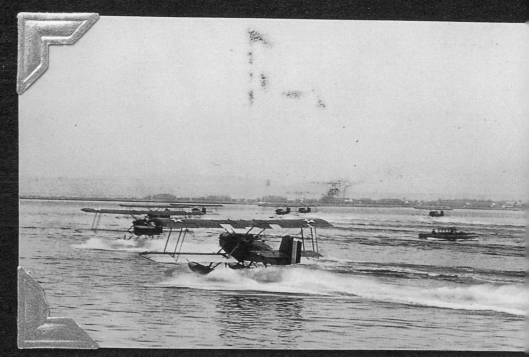

Seaplanes taking off.

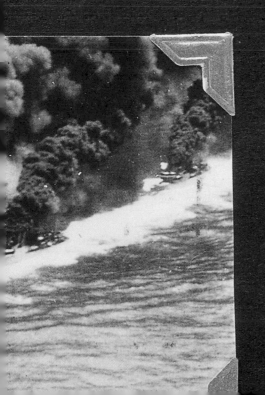

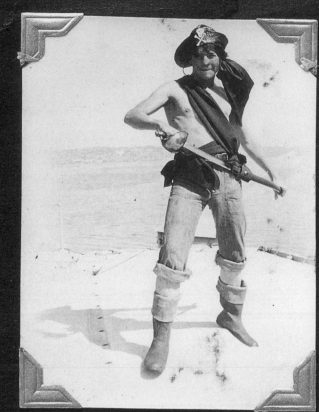

Casler - Neches

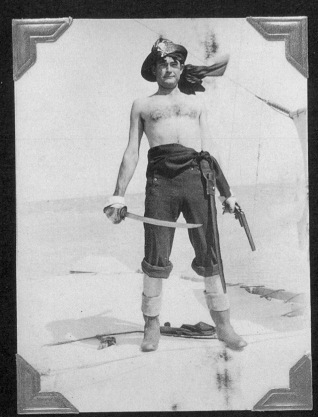

Bryant - Neches

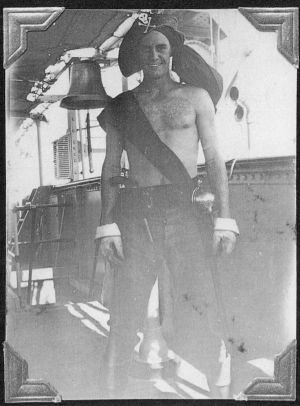

Payne — Neches

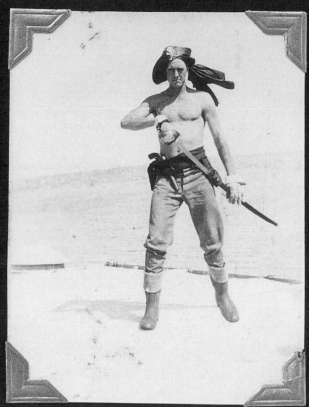

Payne — Neches

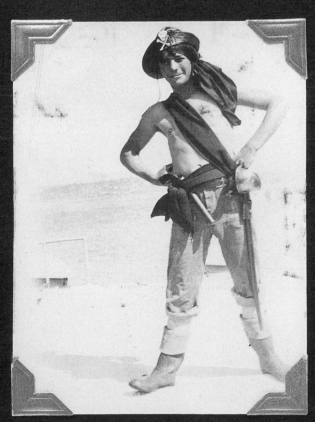

Casler — Neches

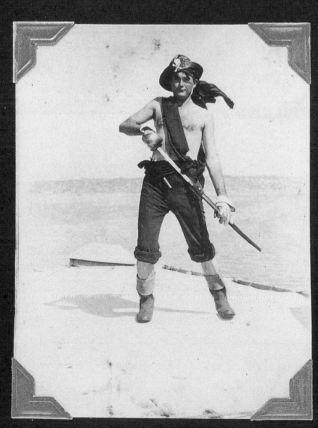

Bryant — Neches

KING NEPTUNE'S DOMAIN

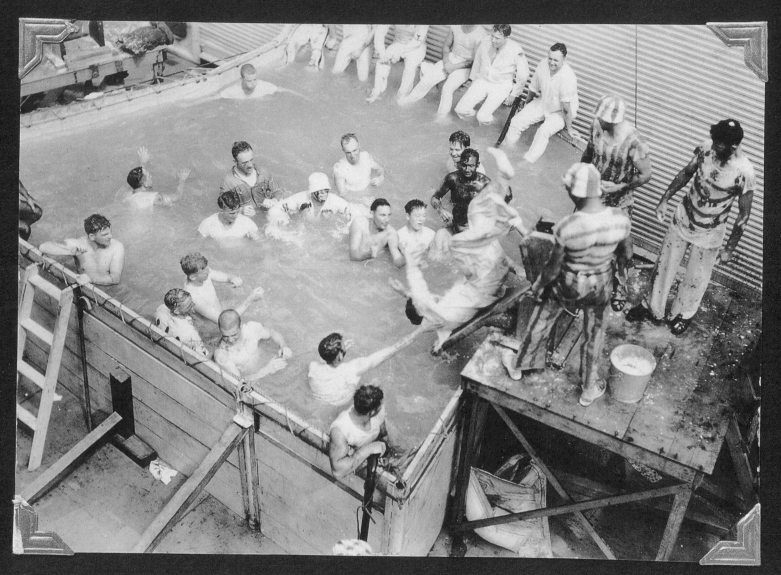

The initiation of all men who are crossing the equator for the first time By King Neptunus Rex and His Royal Subjects who rule the Raging Main. Members of the Ships Crew who have previously crossed the Equator make up the Royal Court.

PANAMA

ATLANTIC OCEAN

Dotted line shows course
of Panama Canal.

Post Office Building - Cristobal, Canal Zone.

"THE ATLANTIC SIDE"
Cristobal and Colon
Population 48,000

Street Scene, Resident District,
Colon, Panama.

Tropical Scene - Colon, Panama.

Navy Landing - Cristobal, C.Z.

Street Scene, Business District,
Colon, Panama.

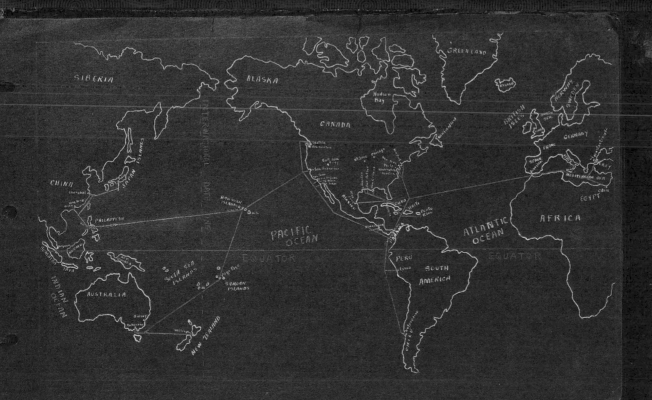

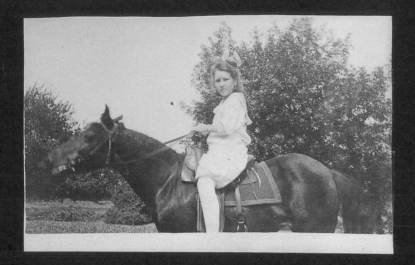

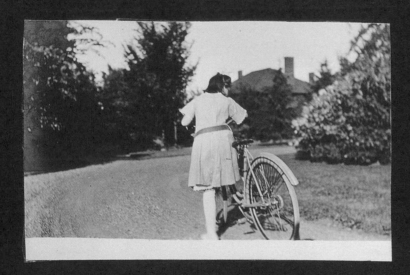

SUMMER SCENES
1915–25

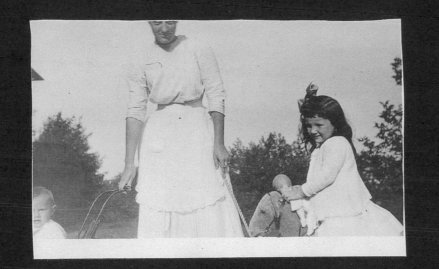

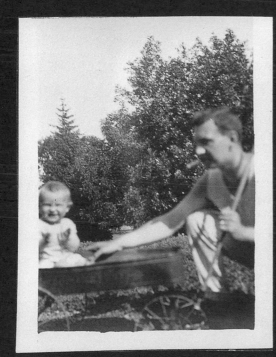

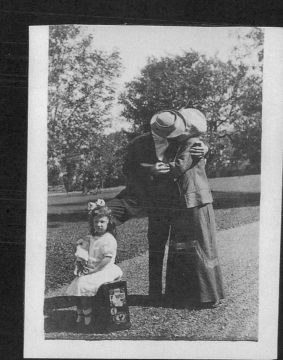

Nov. 11, 1918

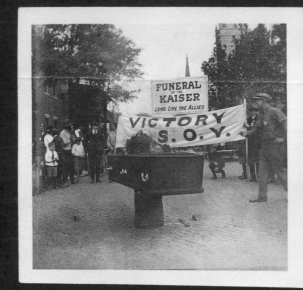

FUNERAL
OF THE
KAISER
LONG LIVE THE ALLIES
VICTORY
S.O.Y.

Ed. Kyle.

"Danny" Fivel

"Snook" Seelinger Captain

"Skinny" Borum

Basket Ball

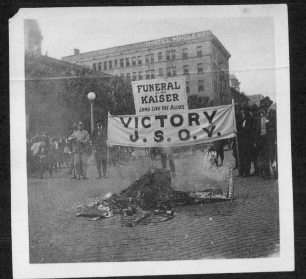

Nov. 11, 1918
Later.

"Fozy" Forsberg.

"Rot" Gallup.

"Head" Holland
'19

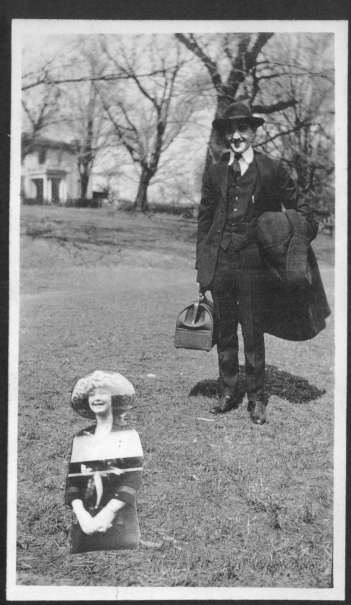

CHARLIE Hudson

Dot EAST.

Father

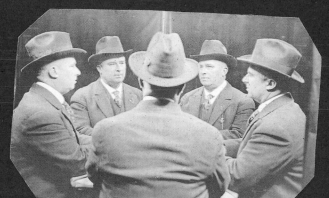

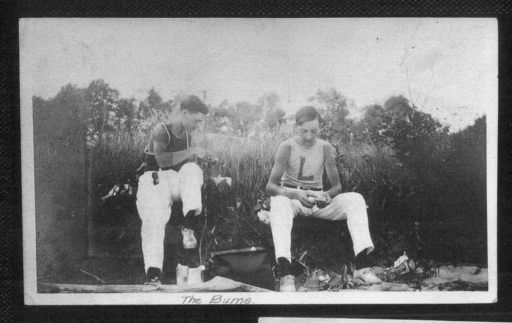

The Bums.

1911

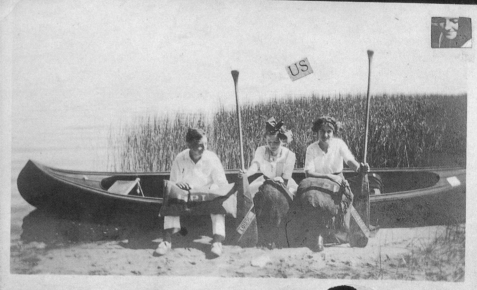

US

PHOTOGRAPHS

**LOUISE P. LAVENDER
1911–12**

This album is distinguished by highly
unusual collage forms. Tiny cut-out pieces
of photographs are pasted on top of
other photographs in such a manner that
it is almost impossible to discern that
the photographs have been altered. The
photographs are artfully placed and the
pages are filled with photos cut out and
embellished with gold circles, frames and
newspaper text.

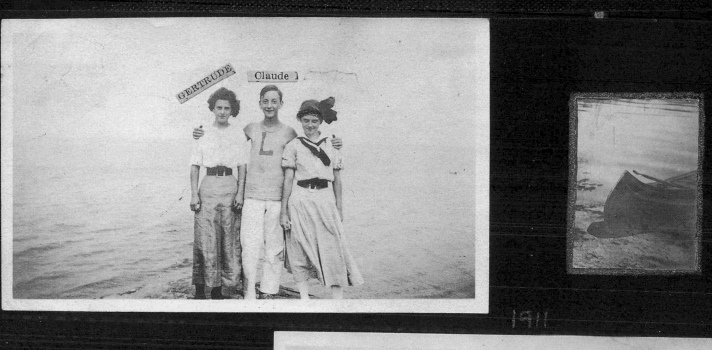

GERTRUDE Claude I

1911

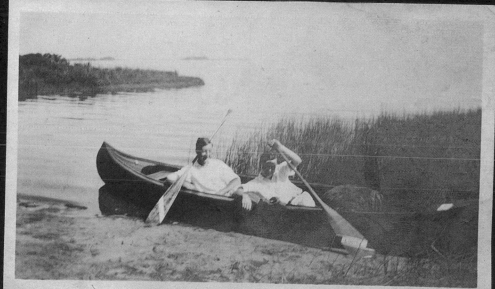

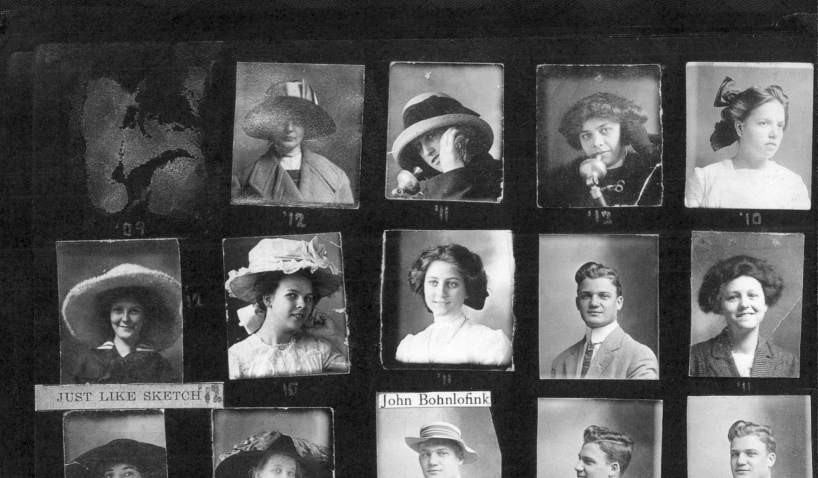

140

'09 '12 '11 '12 '10

JUST LIKE SKETCH

'10

John Bohnlofink

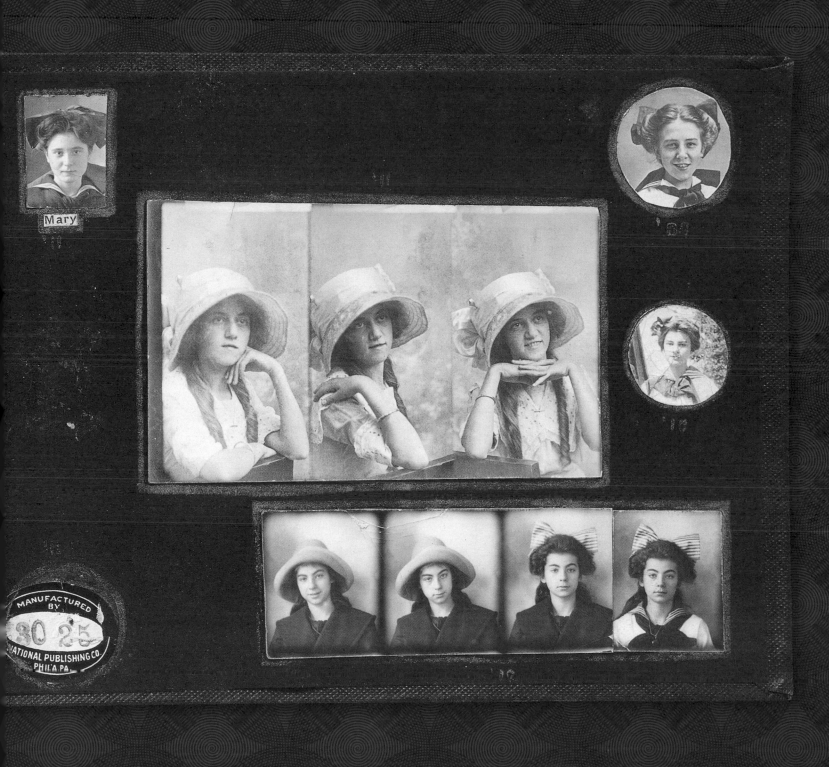

Mary

141

MANUFACTURED BY
80 25
NATIONAL PUBLISHING CO.
PHILA PA

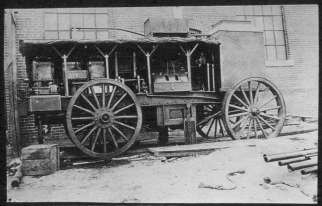

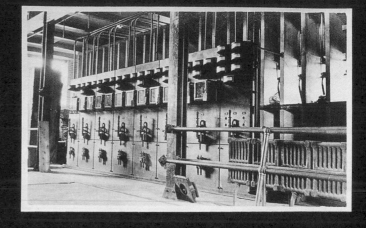

142

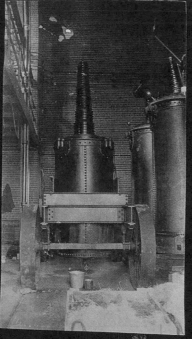

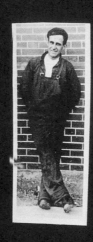

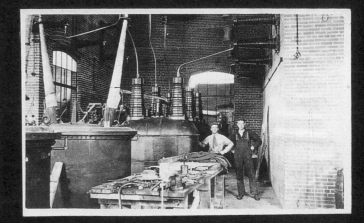

My Memory Book

ELECTRICAL PLANT
c. 1905

This album was made in the Michigan/
Canadian border region and chronicles
a family that moved to the area for the
father's job at a General Electric factory.
Early album pages show alternating views
of the home and landscape they were
leaving to the industrial plant and new life
they were beginning. The awe of machines
and electricity is reflected in the images of
generators, transformers, and power grids
taken inside the electrical plant.

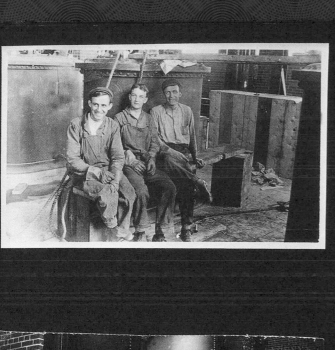

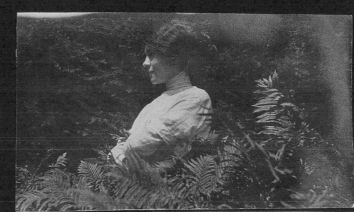

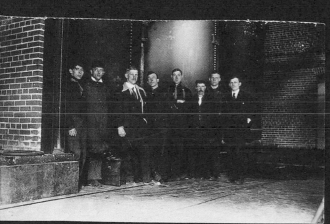

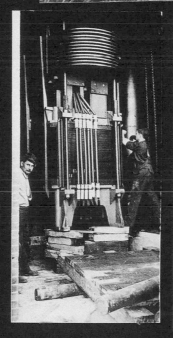

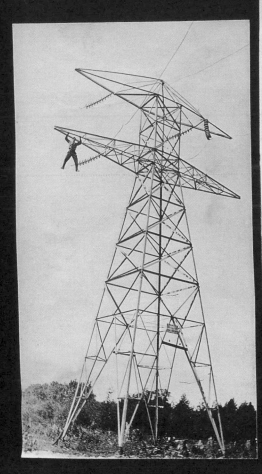
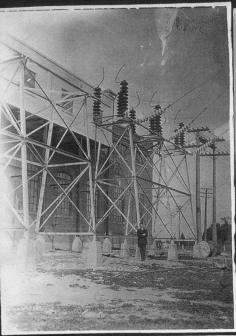
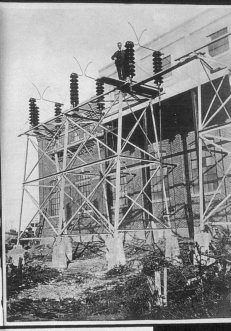
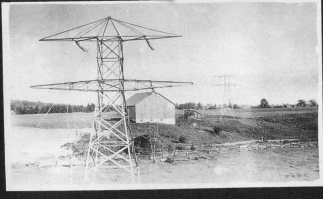

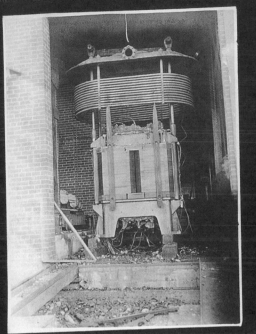

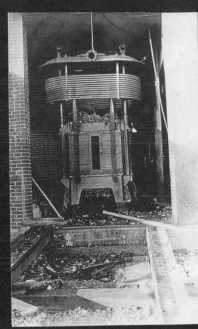

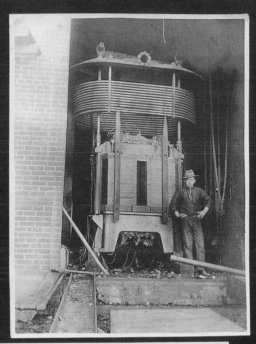

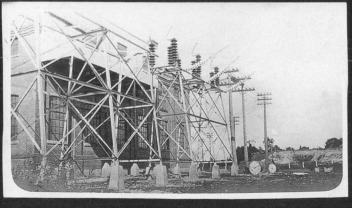

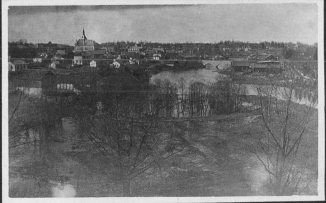

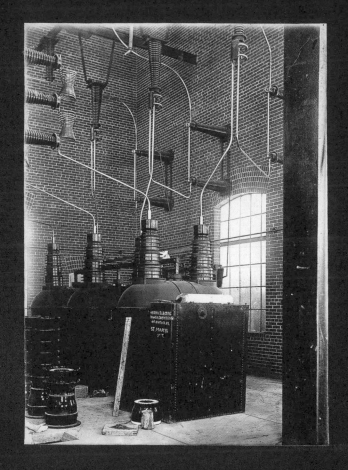

146

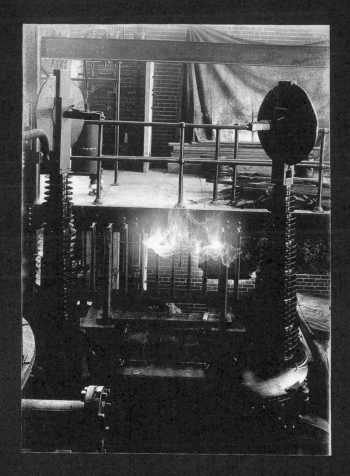

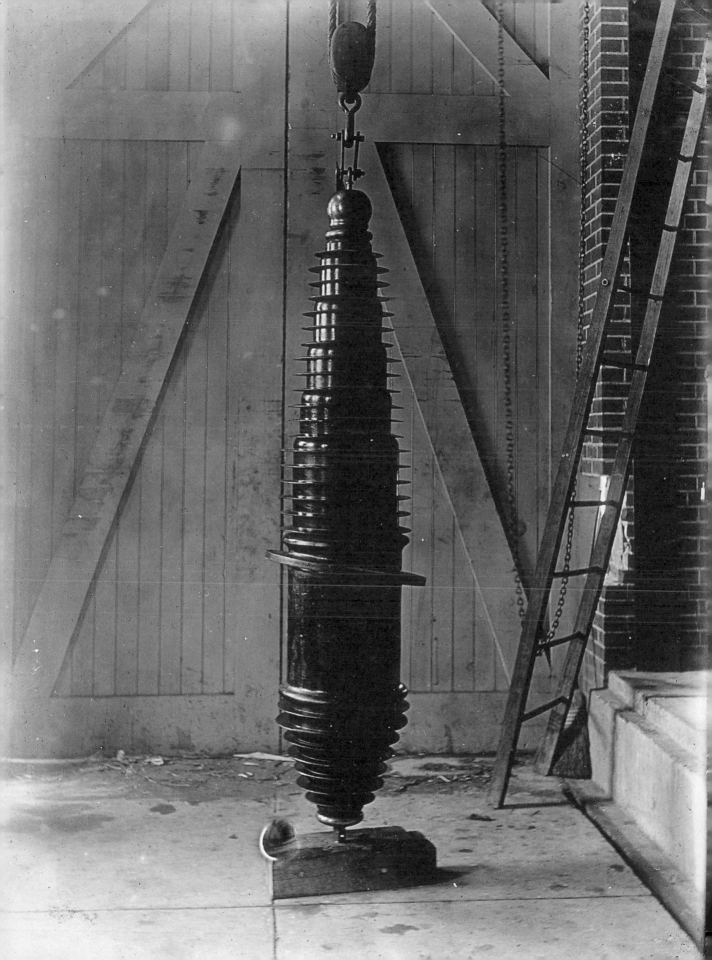

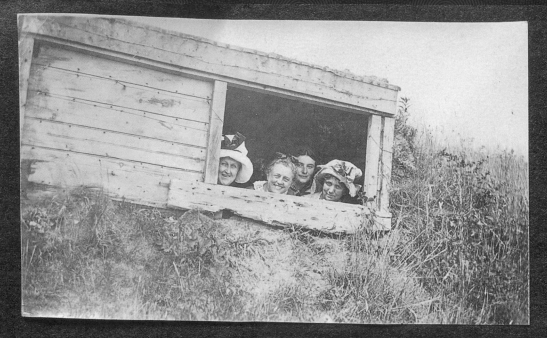

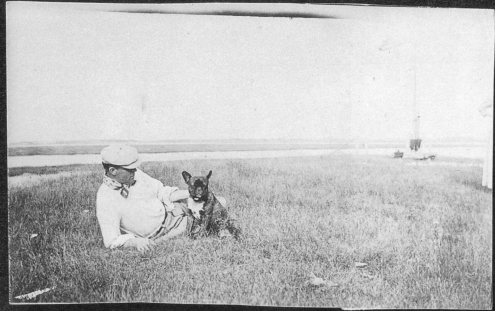

EAST COAST
1910

PHOTOGRAPHS

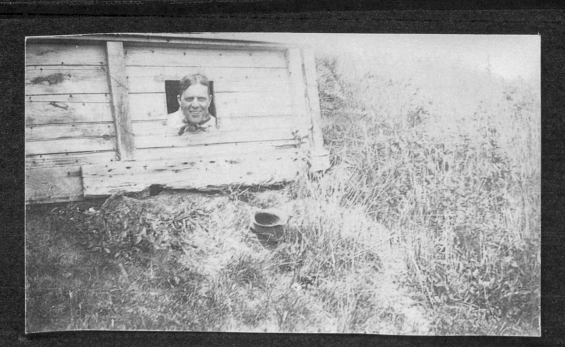

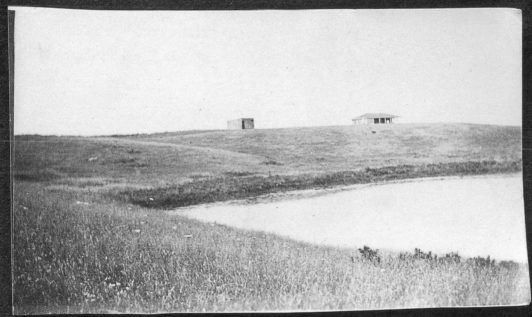

Exhibition Standard
Game Cock

Black Minorcas

Columbia Farm

Columbia Farm

Prize Winners
From
Columbia Farm

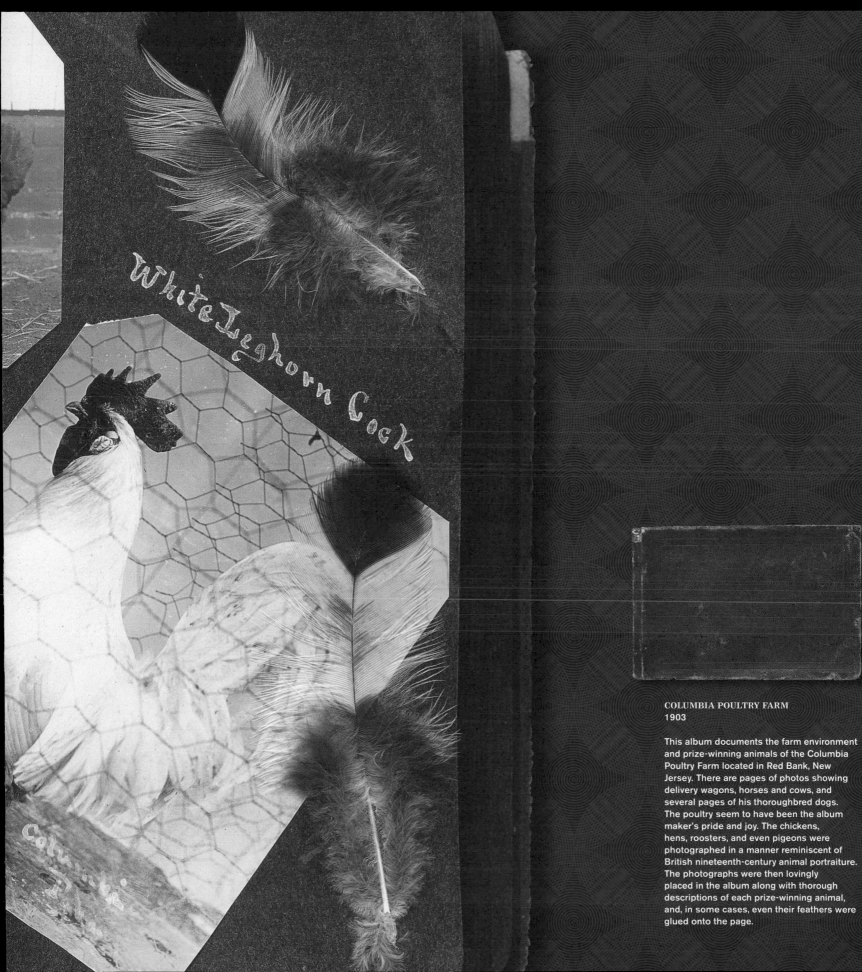

COLUMBIA POULTRY FARM
1903

This album documents the farm environment and prize-winning animals of the Columbia Poultry Farm located in Red Bank, New Jersey. There are pages of photos showing delivery wagons, horses and cows, and several pages of his thoroughbred dogs. The poultry seem to have been the album maker's pride and joy. The chickens, hens, roosters, and even pigeons were photographed in a manner reminiscent of British nineteenth-century animal portraiture. The photographs were then lovingly placed in the album along with thorough descriptions of each prize-winning animal, and, in some cases, even their feathers were glued onto the page.

Ribbons Won
By
Columbia Farm

Madison
Square
Garden
N.Y
1904

Ribbons Won
By Columbia Farm
Inter. State. Fair
Trenton. N.J. 1903

Ribbons Won
By Columbia Farm
Newark Poultry Show
1903

Ribbons Won
By Columbia Farm
Atlantic City Show
1903

153

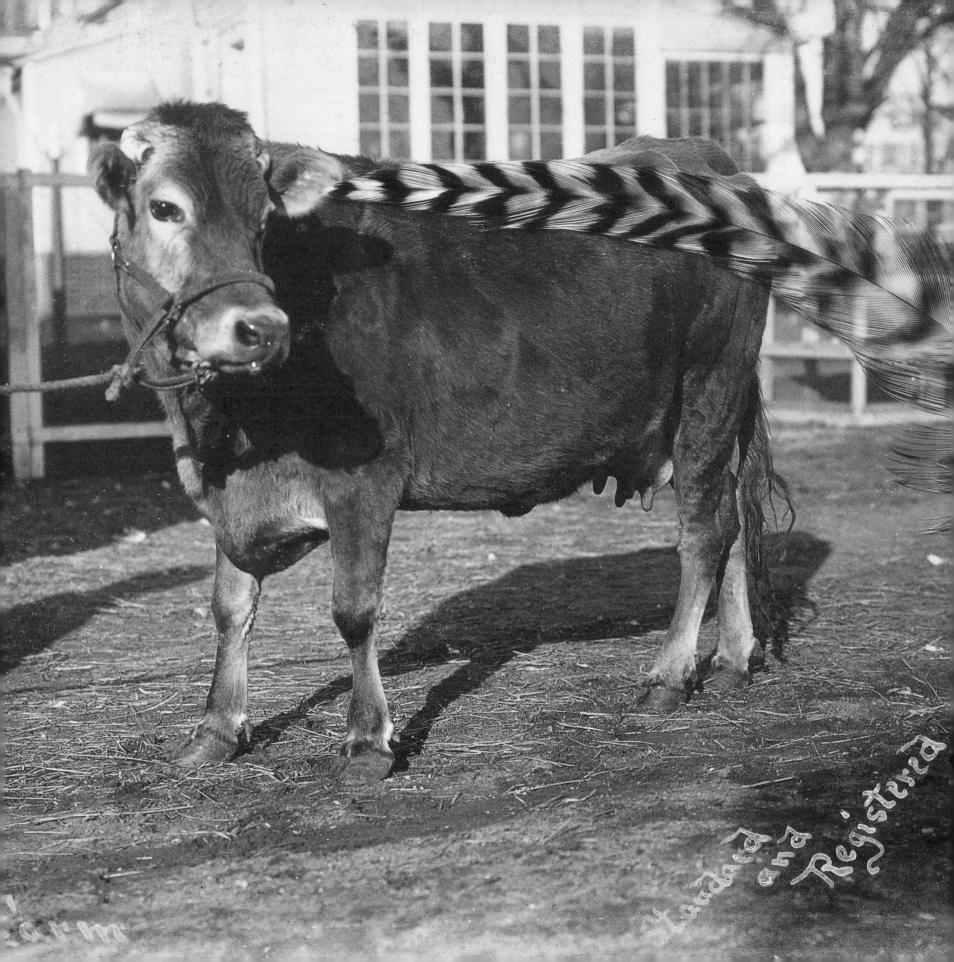

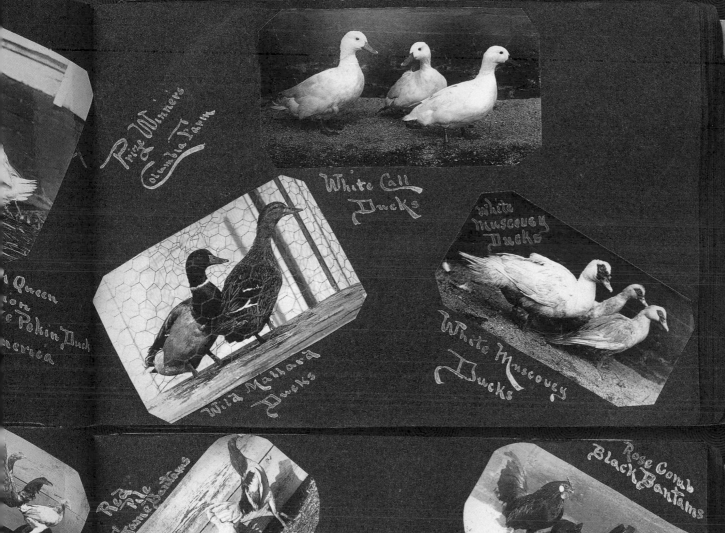

Prize Winners
Columbia Farm

White Call
Ducks

White
Muscovy
Ducks

Wild Mallard
Ducks

White Muscovy
Ducks

Queen
...on
...e Pekin Duck
...erica

Rose Comb
Black Bantams

Red
Pile
Game Bantams

Light Brahma Bantams

1st pen
Stamford
Trenton
Newark
Atlantic
City

Rose Comb
Black Bantam
Cock

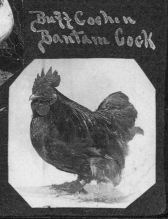

Buff Cochin
Bantam Cock

Prize Winners
On
Columbia Farm

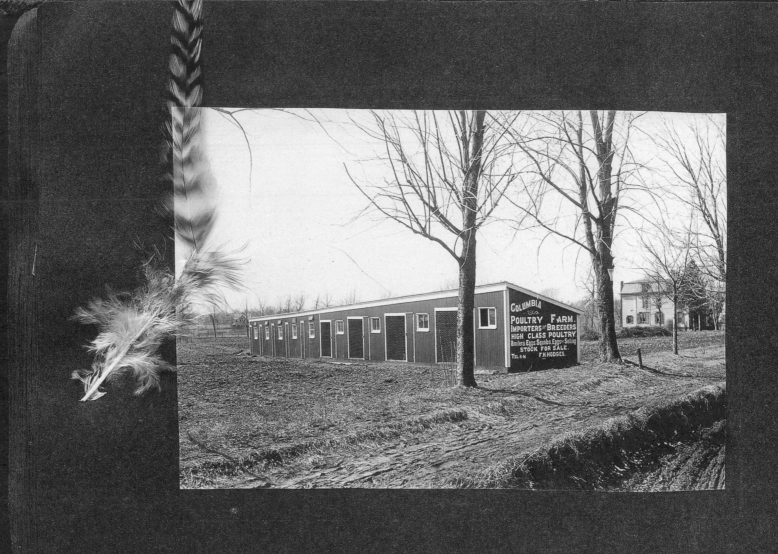

Love me Love my Doll Bathing Beauty Were Lost

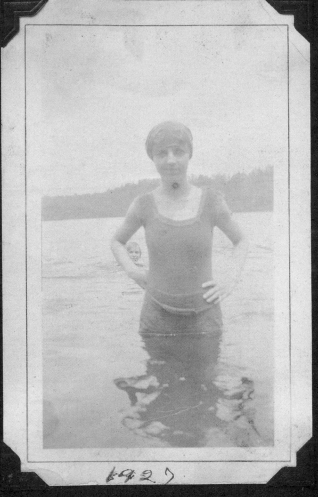

1927

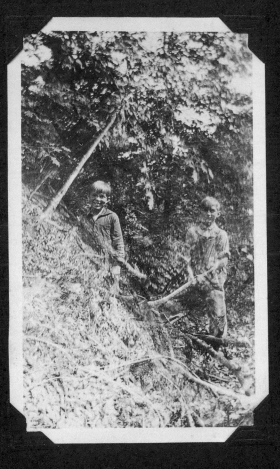

LOVE ME, LOVE MY DOLL
c. 1920–25

A Dry Bath

Lonesome Me

First Love

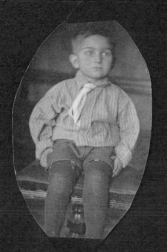

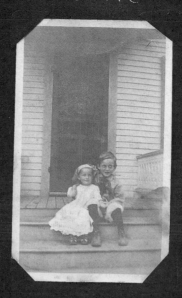

Nurse Maid

Gone

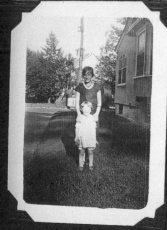

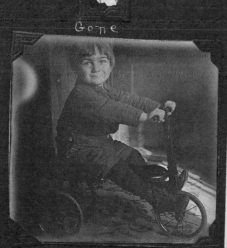

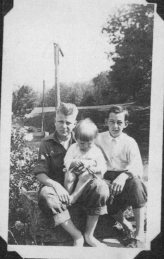

A Trial Spin

Interested

160

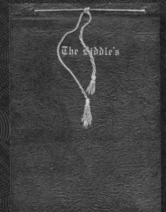

BON BON AND PA PA
c. 1925

This album is distinguished by the funny, detailed inscriptions that accompany nearly every photograph. As organized as a movie script, the album chronicles the first years of marriage between "Bon Bon" and her new husband, "Pa Pa." The album follows the newlyweds through the beginnings of their lives together in southern California: the sparse apartments, the romantic dinners, and camping trips to Big Sur with Bon Bon's mother-in-law. The album also delves into Bon Bon's career as an actress and dancer. Reading the album's narrative produces the acute sense that one is now part of the *"Riddle's,"* Bon Bon and Pa Pa's inner circle.

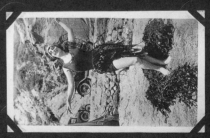

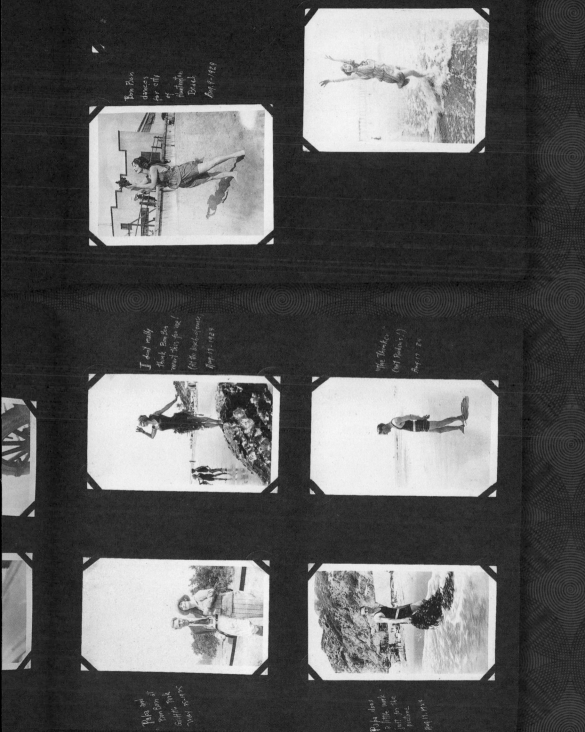

Bon Bon
dances
for city
of
Huntington
Beach
Aug 9-1929

I don't really
think Bon Bon
meant this for me!
(At the beach of course)
Aug 17-1924

"The Thinker"
(not Rodin's)
Aug 17-24

Papa and
Bon Bon at
Griffith Park
May 25-1925

Papa does
a little work
just for the
picture
Aug 11, 1924

On the edge of Big Bear Lake
where we camped for sleep

Aug. 29th 1924
Well here we are at
Big Bear! Got sudden
notion last nite to go to
Mt. Wilson - here's where
we landed after all night
drive. Arrived B.B @ A.M.

Bon Bon always smiles for
her picture no matter how sleepy she i

* @ - @ - These <u>damn</u>
folding beds!

Getting
ready for
bed.

Sleeping in earnest.
Bon Bon got up first + shot it
(umbrella taken out sun)

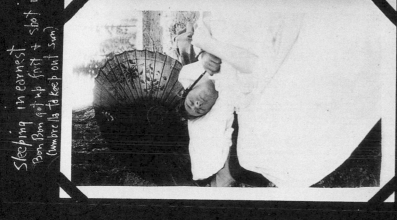

Big Bear

Yes—this really is papa. Getting ready for
sleep after all nite ride up into Grade.

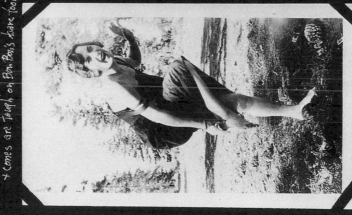

Ouch! Those pine needles
+ cones are tough on Bon Bon's bare tooties

Getting ready for bed.

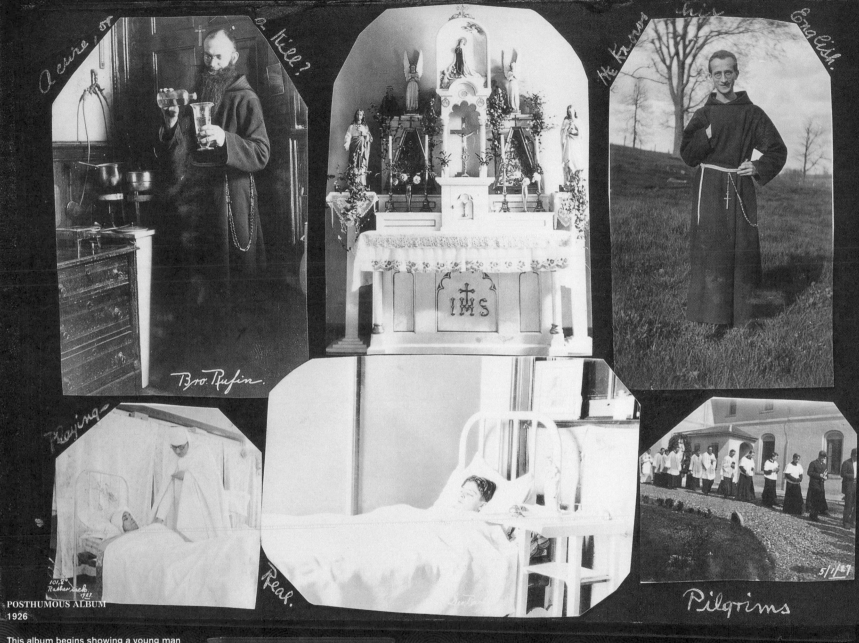

A cure, or to kill?

Bro. Rufin.

He knows his English.

Praying

Real.

Pilgrims

5/1/27

POSTHUMOUS ALBUM
1926

PHOTOGRAPHS

This album begins showing a young man named Hugo Husling and his educational life at a Christian College. The text identifying fellow students and elder priests is often comical and the photographs present an intimate and charming window into life at a religious college in the 1920s. At the very end of the album it is quite shocking to read from a photograph and a newspaper clipping, that the young man we just became familiar with accidentally drowned at the age of 22. We learn from this page that the album was put together lovingly by Mrs. Husling after her son's tragic death.

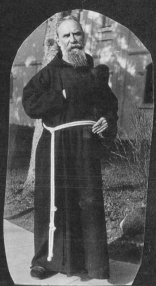

The Big Boss

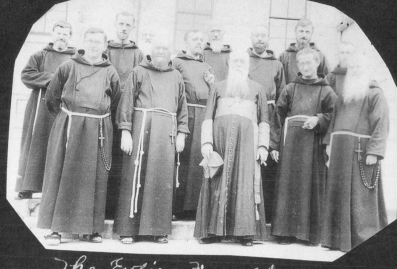

The Entire Faculty
- Wise Men -

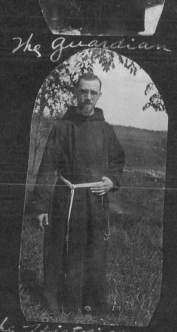

The Guardian

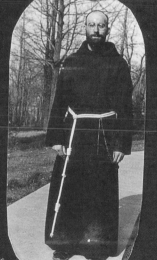

Latin Prof.

The "Refectory", couldn't
get along without it.

The Historian

Bazaar - Oct 24-25-26.
1926.

Bazaar - Oct 24-25-26.
1926.

Money Makers

Museum.

Where we
gambled away
our pin money

"Books on Books"

Kitchen!

The trak workshop.

Museum 1927

Culina - A.G.M. - 1927

Full of whatnots.

Museum.

Museum - 1787.

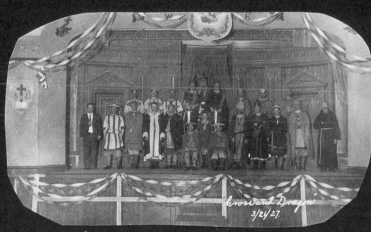

"Crossland Dragon"
3/24/27.

Theatrical Troupe

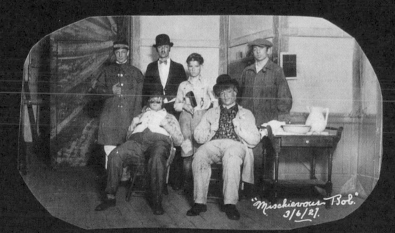

"Mischievous Bob."
3/6/27.

A Comical Half Dozen

Sept. 3, 1933

Merciful Jesus, grant him eternal rest.

Gone all too soon
But at Peace forever

Born April 22, 1910
Died Sept. 3, 1933

Odin Community Shocked by Tragedy

Odin, Kan., Sept. 6.—This community was shocked Sunday afternoon by the drowning of Hugo Huslig, aged 23, in a small but deep lake four miles south of Odin. The tragedy cast a pall over the parish.

Hugo and seven companions of his age went for a swim after their Sunday dinner. The day was pleasant and quite warm. A swim in the cool water was the alluring thing. But for Hugo it meant the plunge into eternity. He was a fair swimmer, but was seized with the cramps after he had been in the water but a minute or two, and was about half way across the lake. Several young men present made heroic efforts to save their companion from death through drowning, but in vain. The hungry waters closed in over him and he sank in sight of his terror-stricken companions. The body was recovered two hours later by means of a hay rake dragged back and forth across the bottom of the lake. Father Niederpruem, pastor of Holy Family parish, Odin, reached the scene of the tragedy within a half hour after Hugo had gone under and gave the submerged victim conditional absolution.

The funeral and burial were held Wednesday morning. Father Niederpruem was celebrant of the solemn requiem, Father Schaefers was deacon, and Father Beran, cousin of the deceased, was sub-deacon. The Odin church was packed, all available standing room was taken up, but there was not enough room for the overflow crowd. Father Schaefers preached the sermon.

Hugo was a very likable young man and he made friends easily. The large congregation present at the funeral was striking evidence of the high esteem in which Hugo was held in his own and neighboring communities. His was the first drowning tragedy in the parish, and he was the first member of the Odin Knights of Columbus to pass away.

The following are left to mourn his tragic death: his parents, Mr. and Mrs. Joseph Huslig; his sisters, Mary Kinzel, Oliva Boor, Rosie, Albina, Bernadette, and Sister M. Bernadine, O. P., member of the Dominican Sisters at Great Bend; his brothers, Leo, Otto, Joseph, and Dominic.

The Huslig relation is one of the largest in the Odin community, and the relatives from far and near were all present to attend the last sad rites.

Hundreds of rosaries were said by the throngs which poured in and out of the Huslig residence during the days and evenings whilst the body lay in the parlor. Burial was made in the parish cemetery.

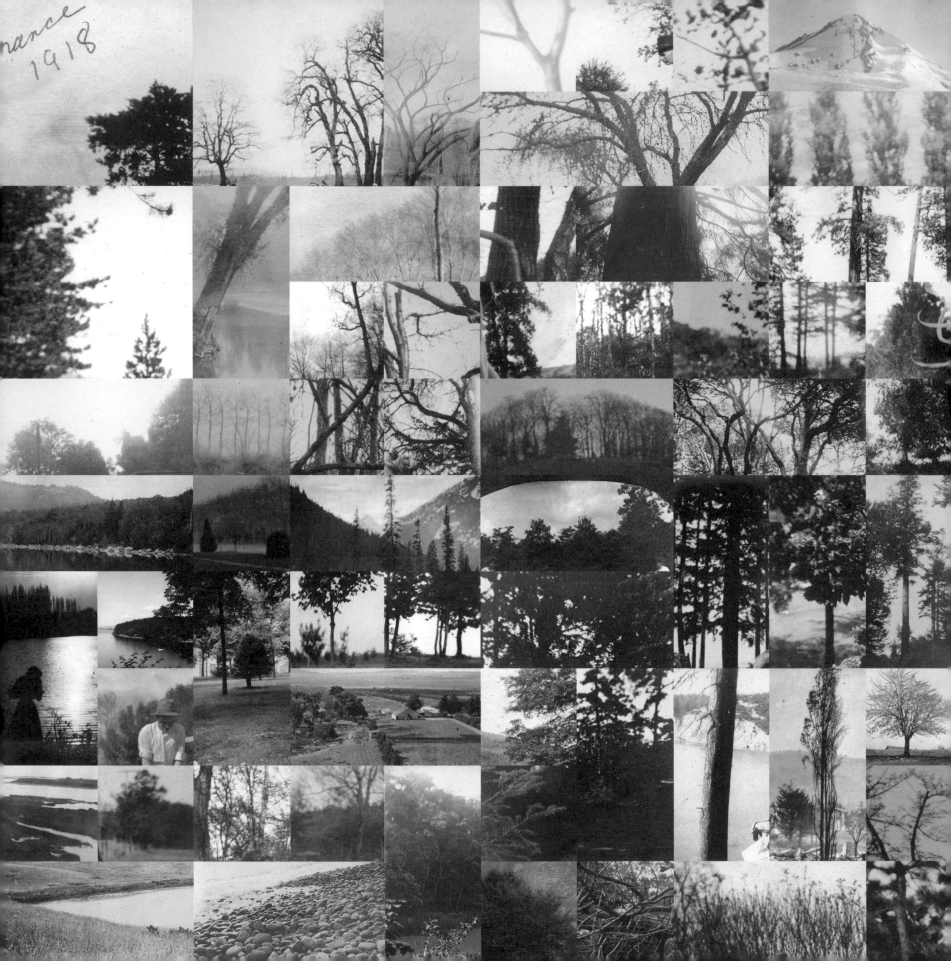

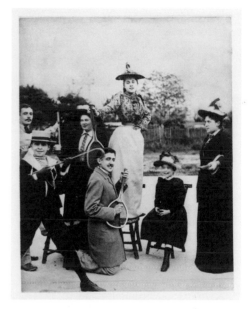

MATTHEW STADLER

◇◇◇◇◇

CONSTANCE CARTWRIGHT, abed with six girlfriends under the white morning sky of Salem, Oregon, puts me in mind of Proust. Surely he would have coveted this snapshot: the marvelous little band of western ladies bundled together like sardines in a tin can. About the time Constance began her album, in the summer of 1904, Proust was ardently pursuing a photograph of Jeanne Pouquet, a young actress whose portrayal of Cleopatra had enchanted him—ten years earlier. "One day," he recalled in a letter to a friend, "I determined to resort to theft." Brassaï, in his remarkable study, *Proust In the Power of Photography,* tells us Proust cornered Pouquet's chambermaid in the linen closet one afternoon and tried bribing her to steal the photo. Alas, to no avail. Then began a convoluted courting of the Pouquet cousins in rural Périgord which, as Proust described it, led him to waste a great deal of time "with some very tiresome people." Years later he wrote to Jeanne Pouquet's daughter, Simone, "I still receive postcards from people in Périgord with whom I made contact in order to get that photo." One afternoon, Simone's mother saw Proust's letter and sent him the snapshot he coveted: a picture of her standing on a chair at a tennis court in Nice, with a timid young Marcel kneeling at her feet, strumming a racket.

◇◇◇◇◇ It is an image that could easily have appeared in any of a number of the albums in Barbara Levine's collection, except of course, for the fact that Proust burned many of his most prized photos when forced to move from his long-time residence on the boulevard Haussmann. Having used the photos for his art (Proust kept and habitually scrutinized photos of nearly all the people from whom he drew his characters) he burned them. What drama! What messianic control: a perfect contrast to the fate of these albums, which, despite the care evident in their assembly,

171

MARCEL PROUST AND JEANNE POUQUET, **c. 1894;** *Reproduced courtesy of La Bibliothèque Nationale de France*

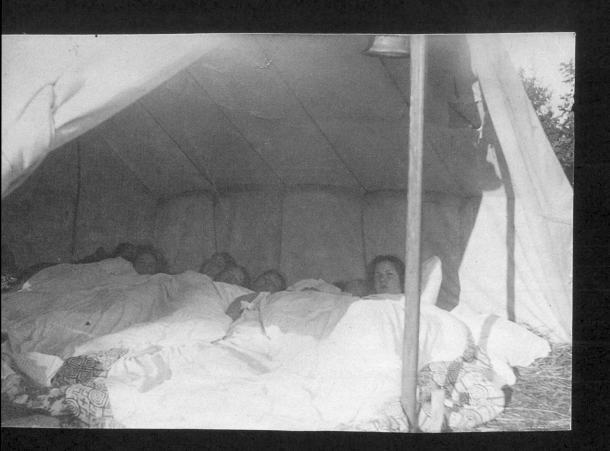

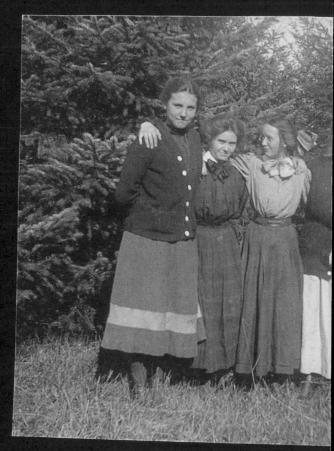

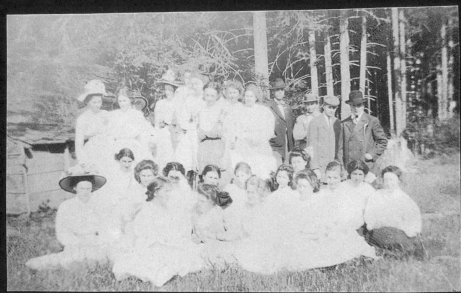

Freshman Picnic
June, 1909

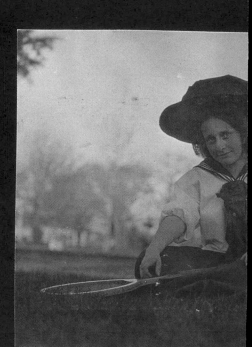

escaped their makers and, in the end, went missing. They arrive in our view through accidents of neglect or misfortune, dislodged from their origins. This pitched dichotomy—the supreme importance of these albums in the moment of their making and the ultimate indifference of their fate—marks them as peculiar changelings. They are not objets d'art, but something less fixed or permanent, floating free of authorship and ownership.

◇◇◇◇◇ The advent, in 1900, of the portable fixed-focus camera brought photography into the lives of a broad public who made their own photos and put them together as albums. Efforts to standardize and train this vast community of amateurs began in publications such as *Kodakery*, Eastman Kodak's monthly circular of home photography dos and don'ts (first published in 1913). Early issues of *Kodakery* asked such self-serving questions as "why not photograph in winter as well as in summer and spring?" Examples included baby albums recording beloved infants at every month of their growth and practical advice on lighting and cropping, all to promote a more standardized snapshot aesthetic. But not everyone subscribed to *Kodakery*. In large part, these publications did not prescribe forms so much as they simply tried to keep up with the profligate innovations of users, cataloguing the ways the photo album evolved in the hands of an enthusiastic public.

◇◇◇◇◇ Many lessons had been learned from the sixty-odd-year history of professional photography and many more from the traditions of painting. But photo albums—even more so than the individual snapshot itself—presented legions of amateurs with a new form that, in our day, might be roughly analogous to the simplicity and variety of the web log, or blog. Like web logs today, the photo album put a broadly familiar medium into the hands of innovators who had little to guide them except the examples of fellow makers. The snapshot album existed in the same relation to professional photography as the web log exists in relation to conventional journalism. And just as surely as a "snapshot style" became codified and adopted by professionals who coveted its aura of authenticity, so, too, the mainstream media today cultivate a "blogger" style, seeking street credibility for many of their transmissions.

◇◇◇◇◇ Proust acquired photos, rather than actually taking them himself. His own portraits were shot by Otto, a Parisian photographer recommended to him by Robert de Montesquiou, the mannered aristocrat whom Proust immortalized as the Baron de Charlus in his great novel, *A recherché du temps perdu*. Proust would trade Otto's portraits for the pictures he desired. De Montesquiou, who shared Proust's acquisitive mania, proved to be a nearly intractable mark. Proust met the older man when he was just twenty-two and immediately asked for a photo, which

de Montesquiou was slow in providing. "I await your photograph impatiently," Proust wrote in a letter to his already-famous friend. And later "Since 'one does not send a photograph through the post,' since I am not expected to call on you until Easter or at the earliest New Year's Day, and since two of your friends, Madame Lemaire and Princess de Wagram have done me the honour of inviting me this week, would you be so kind as to bring me the said photograph, promised but impossible to lay hands on, on Thursday or Saturday, to the rue de Monceau or the avenue de l'Alma." One can imagine the power and meanings exchanged when the photo was finally given.

◇◇◇◇◇ Odette, mistress of the socially ambitious Charles Swann in Proust's tale, also has her portraits taken by Otto, but for Swann these paled beside the allure of a snapshot. Proust reaches back to his own fascination with the tennis-court picture of Jeanne Pouquet when, in the novel, he writes "the 'touched-up' photographs which Odette had taken at Otto's, in which she queened it in a 'princess' gown, her hair waved by Lenthéric, appealed less to Swann than a little snapshot taken at Nice, in which, in a plain cloth cap, her loosely dressed hair protrud[ed] beneath a straw hat trimmed with pansies and a black velvet bow."

◇◇◇◇◇ In another instance Proust describes the central figure in a snapshot as "caught in a pose between stillness and motion"—which is precisely where we find the now anonymous hero of "the logger album," the photos of which span from 1903 to 1919 (pages 97–109). The logger album is a compendium of painstakingly arranged taxonomies of subjects that include felled logs, horses, sporting events, chums, and women. It also suggests a narrative as broadly satisfying as that of a novel. Carefully painted, filigreed borders delineate and charge each photograph, each relation. An early page centers on a stout, cheerful man in bowler hat and broad cloak—our hero. Legs set wide, he is caught in a candid moment of both confidence and utter vacancy. Around him we see orchards, a great stone house, harvested apples, and a second man, cropped in silhouette, crouching beside a packing crate of fruit. The house is empty, a defenseless shell prone on the page, available to our every projection. The two men—unknown to us, now most certainly dead—are also vulnerable; dislodged from their own histories and biographies, they stand before us as great empty dwelling places.

◇◇◇◇◇ Strangely, their vacancy, like a vacuum, empties the viewer, too, and the ghosts of their intimates flood into the space that has blossomed inside us, so that we become, almost involuntarily, instruments through which the dead once again fix them in their sights. Our attention is keenest then—when we recede and relinquish our eyes to these missing lovers. Beckoned by the photo one becomes, as Proust puts it, "the spectator of one's own absence."

◇◇◇◇◇ The photo (and, in particular, the snapshot) disables this paralyzing habit of mind by refiguring flux—what Marcel calls "the animated system, the perpetual motion of our incessant love"—into a series of arrested moments. Fragmented or titrated by this technology, living beings become strange and alien, evacuated. The same effect can be engineered in writing. In a letter to a friend, in December of 1915, Proust reflects on the "disintegration" that his textual strategies wreak on his characters: "A great weakness, no doubt, for a person to consist merely of a succession of momentary flashes; a great strength, also…. Disintegration not only makes the dead person live, but multiplies him." In the face of such motions, our love collapses, allowing our eyes to see, as if gazing upon the dead. "Every habitual glance," Marcel tell us, "is an act of necromancy." The snapshot album is a series of such glances.

◇◇◇◇◇ The logger album unfolds like a great novel, through characters and settings. On page two we meet our hero. On page five we find Multnomah Falls, on the lower Columbia River, about twenty miles East of Portland, Oregon. Page three gives us Mt. Lowe and the Echo Mountain funicular, and page four a new bridge under construction next to a horseshoe waterfall. The Kalispell Flour Mill is visible above the falls. The vacant man who stands so confidently on page two is clearly in Walla Walla, Washington. Later he will attend college in nearby Pullman, and join the ROTC on the eve of World War I. Like Proust's novel, the logger album is haunted by the specter of this war.

◇◇◇◇◇ The album gives us everything in sets or a series. On page six there are ten pictures of men: eight wear hats, three do not; three have watch loops on their belts, one engraved with a "W." The hatless man alone in the middle grins, wielding an enormous iron skillet. These men are bordered in spare, modernist frames drawn in white ink, we imagine, by the hand that placed the photos (page 98). On page eight we find twelve pictures of women: two in pairs, with two Annie Oakleys aiming their pistols. The borders around the women are of filigreed scrollwork, featuring swags, pedestals, and leaf patterns, again in fine, quivering white ink (page 99).

◇◇◇◇◇ Children and animals inhabit the space, as do deep still waters, cataracts, and charred forests. The views of water, or, later, of trails, mountains, and rail lines, emerge in cinematic sequences. The camera moves across the landscape, stealing fixed moments from the dynamism of life. This same effect is scattered throughout the chapters of Proust's novel, emerging as a clearly deliberate strategy, an imitation of the pleasure he knew best from photo albums. Approaching Saint-Etienne by automobile, Marcel narrates a sequence born easily, seamlessly, from the seriality of contemporaneous albums: First, the twin steeples of Saint-Etienne; then a third, as the steeple of Saint-Pierre joins them; and then a single tower (of the two at Trinité) appears; soon, "between the multiplied steeples," the town spreads out; and then, "the complicated but explicit fugue of its roofs." Brassaï maps a total of ten snapshots in this cinematic sequence, and alludes to three related scenes. The reader of Proust can find at least a half-dozen more. It should come as no surprise. At the time, cinema was already shaping literary texts by many writers. Brassaï maintains that Proust took this photo-cinematic capacity even further, to suggest a more philosophical, scientific relativity.

◇◇◇◇◇ Proust continually juxtaposed contrasting portraits as one might a series of snapshots, refracting a single subject through what emerged as a kind of kaleidoscopic sensibility. This had the effect of liberating the subject from that "dynamic system" that the character Marcel called "the perpetual motion of our incessant love," and transforming it into a sequence of estranged or evacuated snapshots, ones that demonstrate how any one thing is simultaneously many others. Brassaï, indeed many commentators (from as early as the 1920s), link this sensibility to the insights of Einstein in physics. Proust sent grateful letters of thanks to some of the critics who hazarded this guess. But it is probably more accurate to link Proust's habits of mind to the dynamics of the snapshot album. The albums refigure the flux of time—not by simulating motion (as in film) nor by mimicking its dynamics but by organizing a kinetic sequence of fixed moments, the analog of Proust's textual strategy.

◇◇◇◇◇ On page twelve of the logger album, men on horseback ride into the mountains. Eight shots repeat this theme, and, in one, we see the men atop sleds hitched to oxen, hauling the equipment of domesticity out into the unwelcoming woods (page 102). Here, the logger album departs from the world of Proust's novel. There will be no shelter where these pioneers are going, no cities, no society. The men will build all of that, willy-nilly, from the materials at hand. And so, while constructing the masculine, these men will also construct the feminine, engineering domesticity on a patch of scorched earth (page 107). The double valance of this common place of North American life echoes some of the slippery nuances of gender in Proust's text—Marcel is preoccupied by feminine men and masculine women, and especially fixes his attention on the doubling that occurs in the son of a beautiful woman or the daughter of a handsome man —but the lawlessness and ease with which the men of the logger album carry themselves through this ambivalent terrain has no parallel.

◇◇◇◇◇ Whatever other forms the makers of these snapshot albums invented, they seem also to have conjured a tremendously pliable and risible ecology of gender, one

174

THE LOGGER ALBUM, 1900

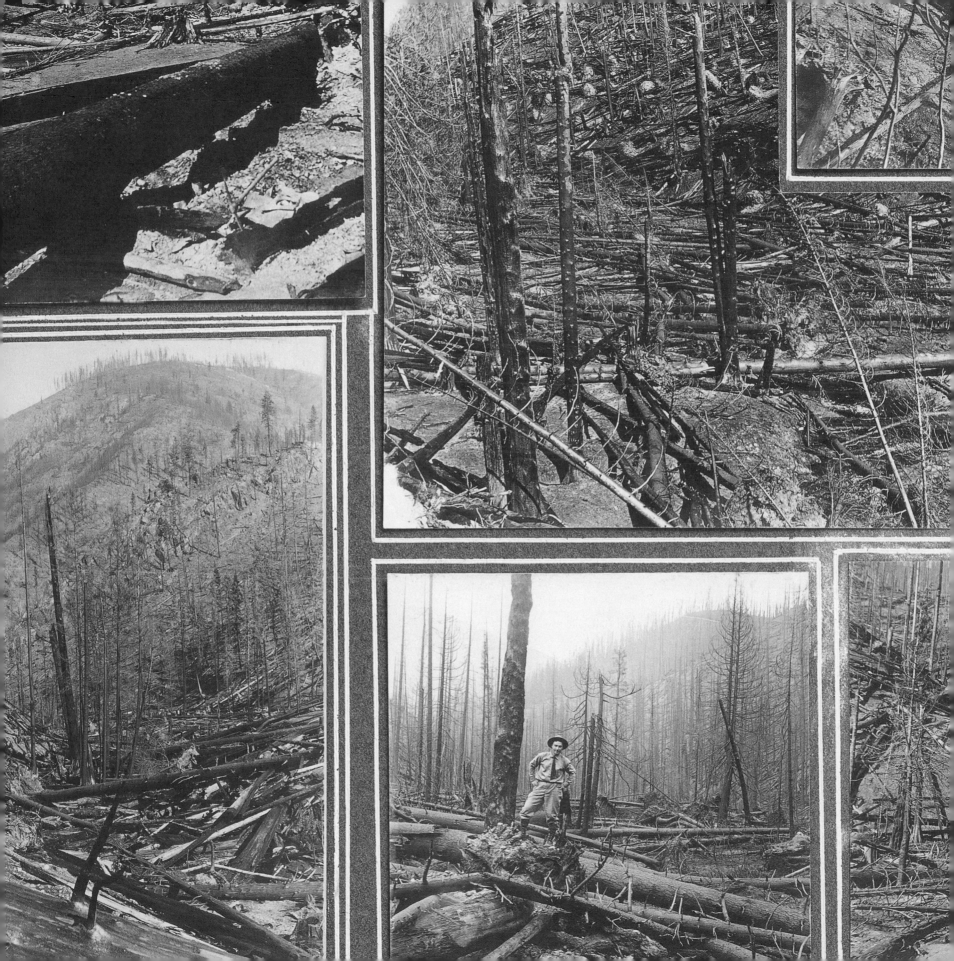

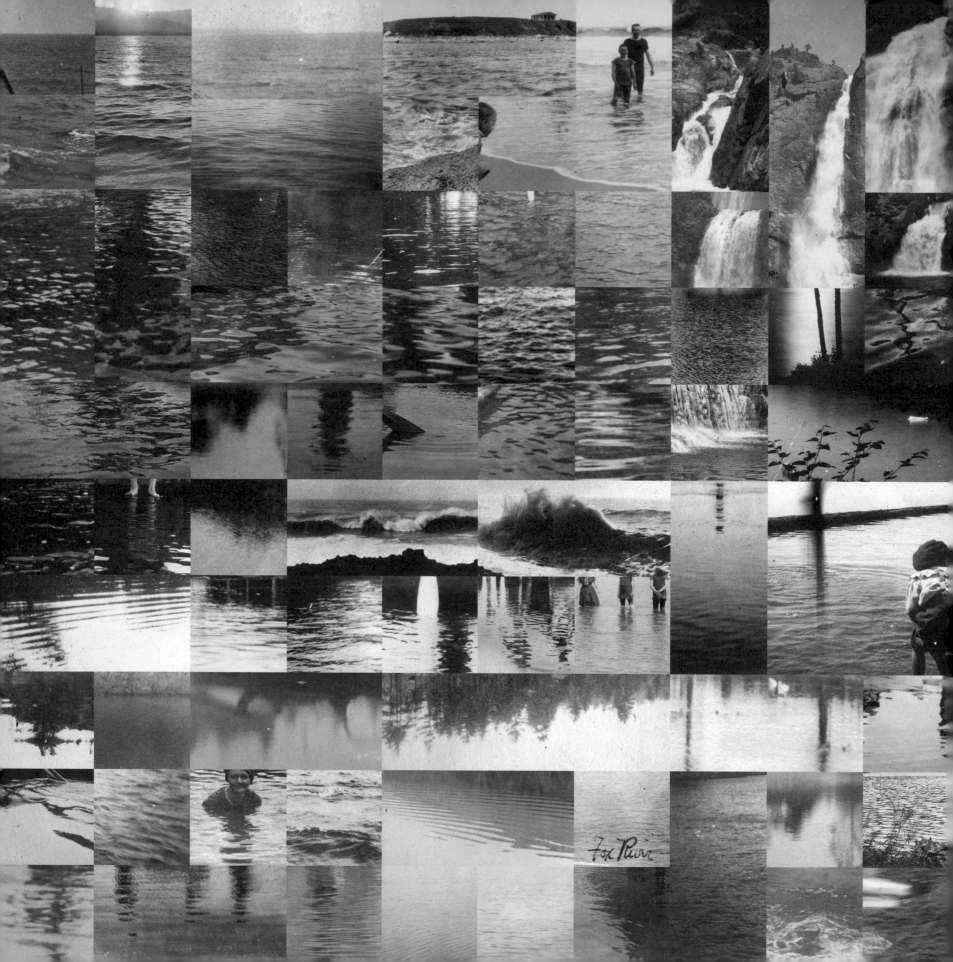

Fox River

distinct from more rigid codes of high art or society. Social dynamics that are strategic, tense, and refined in Proust play out in early American albums as rough-and-tumble picnics among friends. Women in white bloomers clutch cigars. Men lie abed in hammocks, intertwined like vines. A man and a woman, wearing matching aprons and hats, stand in a doorway holding hands. More startling, the narrative trajectories of these pairings are often interchangeable (except for the marriage that awaits many of the two-sexed couples).

◇◇◇◇◇ But the protagonists of the logger album forge deeper into the mountains, effecting greater change. Tracking their expedition within this astonishing record, the camera turns away from human subjects, and continues to deploy the landscape serially, until the solitary figures are reintroduced into a devastated terrain of felled trees and incised earth (page 108). Then, the ersatz city, a hastily thrown-up collection of shacks and facades, logs still wet with the sap of their felling, rises from out of this unpromising chemistry of isolated men and crudely industrialized terrain (page 109). Here, the logger album records the emergence of a built landscape—even a broad cultural pattern—that itself partakes of some of the profligate seriality of the album.

◇◇◇◇◇ The only thing certain is that we don't know these people, and we never will. They are gone, survived by albums. One must reckon with moments of stunning beauty: the ethereal portraits of electrical dynamos; the uncanny triptych of woman, waterfall, and cow; the metal-tipped khaki bootlace that binds the logger album together. But the dynamic constellations of pleasure and temperament that made these—the private persons who placed these pictures on the page: who cut them out as stars, who bordered them with white filigree, who arranged them to spell "CHETUK," who paired friend with friend, who traced the life of a chicken, who grouped sunsets and water and arches, who aligned sawn trees, who turned faces into landscapes, who cropped lovers into baskets, who stole these arrested moments from out of time—are gone now, disappeared. These albums belong to no one.

◇◇◇◇◇ We are left to imagine the careless moment when someone's attention slipped away, and the albums were lost, detached from their origins to float ultimately into the rigorous embrace of this exhibition. You find them here, repossessed, pursued like the treasures Marcel Proust hoarded (and that he ultimately kept from fates similar to these). In our repossession—our ardent regard distilling meanings from the accidental beauty of these remarkable free agents—do we become the new Prousts? Do we take command of that which for so long has eluded mastery, and build, in these pages, the architecture of their final resting place?

◇◇◇◇◇

WORKS CITED

Richard Howard Brassaï, *Proust in the Power of Photography,* trans. Richard Howard (University of Chicago Press, 2001).

Marcel Proust, *Marcel Proust: Selected Letters 1880–1903,* ed. Philip Kolb, trans. Ralph Manheim (Chicago: University of Chicago Press, 1983).

Marcel Proust, *Remembrance of Things Past,* trans. C. K. Scott Moncrief (New York: Random House, 1934).

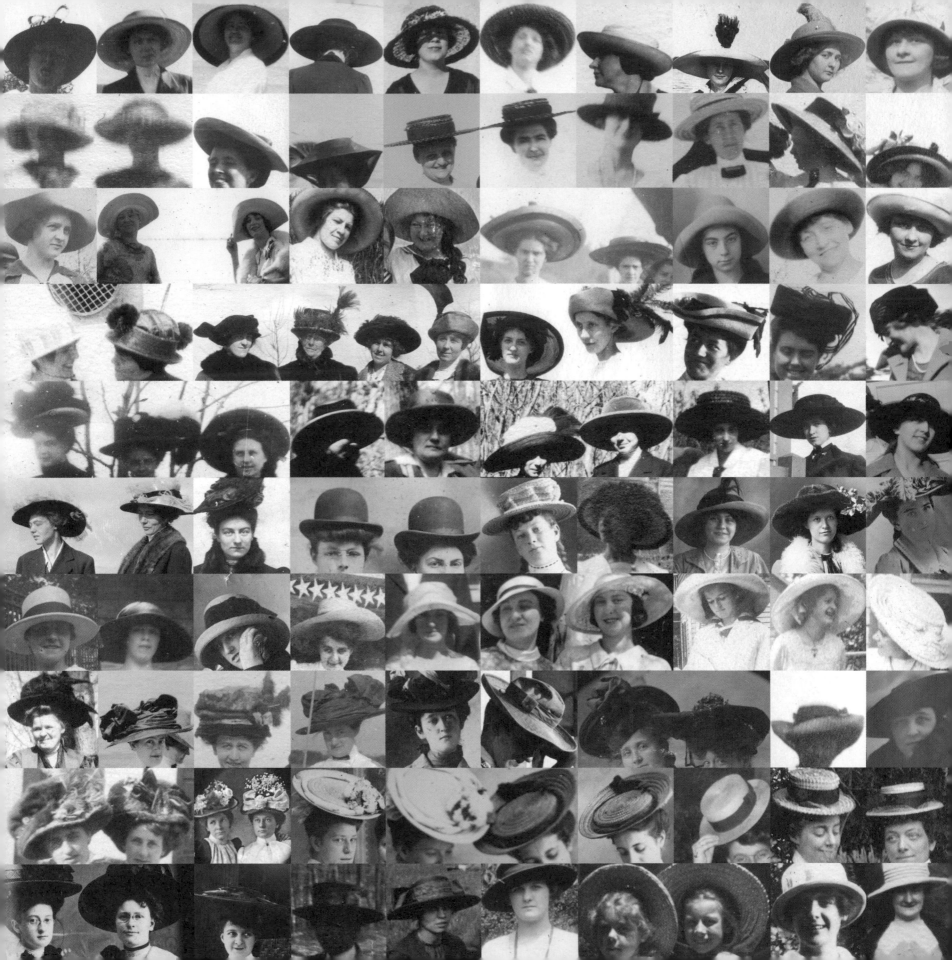

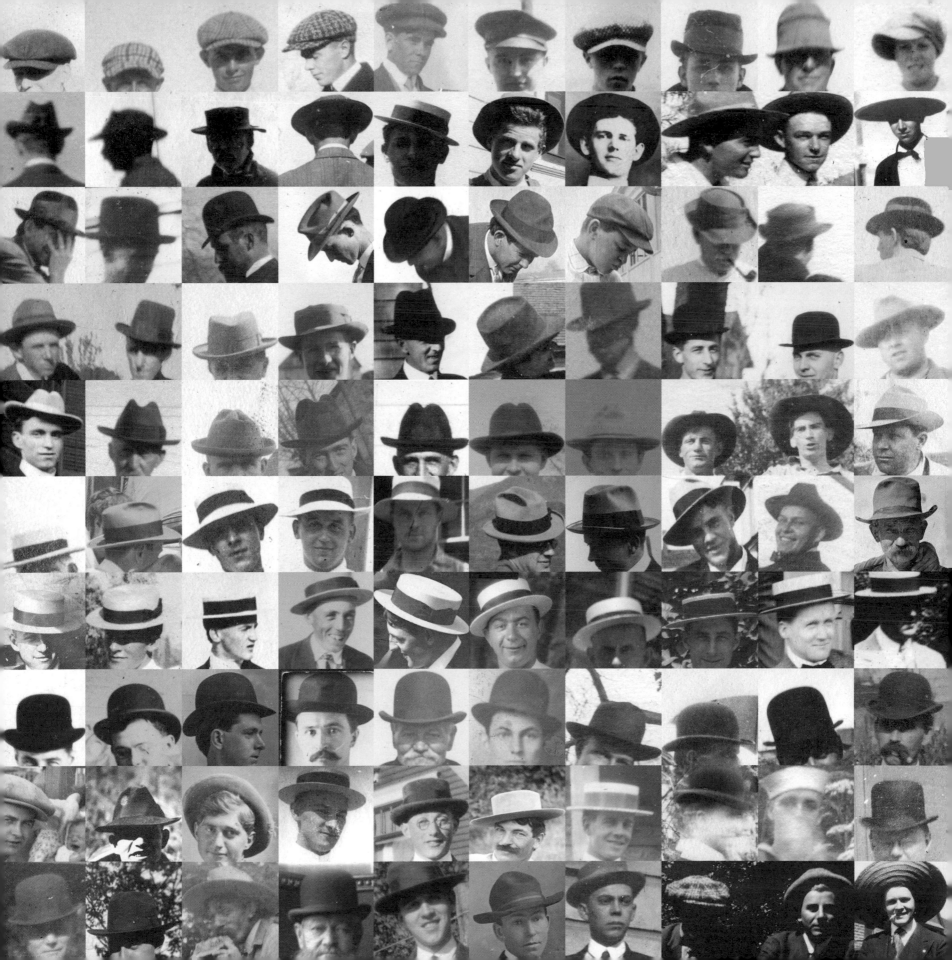

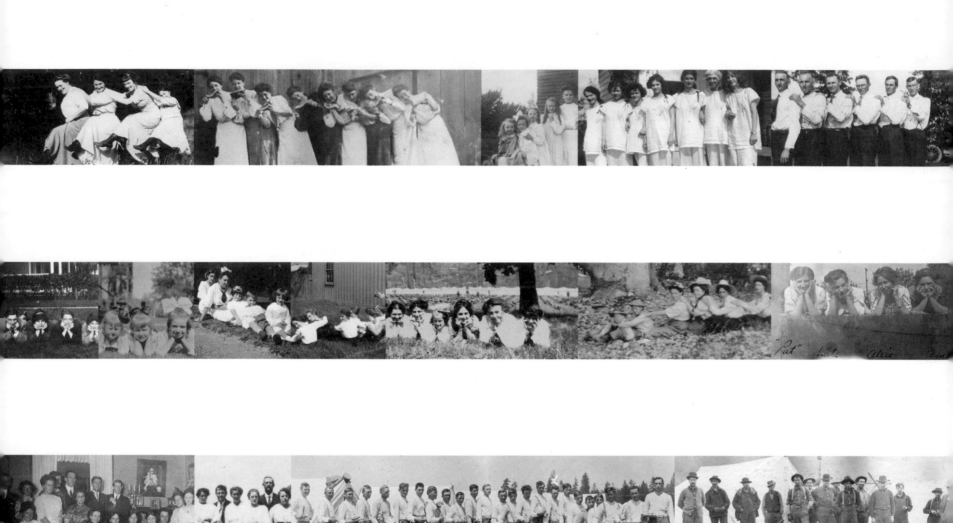

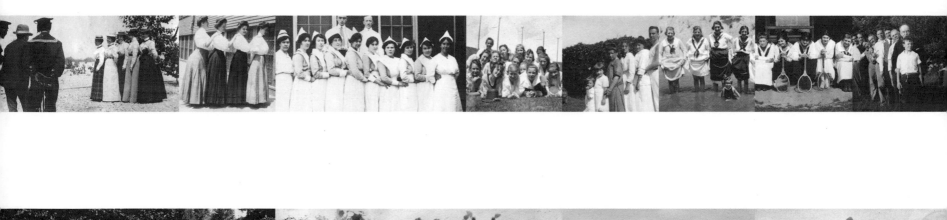

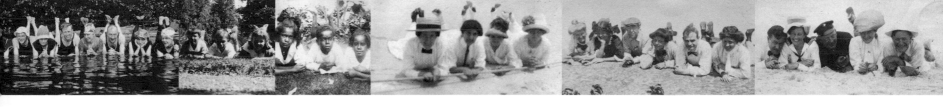

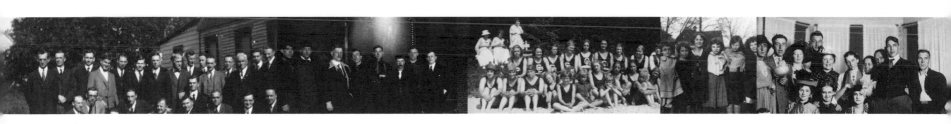

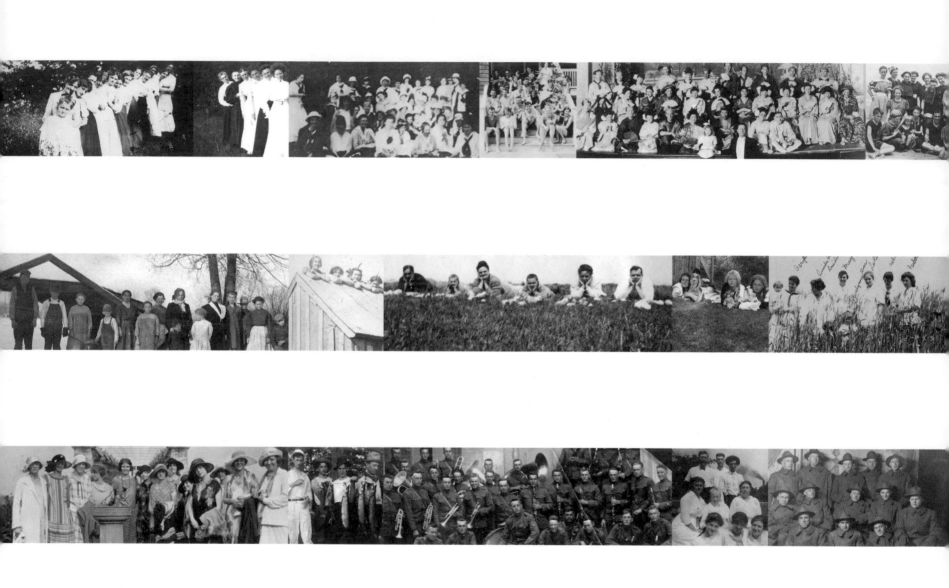

PHOTOGRAPHY'S LOVE CHILD:
ORIGINS OF THE SNAPSHOT

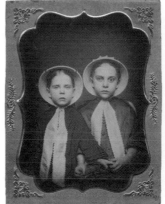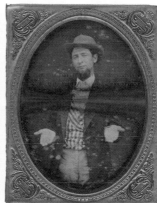

TERRY TOEDTEMEIER

◇◇◇◇◇

NTRODUCED IN 1888, the Kodak camera marked the beginning of a new era in photography: that of the snapshot. Revolutionary as the Kodak camera was, it was nevertheless the logical and inevitable outcome of both technological advances in the medium of photography and growing evidence of the public's desire for self-made photographs. Although the medium of photography was scarcely a half-century old at the time, countless efforts had already been made to simplify the technology of image production so as to make the camera and its recording capabilities more portable and convenient. With each new photographic process, from the earliest daguerreotypes onward, there were correspondingly more and more images that presaged the advent of the snapshot.

◇◇◇◇◇ The children depicted in portrait daguerreotypes are representatives of the first-ever generation of people to have grown up with photography. As suggested by the expressions of the two girls in this anonymous photograph from approximately 1850, the reaction to the new medium was understandably a mix of curiosity and trepidation. Likewise, for scores of practitioners, the process of making daguerreotypes was simultaneously compelling and vexing, as the desire to create diverse images quickly ran up against the limitations of the medium itself. Issues of portability, the difficulties and toxic nature of the process, lengthy exposure times, and expense combined to limit the production of spontaneous or candid images. Yet the desire to make such pictures was there from the beginning.

◇◇◇◇◇ The second generation to live in the age of photography saw rather remarkable changes in the medium. By 1860 the production of glass plate negatives and positive paper prints had become the norm for photographic studios. Although photographers were still dependent upon the darkroom to sensitize their plates, which had to

DAGUERREOTYPES,
left, c. 1850
right, c. 1850

be exposed and processed shortly thereafter, an increasing number of photographs were being made outside the studio with the support of portable dark tents and photographic wagons. Further, multiple copies of a photograph could be printed at a fraction of what a single, in-camera, original daguerreotype had cost. The combination of increased portability, lower cost to the consumer, and the capacity to make multiple prints resulted in a kind of quantum shift in the distribution and assimilation of photographic images. Photographers and publishers began to market images of famous personages, distant places and people, and landmarks and monuments. Though these developments are noted in all histories of the medium, the magnitude of the effect of this explosion of photo-visual information is generally under acknowledged. For the first time in history the visceral experience of seeing things in photographs had become commonplace.

writers and academics, positing the notion that snapshots cannot be made by professional photographers, have all too often disregarded this trend. The images made by professional photographers, it is argued, would necessarily lack a snapshot's "innocence" or naiveté. The notion that the realm of the snapshot is somehow codified by a sacrosanct act of innocence is rather misguided. The snapshot is a spontaneous visual record of an observation deemed, for whatever reason, to be important. Though popularly defined as made by the unskilled and inexperienced, snapshots have and continue to be made people whose perceptions of reality and imaging skills are all over the map.

◇◇◇◇◇ As popular forms of photography continued to evolve through the mid-nineteenth century, there was a correspondingly rigorous advancement "behind the scenes" in the technical capacities of the medium. As early as 1854, a patent for the design of a camera-ready roll of photosensitive

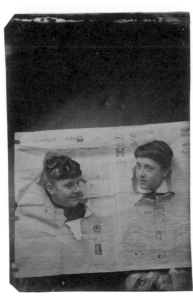 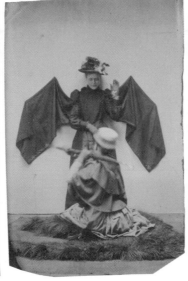 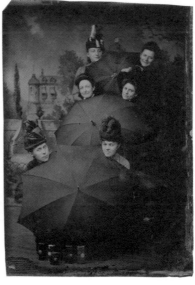 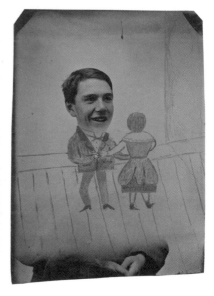

◇◇◇◇◇ Although the means of photographic production remained in the hands of professional photographers and a relatively small number of individuals with the means to support an amateur pursuit, the cost of studio photographs markedly decreased and was an incentive for many people to indulge in frivolous antics not unlike the kinds of joking and penchant for the absurd that would become a hallmark of the snapshot. Often such images were made as tintypes, the least expensive type of photograph then available.

◇◇◇◇◇ Whereas the general public craved the opportunity to make candid and self-defined images, but lacked the means to do so, professional photographers where in a position to act on such impulses. Time and again, these individuals succeeded in making images distinctly removed from the staid and conventional poses of the studio. Some scholarly

paper had been applied for in England.[1] By 1875, the Russian inventor, Leon Warnerke had demonstrated that a newly developed gelatin-based photo emulsion could be applied to a paper-based roll, exposed in a compatibly designed camera, developed and stripped from its paper base, and transferred to a glass support from which finished prints could be made. In the *Photographic News* of June 25, 1875, Warnerke wrote: "Who can with the glass system, dream of taking one thousand plates for his long excursion? But with film, that number or one still larger, would not increase the weight of the traveller's [sic] luggage by more than a few ounces, and by few inches in volume."[2] The process Warnerke had advanced was identical to the one that George Eastman would employ to process roll film negatives from the first Kodak cameras in 1888.

1 Brian Coe, *Cameras— From Daguerreotypes to Instant Pictures* (Gothenburg, Sweden: AB Nordbook, 1978), 79–80.

2 Ibid.

3 Ibid.

4 Stirn camera newspaper advertisement (source unknown): collection of the author.

5 Letter by H. F. Kellogg, Portland, OR; collection of the author.

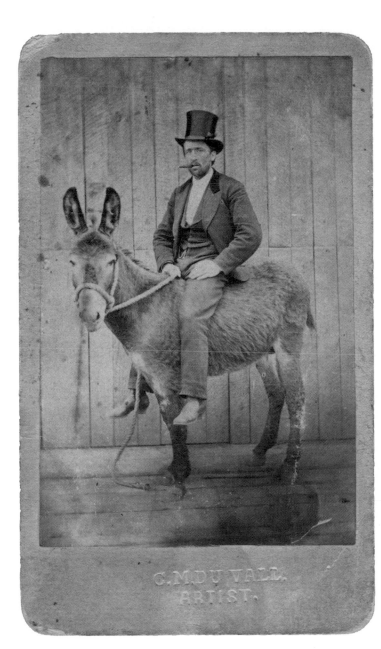

MAN ON BURRO,
c. 1872–74

opposite, from left
TWO WOMEN
POKE HEADS THRU
NEWSPAPER, 1888

WOMAN IN BAT
COSTUME, c. 1880s

SIX WOMEN PEERING
FROM UMBRELLAS,
c. 1880s

ARCADE PHOTO,
c. 1880

◇◇◇◇◇ In 1884, George Eastman working with camera manufacturer, William H. Walker, also of Rochester, New York, designed and produced a precision, paper-based roll-film holder that could be used with existing camera systems.[3] Though other roll-film designs had preceded the Eastman-Walker system, theirs was the most popular and commercially successful alternative to glass plate photography. In an attempt to produce a camera that was relatively small and dedicated to the use of roll film, Eastman devised the design for a "detective camera," a hand camera that could be used rather inconspicuously. Although the camera Eastman produced proved too expensive to profitably manufacture and was subsequently abandoned after only fifty examples had been made, it was the last in a series of efforts that led to the development of the legendary Kodak. It is noteworthy that Eastman had targeted the detective camera as a model for the mass-market camera he had hoped to produce. Portable and stealthy, detective cameras were novel, and their use epitomized the private appeal of self-directed picture making.

◇◇◇◇◇ Of the several designs of detective cameras available in the 1880s, perhaps the most notable was C. P. Stirn's Concealed Vest Camera, introduced in 1886. The camera was a slim (one inch thick), disc-shaped device, five and a quarter inches in diameter and flat enough to be held against the chest, under a vest or coat. As stated in an advertisement from 1888, the Stirn "Takes 6 sharp instantaneous pictures without a change of plate."[4] The Stirn camera held a single circular, glass, gelatin dry plate, 140 millimeters in diameter. With the lens mounted near the top of the camera, six images, 40 millimeters in diameter, could be exposed by sequentially rotating the plate for each successive exposure. Though essentially an expensive novelty, the Stirn camera appealed to the proto–snap shooter who, like the legions to follow, sought to record their private impressions of day-to-day life in photographs. One such individual was Herbert F. Kellogg, secretary of the Standard Building and Loan Association of San Francisco, an avid amateur photographer active from the 1880s through the 1910s who was ever eager to try the newest and most interesting of portable cameras. Kellogg's pictures span the point in time when Eastman's legendary Kodak was introduced.

"In those days we did not have the fast lenses and films of today, but in the bright sunshine of California, on the streets of San Francisco or on the ferry boats crossing the bay, one could pick up studies of the wily Chinee [sic], lady shoppers or high hat business men, without fear of detection. The horse and buggy days were still with us, and I went so far as to snap shots from the back of my cow pony as she walked along."[5]

Herbert F. Kellogg, Portland, Oregon, January 1940.

185

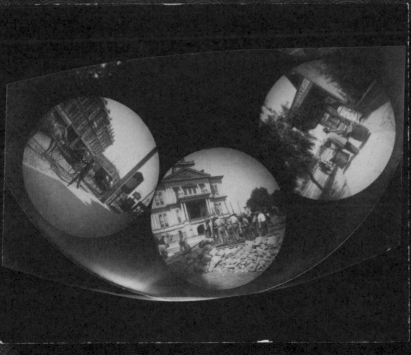

ZINE ADVERTISER.

C. P. STIRN'S
(PATENTED)

Concealed Vest Camera.

Newest PHOTOGRAPHIC INVEN-
TION. Takes 6 SHARP INSTAN-
TANEOUS PICTURES without a
change of plate.

This Camera is carried under the coat or vest invisible
to the eye.
Stationary or moving pictures taken unbeknown to
the object.
Lens always in focus.
Fine Nickel-plated Camera in Handsome Box with 6
plates, for 36 pictures for Camera No. 1, or 24
larger pictures for Camera No. 2.

Nickel or Oxidized, Camera No. 1, each . . . $10.00
Magic Lantern Size, " No. 2, " . . $15.00
Every Camera Guaranteed Perfect.
No Tourist, Artist, or Student, Amateur or Professional,
should be without this Camera.

C. P. STIRN'S Latest: CAMERA AMERICA
(PATENTED).
24 Time or Instantaneous Pictures without change of Plate.

Price, complete, $25.00 each.

FOR SALE BY
STIRN & LYON,
Sole Agents for the United States and Canada,
20 Park Place, New York, U. S. A.
AND ALL THE LEADING PHOTOGRAPHIC STOCK DEALERS.
Descriptive Price-List and Specimen Photo mailed free
on application. Canvassers wanted in
every Town and City.

clockwise from top
**A KELLOGG KODAK
NO. 1 PANORAMIC
PHOTO OF THE
SAN FRANCISCO
EARTHQUAKE, DORE
STREET, 1906**

**STIRN
CONCEALED VEST
ADVERTISEMENT,
c. 1888**

**STIRN CAMERA
CONTACT SHEET BY
KELLOGG AND AN
ENLARGED IMAGE,
c. 1880s**

opposite
**KODAK #1 PHOTO
AND REVERSE SIDE
SHOWING IMPRINT,
c. 1890**

6 Brian Coe and Paul
 Gates, *The Snapshot
 Photograph: The Rise of
 Popular Photography
 1888–1939* (London: Ash &
 Grant, 1977): 17.

7 James E. Paster, "Advertis-
 ing Immortality by Kodak,"
 History of Photography
 (Summer, 1992) Vol. 16,
 No. 2: 135–139.

◇◇◇◇◇ Whereas Kellogg's enthusiasm for roll film and small box cameras required no encouragement, such devices were not particularly popular with the vast majority of professional photographers who made up the bulk of the photographic market. Seeking a new and potentially far greater market, George Eastman designed to capture the interests of the public at large: those who wished to create their own images but had little if any interest in photographic processing. Effectively reaching this market was less a problem of providing cameras than of providing support services. When Eastman registered the trademark name "Kodak" on September 4, 1888, he not only introduced a new camera but an entirely new service industry, one that could provide photo processing worldwide. Heralded by the now famous slogan: "You push the button—We do the rest," the Kodak was a camera that virtually anyone could operate and that was supported by an industry dedicated to pro-

straight and press a button…with an instrument which altogether removes from the practice of photography the necessity for exceptional facilities, or in fact, any special knowledge of the art. It can be employed without preliminary study, without a darkroom, and without chemicals."[6]

◇◇◇◇◇ Eastman cultivated the amateur market with a variety of advertising strategies that underscored the ease with which Kodak cameras could be operated and their ability to "stop time, capture moments and relive the past."[7] The Kodak camera, unique in the marketplace, allowed a new generation of casual picture takers the opportunity to record once-in-a-lifetime events in photographs that would outlive their makers—in essence: pictures in pursuit of immortality.[8]

◇◇◇◇◇ By the end of the nineteenth century a wide variety of Kodak roll film cameras were available to the public. In 1898 the *British Journal of Photography* estimated that more than 1,500,000 film cameras were in use worldwide.[9] The following year Eastman's chemist, Henry Reichenbach, pioneered the breakthrough discovery of a flexible, clear nitro-cellulose film that could be used as a base or substrate for gelatin emulsions. All subsequent Kodak cameras were designed to use cellulose-based film. Initially the film required loading and unloading in darkness, but protective leaders were soon added to roll film enabling users to load and unload their cameras in daylight. The last remaining hurdle in making photography accessible to everyone was the cost of the camera itself. Eastman wanted to market a camera that was inexpensive enough that even children could enjoy making photographs. In 1900 he introduced a simple box camera called the Brownie, which sold for the unprecedented low price of one dollar. Immensely popular, 100,000 Brownie cameras were sold in the first year of production.

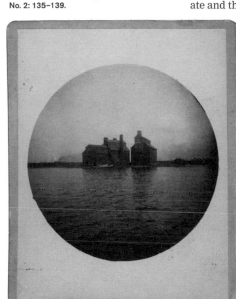

8 Ibid.

9 Brian Coe and Paul
 Gates, *The Snapshot
 Photograph: The Rise of
 Popular Photography
 1888–1939* (London: Ash &
 Grant, 1977), 21.

10 "The American Snapshot—
 An Exhibition of the Folk
 Art of the Camera—March
 1 to April 30, 1944" (New
 York: The Museum of
 Modern Art); exhibition
 brochure from the collec-
 tion of Tom Robinson.

cessing and printing the negatives it produced. Preloaded, the Kodak #1 camera allowed the user to sequentially capture one hundred latent images. Once the end of the roll was reached the camera was mailed back to the Eastman Company in Rochester, New York, where the film was removed and the camera was reloaded and sent back to its owner. Five to ten days later, after the paper-based negative stripping film had been developed and printed at Eastman's facilities, one hundred card-mounted prints were shipped back to the customer. In Eastman's own words:

"The principle of the Kodak camera is in the separation of the work that any person whomsoever can do in making a photograph, from the work that only an expert can do…. We furnish anybody, man, woman or child, who has sufficient intelligence to point a box

"The snapshot has become, in truth, a folk art, spontaneous, almost effortless, yet deeply expressive. It is an honest art, partly because it doesn't occur to the average snap shooter to look beyond reality, partly because the domain of the camera is in the world of things as they are, and partly because it is simply more trouble to make an untrue picture than a true picture."[10]

Willard D. Morgan, Director, Department of Photography,
The Museum of Modern Art, 1944

◇◇◇◇◇ *The American Snapshot* exhibition presented by the Museum of Modern Art in the spring of 1944 serves as a kind of benchmark or historic beginning point in the appreciation of the snapshot as an expressive medium by a major cultural institution. Drawn from the collection of the Eastman Kodak Company, the exhibition presented

the snapshot as a universal visual language punctuated by images with particular beauty and transcendent appeal. The capacity to create snapshots was little more than a half-century old at the time of *The American Snapshot* exhibition, yet the sheer quantity of cameras in use was, by any estimation, enormous. In the "Notes and News" column of the November 1948 issue of *American Photographer* there is a reference to a survey made by *American Magazine* to "a cross-section of their 2,480,000 reading families" that drew the following conclusion: "It would seem from this survey that John Gunther's estimate of 20,000,000 cameras in use in America (*Inside U.S.A.*), is too small."[11]

◇◇◇◇◇ The expressive qualities of the snapshot, and the multitude ways in which they reflect individual and cultural values, has been of growing interest to collectors—a trend that has been gaining momentum for several decades. In the mid-1970s, as photography garnered increasing cache in the art world, a new wave of collectors emerged with an obsessive interest in snapshots as an unbridled form of photographic expression—evidenced by such publications as *Drugstore Photographs* and *American Snapshots*.[12] Over the past decade, the trade in snapshots and real photo postcards in the collecting community has mushroomed. Collectors report the appeal of snapshots as a seemingly never-ending source of contemplation, finding in their spontaneity and lack of edifice an honesty of expression and an aesthetic richness that kindles the imagination. Further, as the prices of fine art photographs have risen to levels increasingly beyond the reach of the average individual, snapshots continue to be relatively affordable and widely available.

◇◇◇◇◇ It is often the case, particularly with early examples, a snapshot album results from the efforts of a single individual who may have made all or most of the images. To this end an album provides insight into the interests and aesthetic sensibilities of its maker or makers. Extracting an individual snapshot from an album, for whatever reasons, is to remove it from this interesting and informative context. *Snapshot Chronicles,* unlike other snapshot exhibitions before it, breaks new ground by presenting whole, unedited albums. Though the problem of displaying these objects in an exhibition poses difficulties not encountered in traditional presentations of framed works, the efforts are well worth the trouble. In their varied forms and character the albums in *Snapshot Chronicles* are unadulterated records of their makers, edited only by the people who made them.

◇◇◇◇◇

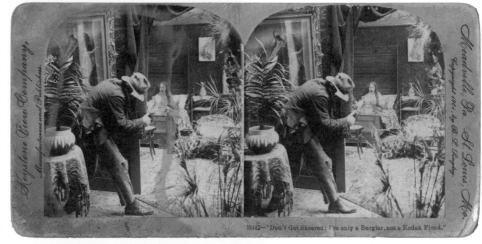

11 "News and Notes," *American Photographer* (Boston: American Photographic Publishing Company, 1948) Vol. 42, No. 11: 732.

12 *Drugstore Photographs—Snapshots from the Collections of Christopher Rauschenberg and Terry Toedtemeier* (Portland, OR: Pair O'Dice Press, 1976); Ken Graves and Mitchell Payne, *American Snapshots* (Oakland, CA: Scrimshaw Press, 1977).

UNTITLED, THE
AUTHOR AS A BOY,
c.1950

opposite, from top
MOMA BROCHURE
COVER, 1944

"DON'T BE SKEERED,
I'M ONLY A BURGLAR,
NOT A KODAK
FIEND," KEYSTONE
VIEW COMPANY
STEREOVIEW, 1901

FROM *DRUGSTORE
PHOTOGRAPHS*, 1976

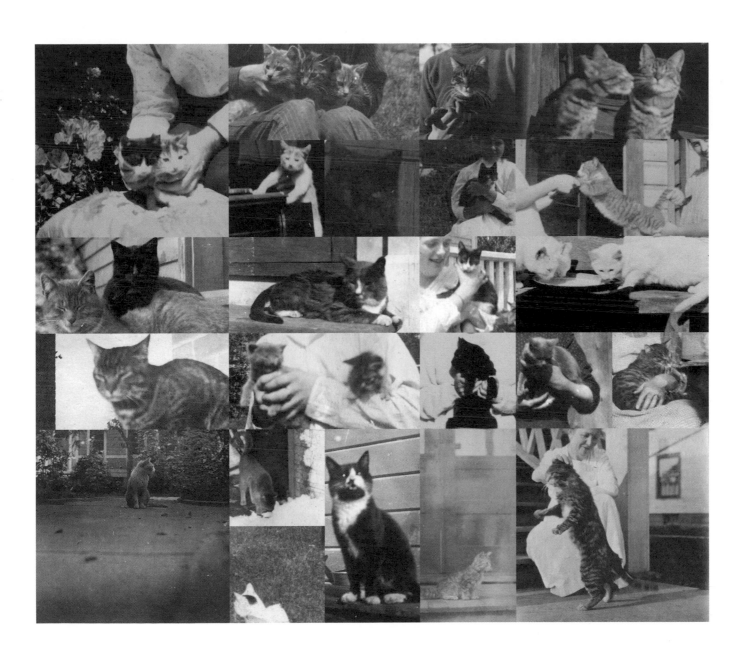

ACKNOWLEDGMENTS

HE PURSUIT of this publication and exhibition has been in and of itself a page-turning story. For years I have gone regularly to flea markets and rummage sales hunting for anonymous snapshot albums. My studio and garage are always overflowing with albums and you can always find me by following the bits of crumbled black paper that seem to always be falling out of them. Only recently with the idea of this project have I begun to share my collection with others, and I have been surprised, and overwhelmed at times, by the variety of people inspired and mesmerized by these old photo albums. Every step along the way of this project has been an exciting and humbling experience filled with generous, talented friends, family, and colleagues without whom *Snapshot Chronicles: Inventing The American Photo Album* would have never materialized.

IN MEMORY OF
ANN WOOLF

◇◇◇◇◇ For her belief in the idea from its inception and her dedication to making the best possible exhibition and publication I want to thank Stephanie Snyder, the director of the Douglas F. Cooley Memorial Art Gallery at Reed College. Stephanie generously embraced a collaborative process on this project and through her intelligence and reverence for the artistry of the albums took the project to new levels of meaning. For championing me and supporting the full potential of this project, I am grateful to Lesli Cohen and the Cohen Family Fund. Thank you to both Jennifer Thompson and Clare Jacobson at Princeton Architectural Press for being such wonders to work with and being commited to this book.

◇◇◇◇◇ I am grateful to my collaborator and friend of twelve years, Stephen Jaycox. Among so many invaluable contributions to this project, Stephen astutely suggested that Martin Venezky would be the perfect graphic designer for this publication, and he was right. Martin has created a rich visual world for these albums from the past, and as a result they speak to us powerfully in the present. Together Martin and Stephen, along with Steven Feuer, interpolated the language of the albums into an exhibition design that animated the album pages from the confines of their covers.

◇◇◇◇◇ For their insights and masterful writing thanks to essayists Terry Toedtemeier and Matthew Stadler. Special thanks to Frish Brandt for a wonderful dialogue that resulted in our collaborative essay for the catalog. For their interest early on, unwavering support, and help throughout, thanks to Clara Basile, Naomi Epel, Ellen Ullman, Elliot Ross, Peter Stein, my snapshot pals Robert Jackson and James Lamkin, Alan Rapp at Chronicle Books, photographer extraordinaire Dana Davis, scanner magician Melody Owen, Cooley Gallery staff Silas Cook and Robin Richard, and Catherine King and Susan Goldstein at the San Francisco Main Public Library.

◇◇◇◇◇ Thanks to all the anonymous album makers for a treasure trove of picture stories and inspiration.

◇◇◇◇◇ And to Paige Ramey, for everything and everything.

◇◇◇◇

BARBARA LEVINE